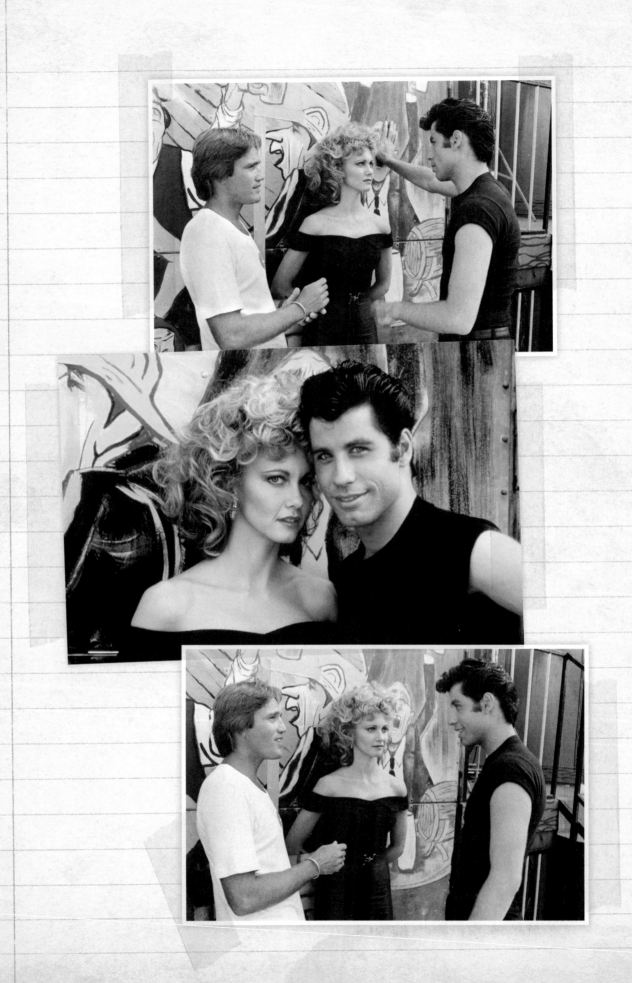

GREASE

The DIRECTOR'S NOTEBOOK

RANDAL KLEISER

Foreword by John Travolta

HARPER
DESIGN

An Imprint of HarperCollins Publishers

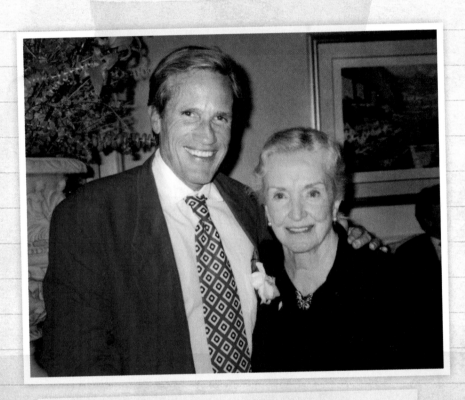

This book is dedicated to NINA FOCH, whom I first saw in
The Ten Commandments when I was ten, and who became
my teacher, mentor, supporter, and lifelong friend.

CONTENTS

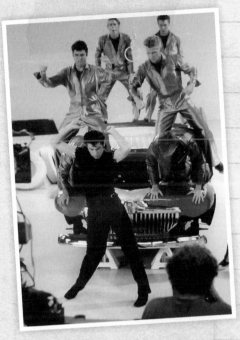

ADAPTING THE PLAY *GREASE* TO FILM

IN LATE 1976, after I signed on to direct the movie, producer Allan Carr organized a trip to Chicago to attend the road company production of the iconic stage musical by Jim Jacobs and Warren Casey. It had opened at the Kingston Mines Theatre Company in Chicago in 1971, then it moved to Off-Broadway in 1972, transferring to Broadway that same year, and it was still running strong.

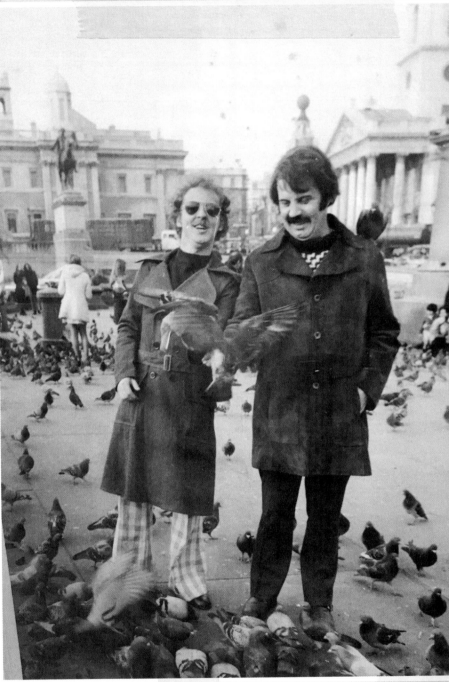

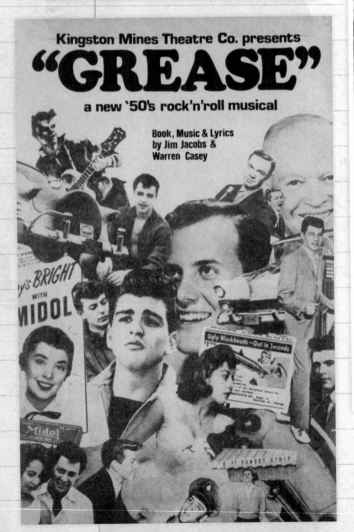

ABOVE AND OPPOSITE TOP: The original *Grease* team of Jim Jacobs (*left*) and Warren Casey (*right*) • LEFT: Program cover from the original Chicago production of *Grease*, 1971 • OPPOSITE BOTTOM: Poster from the original Chicago production of *Grease*, 1971

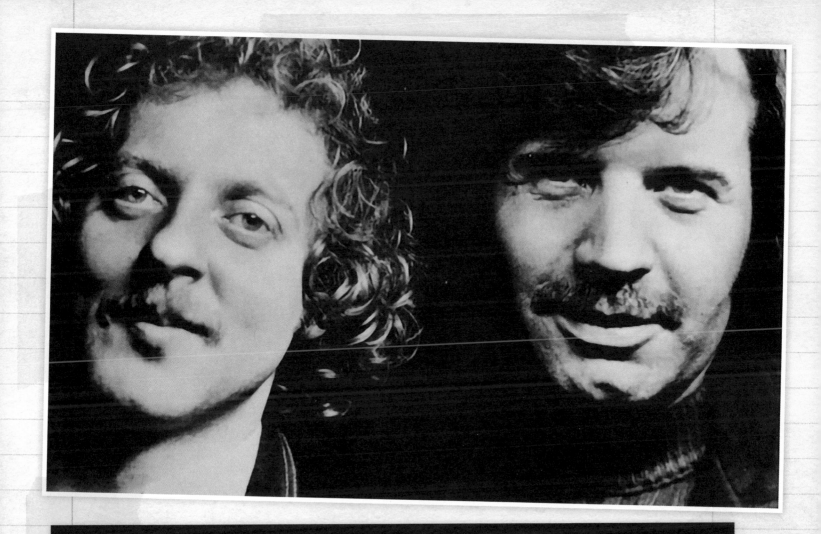

The Kingston Mines
Theatre Company

presents

GREASE

A ROCK 'N ROLL MUSICAL 'BOUT '50s TEENS
WRITTEN BY WARREN CASEY AND JIM JACOBS

DIRECTED BY GUY BARILE

Seeing it for the first time, I was most impressed by Tom Moore's spirited direction and the play's relevance to the high school experience. I began to envision how to adapt it to a movie. It was easy to imagine a movie version of "Summer Nights," and the same for "We Go Together" and "Greased Lightnin'." When the choreographer of the play was hired, I realized how critical it was to have Patricia Birch as my partner; she both understood the vision of the play and knew where all its beats, laughs, and highlights were.

The play was set in an urban Chicago and was raunchy, raw, and aggressive. Based on Jim Jacobs's high school experience at William Taft High School, it was toned down for New York's Broadway stage—and not to the total liking of Jacobs and Casey. Allan, one of the producers of the film, had a suburban Chicago background. He felt by further toning down the raunch and adjusting the script to a more West Coast feel, the characters would appeal to a wider audience. Plus we were shooting the movie in sunny Southern California.

Pat, although not thrilled with palm trees and convertibles, always thought the story would work in any venue or period. Teenagers have common problems—fitting in, being popular. In any high school you can find characters and teen relationships similar to those in *Grease*, which is why the original play works around the world in different cultures.

Allan had brought in his friend Bronte Woodard to write the screenplay. Their concept was to make it funnier, and they wrote lines that were either campy or had a sitcom feeling that had nothing to do with the tone of the original play. I became worried when I read it, so much so that during rehearsals, the actors and I would read a scene from the adapted screenplay, and then read the same scene from the original play. The original play was tried-and-true and worked.

For the five weeks up to principal photography, we rehearsed the script and the musical numbers at Paramount Studios. In the mornings, Pat would choreograph the dancers while I worked on scenes with the actors in the afternoons. Several of the cast had been in the stage musical, so they were extremely familiar with their characters and knew exactly what lines and sight gags got great audience reaction. They helped us keep true to the spirit of the play and came up with bits.

Our casting director, Joel Thurm, was very familiar with the Chicago and Broadway stage productions and shared my concerns about the screenplay. Allan and Bronte would come in each day to hear how the rehearsals were going, and as long as they heard one or two of their lines, they seemed happy. During the shoot, Allan was rarely on the set and didn't pay attention to the fact that we never shot many of the lines he and Bronte added. This book shows the shooting script and all the changes that were made to get back to the spirit of the original play.

We began the shoot on June 25, 1977, at Venice High School.

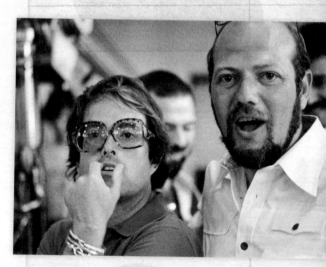

..
TOP: Choreographer Pat Birch on the set • ABOVE: Screenplay adapters Allan Carr (*left*) and Bronte Woodard (*right*)

FOREWORD

IT'S INCREDIBLE THAT MORE THAN FORTY YEARS after the movie *Grease* premiered, it continues to mean so much to so many people on such a deep level. It's taken people out of their worst moments and given them their best moments. And it's still the go-to movie when people need to be cheered up. The cast and I are asked all the time, "Did you know that the movie would be such a big hit?" I have to say even then I knew it would be big, but I never guessed its impact would be so long lasting.

Grease has been a part of me since I played Doody on Broadway. As a young actor just starting my career, I was amazed by how well Jim Jacobs and Warren Casey captured the differences between preppies, jocks, and greasers—and especially the greasers' "coolness" factor. Add rock and roll, dancing, and songs and their play was a combination that couldn't be beat.

As soon as I was cast as Danny Zuko for the movie version of *Grease*, I wanted Randal to be the director because we had great rapport after working on *The Boy in a Plastic Bubble*. He helped bring together a phenomenal cast for *Grease* and agreed that Olivia was the only one to play Sandy. Some of us had been in the play version of *Grease*, and we all worked well together—as Patty Simcox said, we "became lifelong friends." The team behind the scenes also brought the highest level of expertise. Songwriter John Farrar and musical director Louis St. Louis were such perfectionists that they would not allow any mistakes in pitch or performance. The costumes by Albert Wolsky and sets by Phil Jefferies were like the best of the fifties and the seventies all rolled into one. The choreography by Pat Birch and cinematography by Bill Butler captured the colors and layers of high school. And Randal as director had a vision that would not allow less than the best from all of us.

Randal's book has photos even I haven't seen before, and new interviews from cast and crew. His production script shows the changes and rewrites that happened while we were shooting—from improvised lines to added songs to how often we returned to the original words of Jacobs and Casey's hit play.

I'm so grateful to have had the chance to be in a film that has endured and will endure forever. It's been a few decades since I first put on the T-Bird jacket, but when I get together with my fellow Greasers, it's as though no time has passed at all. That's the feeling I get when I read this book, and I hope you feel it too.

—John Travolta

PREPRODUCTION

GETTING THE JOB

IN THE SPRING OF 1973, I held a screening of my USC master's thesis, *Peege*, a short film about a family's visit to an elderly relative in a nursing home, at the Directors Guild of America on Sunset Boulevard. Joel Thurm, the producer of an upcoming ABC TV movie, *The Boy in the Plastic Bubble*, invited to the screening a young actor who would be starring as Tod, the young man with a deficient immune system— John Travolta. John was already famous from the TV show *Welcome Back, Kotter*, but this would be his first leading role. He liked my short and approved the idea of my directing the TV movie.

On the production of *The Boy in the Plastic Bubble*, John and I clicked and developed a good working relationship. John is a perfectionist and would often call me late at night to ask which take of his performance that day I had chosen to print.

Me and John Travolta on the set of the ABC TV movie *The Boy in the Plastic Bubble*, 1975

One of *Grease*'s producers, Robert Stigwood, had his eye on John and offered him a three-picture deal at Paramount. John requested that I be considered as a director. I had directed another TV movie called *All Together Now* for Stigwood's company RSO, so Stigwood was familiar with my work. In June 1976, Nik Cohn's *New York* magazine story "Tribal Rites of the New Saturday Night" hit the stands. Stigwood flew me to New York for a meeting in his Central Park West penthouse with Cohn to talk about turning it into a vehicle for John. Of course, this was to become *Saturday Night Fever*. I went back to LA and didn't hear anything for several weeks. I was busy on my own projects and didn't think too much about the delay. But one day I got a call: I was offered to direct another Paramount/Travolta film, *Grease*.

It turned out that Stigwood had partnered with Allan Carr, who held the rights to the Broadway smash. I knew Allan from various parties around Hollywood as the gay P. T. Barnum who wore caftans and was known for throwing lavish bashes. When he would introduce people to each other, he would list their movie credits, like a walking IMDb. He invited me to the premiere of *Tommy*, where he introduced me to Stigwood. Although I had directed the TV movie *All Together Now* for Stigwood, I had never met him. I suddenly found myself at the right time and right place to step into the director position of what would become the biggest movie of my career.

A few weeks before principal photography began, my teacher and mentor from USC film school, Nina Foch, threw a dinner party for me. She knew I might need some advice and seated me next to Robert Wise, the director of the films *The Sound of Music* and *West Side Story*. Wise had directed Nina to an Oscar nomination for MGM's *Executive Suite*, and they were old friends. I was intimidated at first, but Mr. Wise congratulated me on the assignment and was very encouraging. Then he asked, "How much prep time are they giving you?"

"Around five weeks," I replied.

His answer startled me. "Get out of that job right away," he said. "You'll never be able to do this. It's going to be a disaster." My stomach felt a jolt. Quit? Luckily, I didn't listen to him about that.

But he did give me other tips, such as to listen to and work closely with your cameraman and choreographer. He also lent me his personal print of *West Side Story*, which I ran on the Paramount lot with our cinematographer, Bill Butler. Bill and I studied the cutting pattern of the ensemble number "Tonight," in which the Jets and Sharks sing about a rumble and the lovers sing about connecting. The song cuts back and forth between the stories. This was very helpful in designing "Summer Nights," where we cut back and forth from Danny's story to Sandy's.

THE CAST

CASTING CAN MAKE OR BREAK ANY FILM PROJECT. Sometimes you *know* an actor is right for the part immediately. Sometimes you think an actor is all wrong and they surprise you in the reading.

Once you choose the actors, 90 percent of directing is in the bag. Then you want to get the best out of them. I've found the best way to do that is to help them feel creative and free to make any suggestions. While working on the set, I like to let actors try things—I'll sometimes even shoot a scene in which they get to experiment, even if I don't think it will end up in the picture. There's always a chance their experiment will turn out really great.

Choreographer Pat Birch, me, and producer Allan Carr during a Paramount Studios casting session

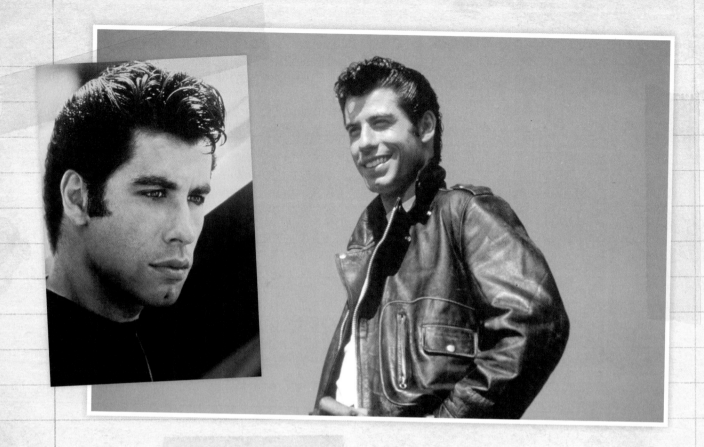

John Travolta as **DANNY ZUKO**

John's first connection with *Grease* was when he played Doody in the national road company, with Barry Bostwick playing the role of Danny Zuko. He was already a teen idol when I first worked with him on *The Boy in the Plastic Bubble*. John was well-known as Vinnie Barbarino, one of the students in the TV comedy *Welcome Back, Kotter*. He was excited about playing his first leading role, that of a young man with a compromised immune system. I was impressed with how he was able to make the character truthful and show vulnerability. He is soft-spoken but has an inner toughness. On the set John was—as he is now—kind, giving, and loved by his fellow actors. He gets lots of respect.

We worked quickly on *The Boy in the Plastic Bubble,* shooting it in fourteen days. I cast Diana Hyland to play his mother. Months later, I attended the premiere of *Carrie* and ran into John sitting with Diana. I was dumbfounded because I'd never had an inkling that they were seeing each other. He was truly in love with her. Tragically, she developed breast cancer and passed away in March 1977. At the Emmys that year, she won the Best Supporting Actress Award, and John took the stage to accept it for her. He held it up and said, "This is for you, Diana." It was very moving.

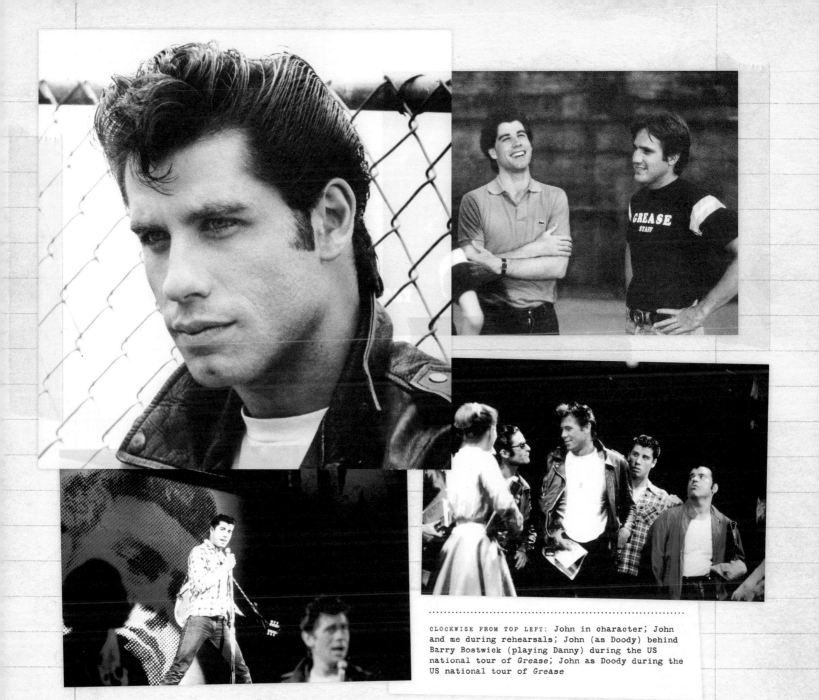

CLOCKWISE FROM TOP LEFT: John in character; John and me during rehearsals; John (as Doody) behind Barry Bostwick (playing Danny) during the US national tour of Grease; John as Doody during the US national tour of Grease

We had a good working relationship, so I was thrilled when John requested me as the director for *Grease*. By the summer of '77, *Saturday Night Fever* had not yet been released, but there was a major buzz about it. It was clear it was going be a hit and transform him into a huge star. Working with John on *Grease* was a different experience from working with him on our TV movie. He now had an entourage, and this brought a change in attitude in him. Not a bad one, but now he knew he was going to be big. That was also an adjustment for me, because I had been thinking of him as just "John the actor," and suddenly he was "John the star." But his youthful energy and combination of sex appeal and warmth hadn't changed—and that's what came across when he played Danny Zuko.

Olivia Newton-John as SANDY OLSSON

I first met Olivia Newton-John, who was already a world-famous singer, at a party at singer Helen Reddy's home. The evening had been especially set up for us to meet her. Allan Carr said she'd be perfect, and I could see her in the role of the sweet and innocent Sandy at the movie's beginning. It was harder for me to imagine Olivia portraying the wild character at the end of the movie, but I was open-minded. Especially since there was no one anywhere as suited for the role.

We needed a talent who could act as well as sing, someone who could play the "good girl" as well as the black-leather-clad sexpot at the end of the film. Olivia became our first choice to play Sandy. Because of her bad experience on her first movie, she was cautious about acting again. She asked for a screen test. This was unheard of, because normally the studio requests a test to determine whether it wants to hire someone.

If she didn't feel right about the film or her chemistry with John, she wanted to be able to say no. I understood where she was coming from. Her US film debut, a sci-fi 1970 musical called *Toomorrow*, had bombed, and I didn't blame her for being cautious, since her singing career was doing so well. Then she revealed she was concerned about playing a seventeen-year-old. At the time, she was twenty-nine and John was twenty-three. I told her that this was going to be a kind of bigger-than-life, almost surreal high school and that we were casting actors who were in their twenties. That seemed to help.

For her test, we chose the drive-in scene where Danny tries to seduce Sandy. The day of the test, John, the more experienced actor, was aware of her fears and took her under his wing. He joked around with her, treating her like an older brother would. I remembered my directing training and lightly touched her on the shoulder when speaking with her about the scene. This simple gesture can ground an actor and make them feel secure.

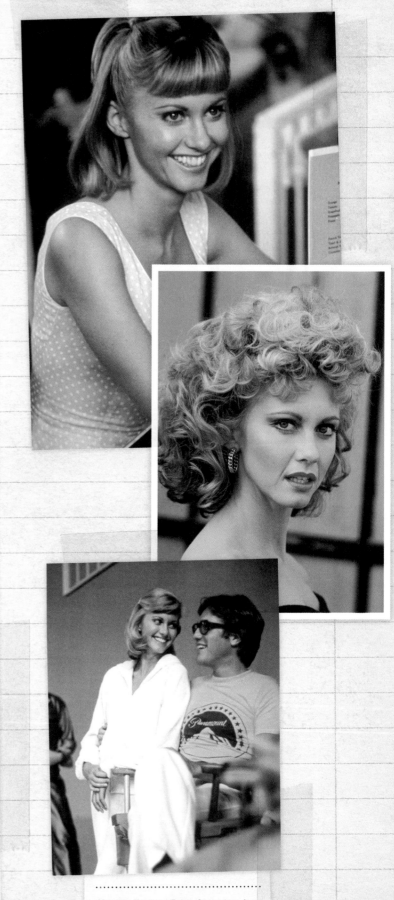

Olivia Newton-John dropping by to watch the shooting of the "Greased Lightnin'" number

Our cinematographer, Bill Butler, developed a ring of light to go around the lens and give Olivia a young look. This soft light from the front of the camera erases slight lines in the face (not that Olivia had many). This technique is often used by photographers when shooting women for magazine covers.

But it became clear during the rehearsal for the test that something was off. Earlier, Allan and Bronte Woodard had rewritten parts of the original play to "improve" the dialogue—and their version wasn't working. I remembered how Tom Moore's direction had great comedy beats in the stage version that I had seen. The casting director, Joel Thurm, pulled out a copy of the theatrical script, and John and Olivia began to rehearse with it. Suddenly, we had the scene: the two actors were connecting, and it was quite funny. As John and I knew she would, Olivia easily nailed both the naïveté and the comedy of the character. After the shoot, she was more relaxed, and it seemed that her apprehensions had subsided. But now we needed her to see the test—and decide to do the movie. If she didn't like what she saw and backed out, we didn't have a solid replacement who could sing and act.

As she viewed the test, we held our breath. Olivia saw that she looked great, seemed to match John in age, and had great chemistry with him. She agreed to do the picture (and we breathed a sigh of relief). One last tweak to the script transformed Sandy Dumbrowski into an Aussie named Sandy Olsson.

During this casting period we needed a possible backup Sandy in case Olivia didn't want the role. My former college roommate, George Lucas, was finishing a movie with the daughter of Debbie Reynolds. I knew Carrie Fisher from parties around town but didn't know if she could be right for the part of Sandy. I called George and asked if he had any footage of her I could see. He said to come down to Samuel Goldwyn Studios, where he was mixing the soundtracks for *Star Wars*. I entered the mixing stage and watched the screen. It was a battle scene between spaceships, with the action cutting back and forth. "Where's Carrie?" I asked. A quick cut went by on the screen: Carrie turning her head (with those huge buns) to follow the action of a ship. "That's her," George said.

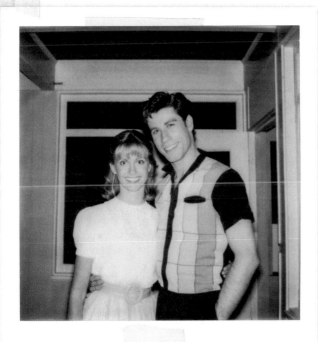

A Polaroid taken at the screen test. John and Olivia look costumed for the part, but that was just what they happened to wear that day.

Of course, from that short clip there was zero chance that anyone could tell if she could act, sing, and dance through a musical. I thanked George and left, quite concerned about what we would do if Olivia said no. Suffice to say, we were all thrilled and relieved that Olivia decided to join us and play Sandy.

Working with Olivia on *Grease* was a great experience. I often tell people that Olivia in person is exactly how you would expect her to be: loving, warm, charming, and beautiful. She has a lot of depth and soul. We developed a close relationship on the set, and I feel she trusted that I was looking out for her during each moment on-screen.

I think if we had used an American as Sandy, it wouldn't have been as interesting. The choice of changing Sandy to an Australian may have been based on Olivia's accent, but having Sandy be an outsider in a new country made Olivia's naïveté believable and added a special element to her portrayal.

And the fact that Olivia had been a singer for so many years also had prepared her for the role—acting is part of being able to interpret the lyrics of a song. In "Hopelessly Devoted to You," we just kept the camera on her face in one long take so she could perform the way she does in concert.

Jeff Conaway as KENICKIE

Jeff was constantly coming up with all kinds of ideas during rehearsals and on the set because he was so familiar with the play. He had played Danny Zuko on Broadway for two years, and so it seemed as if he knew every beat of the show.

Those in the cast who hadn't seen the play would ask Jeff questions about the characters, and he and the other Broadway cast members would fill them in on the background—where some bit had come from or how a certain bit had come alive onstage. During the shoot, my relationship with him developed into that of a kind of big brother or uncle. On his part, there was also a bit of playful rebellion, as if I were the teacher and he was a class cutup.

When his agent told him he was being called to audition for Kenickie, Jeff at first refused, because he viewed the stage production's Kenickie as a "no-neck monster." That is overstating it a bit, but the stage version of Kenickie was more dangerous, as if he really would use the lead pipe he was carrying around. Thankfully for us, Jeff decided to audition; his version of Danny Zuko's best friend was tough, but you got the impression his toughness was an act. Jeff may have been disappointed that he wasn't playing Danny, but he threw himself into every scene with enthusiasm. He used to say, "I get to be a senior in high school again and do whatever I want to do!" His energy helped keep everything going.

John was his best friend in real life—they'd known each other since they were teenagers—and there was a lot of chemistry between them that comes out in the film. We were all devastated by Jeff's passing in 2011. Many of us attended his funeral, where his friends the Temptations sang a tribute to him.

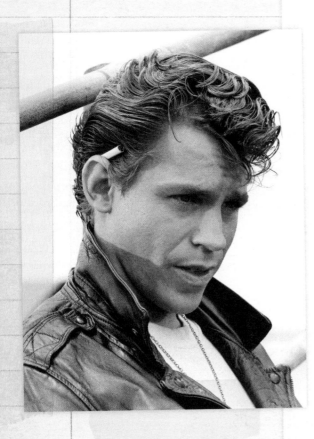

Barry Pearl as DOODY

Barry first worked with Pat Birch in 1967 on *You're a Good Man, Charlie Brown*. He became involved with *Grease* in 1973 when he replaced Michael Lembeck, who broke his ankle onstage in Toronto during the "We Go Together" number. He joined the cast as Sonny and met John Travolta, who was playing Doody. He remained part of the national tour for its last ten months. In our casting session, he auditioned for Doody, singing "Blue Suede Shoes" and improvising a comedy bit that got him the part right there in the room. Barry made the character into a class clown in the vein of the Three Stooges, one of his favorite comedy trios (and mine as well). He was a joy to work with because every minute he was coming up with ways to add comedy beats to his scenes. Pulling out a squirt gun when he sees the rival gang, working out bits with Kelly Ward and Michael Tucci, goofing for the *National Bandstand*'s live cameras, and many added asides . . . he contributed a lot to the tone of *Grease*.

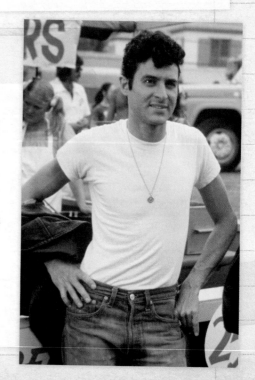

Michael Tucci as SONNY

Michael has a long history with the play. He started as an understudy on the national tour and first got a chance to go onstage in Toronto. He played Kenickie for a few performances. He moved to Los Angeles, and Joel Thurm, our casting director, saw Michael in a performance of *Hold Me!*, a play by Jules Feiffer. After the play, Joel told him to come to Paramount the next day for an audition. He dutifully arrived at Paramount, read and ad-libbed and got everyone laughing, and on the spot he was cast for Sonny.

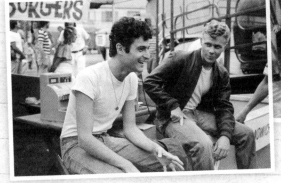

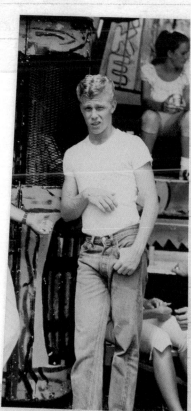

Kelly Ward as PUTZIE

John and I had worked with Kelly on *The Boy in the Plastic Bubble*, and Kelly had worked with Pat Birch in a Broadway production of *Truckload*. It's hard to believe, because Kelly was great as Putzie, but he hadn't thought about auditioning for the movie. He was down on his luck and needed cash badly. He begged Pat Birch for a job helping her with the casting sessions, and once hired, tried to make himself as useful as possible. It was the real Hollywood moment when we asked him to read for the part of Putzie. Pat Birch later called him perfect for the part: "naive and horny."

The PINK LADIES

Stockard Channing as RIZZO

Now one of the great actors of stage and film, Stockard was playing an unworldly secretary in Neil Simon's movie *The Cheap Detective* when she read for the part of tough-but-vulnerable Betty Rizzo. Stockard was someone Allan Carr knew very well. He was her manager, and she was always the first choice for Rizzo, the bad girl with the heart of gold. Rizzo's number, "There Are Worse Things I Could Do," is one of the best examples of how song and acting can convey emotion. Stockard got across all the secret yearnings of a teenager. She was one of the last principal actors to be cast, but her character is one of the most memorable. One critic compared her to Thelma Ritter, a character actress who would often steal scenes.

In 1994, I hosted an Oscar party for her at my home when she received a Best Actress in a Leading Role nomination for *Six Degrees of Separation*. The party became one of the many *Grease* cast reunions we have had over the years.

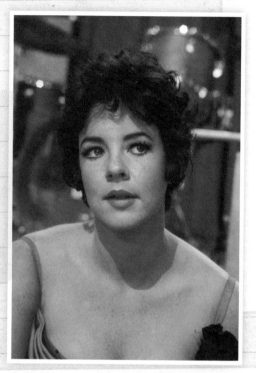

Jamie Donnelly as JAN

Jamie was in the US premiere of the play *The Rocky Horror Show* with Tim Curry and Meat Loaf. She then played Jan in the Broadway production of *Grease* but wasn't keen on auditioning for Jan in the movie, as she didn't think she would win the role. Eventually, after hearing that other stage production actors like John and Jeff were in the film, she decided to come in and read. Jamie wanted to branch out and read for other roles. But as she read for part after part—anything but Jan—it was clear to us that no one but Jamie could *be* Jan.

Jamie liked that the movie version of Jan was a late bloomer, from a sloppy kid who ate all the time to someone who had fallen in love (with Putzie) and was aware of presenting herself in a neater way.

Jamie told me a touching story about a woman who came over to her on the street to thank her one day. "For what?" Jamie asked. The woman had never been able to get her daughter, who had Down syndrome, to brush her teeth. Then her daughter watched Jan do it during Frenchy's sleepover scene, and she was able to imitate Jan from then on.

Didi Conn as FRENCHY

Didi had already starred in *You Light Up My Life* when she showed up to audition for the role of Frenchy. She was to read the scene where Frenchy consoles Sandy with "Men are rats. Worse. Fleas on rats," after Danny has rejected her at the pep rally. At the Paramount gate, she picked up the envelope containing only this scene from the security guard. She was frustrated by how little information she got from it about why she would say those lines to Sandy. She begged the security guard to let her borrow the rest of the script, and he refused but did let her sit on the floor of his booth and read it through.

From the moment Didi read, we stopped looking for Frenchy. Her voice and her mannerisms were perfect. She later became the mistress of ceremonies at our Hollywood Bowl sing-alongs. For the past four decades people recognize her every day, she told me, mainly because of her voice.

Dinah Manoff as MARTY

The Broadway production's role of Marty was a brassy, Julie Newmar type. Dinah brought out a more vulnerable, down-to-earth side of Marty. After eight callbacks, she felt she'd lost the part because of her dance audition, in which she felt uncomfortable. However, we loved her for the part when she started basing the character on a high school virgin imitating Marilyn Monroe. During the production her hairdo was based on Marilyn and Rita Hayworth. Her costumes were designed similarly.

She comes across with the ultimate teen crush on Edd Byrnes's character Vince Fontaine at the dance. I love the moment when she stands next to Vince and mugs in a sexy way for the live TV cameras.

When asked about the fifties, Dinah said, "Up the fifties." She had good reason to feel that way. Her mother, Academy Award winner Lee Grant, and her father, Arnold Manoff, had been called up by the House Un-American Activities committee during that decade. They were blacklisted for years.

Annette Cardona (aka Annette Charles) as CHA CHA DiGREGORIO

Sultry Cha Cha, "the best dancer at St. Bernadette's—with the worst reputation" wasn't anything like the character in the play. That character is an overweight girl who shows up at the prom, and Danny doesn't want to dance with her. For the movie, we made her the girlfriend of the leader of the rival gang, the Scorpions. Part of her audition was to dance with John to see if they would click—they did. Annette went on to teach dance and support the plight of transgender youth for many years. I was deeply saddened when she passed away prematurely in 2011 of lung cancer, although she never smoked.

Dennis Stewart as LEO or "CRATERFACE"

The leader of the Scorpions was a character invented for the movie. Leo's dialogue and dress come across like something you would hear and see even today: "Get the dude, man." "We're racin' for pinks, punk." During production, Dennis also worked as a dancer on the other Robert Stigwood movie shooting at the same time, *Sgt. Pepper's Lonely Hearts Club Band.*

Steve Ford as TOM CHISUM

Steve Ford, the son of President Gerald Ford, was cast to play Sandy's boyfriend Tom Chisum. During our rehearsal period on the Paramount soundstage, Pat Birch made Steve dance in the center of the circle to see if he could move. The next day, we heard he had backed out of the movie. We quickly turned to Lorenzo Lamas.

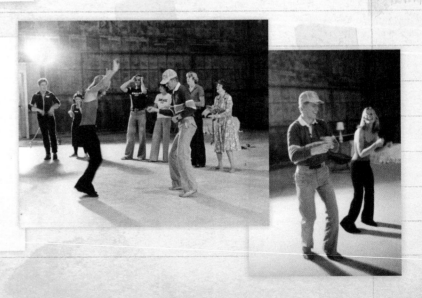

Lorenzo Lamas as TOM CHISUM

The son of Arlene Dahl and Fernando Lamas, Lorenzo's first brush with film was at the age of ten, when he was in *100 Rifles* with his dad. When Steve Ford dropped out of the role, Allan Carr remembered meeting Lorenzo and brought him in. Lorenzo was surprised that he didn't have any lines to read. But he had the right look and we cast him, although we did dye his hair blond so his look wouldn't conflict with Danny's. And he got some lines in, after a fashion, when he mouthed, "Hi . . . how are you," to Sandy at the pep rally.

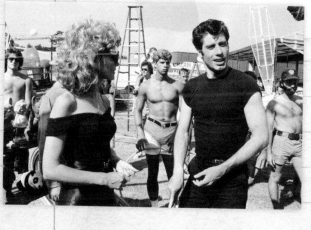

Susan Buckner as PATTY SIMCOX

An accomplished dancer and actor, as well as Miss Washington 1971 and a contender for Miss America 1972, Susan was perfect for Goody Two-shoes head cheerleader Patty Simcox. Susan drew inspiration from a girl she went to high school with who drove everyone crazy with her relentless school spirit. She "just loves the first day of school!" Susan nailed Patty.

Eddie Deezen as EUGENE FELZNICK

There is a Eugene in every school. Eddie dove into the part and made the character iconic, so much so that when his character was almost written out of the script, it made it back in. Nowadays Eddie is one of the most sought-after actors during *Grease* appearances—everyone wants his autograph. Who would have predicted Eugene would go from nerd to superstar?

The GROWN-UPS

Casting director Joel Thurm brought up the instantly popular idea of using famous actors from fifties TV shows as the teachers. Like many other baby boomers, I grew up watching Eve Arden in *Our Miss Brooks* every week with my family in Rosemont, Pennsylvania. All the actors we cast to play the adults felt as if they were part of my extended family. For me, just meeting these icons from my adolescence was a real trip. Directing them was surreal.

Eve Arden as PRINCIPAL McGEE

It was extremely exciting for me when we cast Eve Arden. She made her Broadway debut in the *Ziegfeld Follies of 1934* and went on to make many movies, often playing the sassy, wisecracking best friend. She received an Academy Award nomination for Best Actress in a supporting role in *Mildred Pierce*. Eve could not have been easier to work with. When my parents visited the set, she treated them like old friends. Watching this Emmy-winning actor rehearsing scenes with Dody Goodman had me in stitches as the two played off each other and improvised bits.

Dody Goodman as BLANCHE HODEL

Dody was very popular as a regular guest on Jack Paar's *Tonight Show* during the fifties. She had a voice that everyone recognized: "like a *Tweetie Pie* cartoon bird strangling on peanut butter." In the mid-seventies, everyone knew her as Mary Hartman's wacky mother in *Mary Hartman, Mary Hartman*. She often played a kind of scatterbrain in her roles, but her timing was exquisite—such as in her scenes with Eve Arden as Principal McGee. During the dance contest, Dody stayed in character and constantly improvised bits. One of our roving cameras caught her dancing alone madly, and later gazing up at Johnny Casino lovingly.

Sid Caesar as COACH CALHOUN

In the 1950s, every Saturday our family tuned into *Your Show of Shows* along with most of America to watch Sid Caesar. Sid said more with one raised eyebrow, one gesture, or one significant pause than other comedians might in a whole dialogue scene. He was actually a replacement. Allan Carr had inexplicably hired *Deep Throat* porn star Harry Reems to play the high school coach. The studio objected and Allan had to break the news to Harry. He gave him a check for five thousand dollars out of his own account. We went with Sid Caesar and were impressed by his old-school professionalism. Sid never left the set to go to his trailer. He didn't even sit in one of the director's chairs that each cast member is provided. He would sit on the floor and chat with the extras, answering any questions, joking and treating everyone with warmth.

Joan Blondell as VI

Joan was the consummate old-school actor. Born into a vaudeville family, she was one of Hollywood's highest-paid actors during the Depression yet post-Code Hollywood censored some of her best scenes from films like *The Public Enemy*, in which she served breakfast to her boyfriend in bed (clearly having slept with him, a no-no in Puritan America). She had award-winning roles in theater, TV, and movies well into the 1970s. Playing the confidante with a heart of gold made her just right for Vi, the seen-it-all but kind waitress. When asked if she longed for the old days of the studio system, she said, "Not at all. I'm so happy to be here, and isn't this song fun?" Her wisecracks made everyone laugh, and she was one classy lady.

Frankie Avalon as the TEEN ANGEL

Unlike most teen idols, Frankie Avalon had extensive training as a musician; before he was discovered as a singer, his trumpet playing was featured on TV's *The Honeymooners* and on albums for various bands. In high school I remember listening to him on AM radio sing "Venus," "Dede Dinah," and "Bobby Sox to Blue Jeans." He and Annette Funicello teamed up for a long and successful series of Beach Party movies, cementing his role as a teen icon. I ran into Frankie a few years ago and he told me that in his concerts, of all his songs, the most requested is "Beauty School Dropout."

Fannie Flagg as NURSE WILKINS

Fannie almost played Principal McGee, but a last-minute casting change shifted her to the Nurse Wilkins role. Even wearing a nurse's hat and cape, Fannie was instantly recognizable to audiences from her wisecracks on *The Jack Benny Show* and *The Tonight Show*. She is probably best known as the writer of her best-selling novel and 1991's hit film *Fried Green Tomatoes*.

Alice Ghostley as MRS. MURDOCK

Most baby boomers watching *Grease* recognized Alice right away as the bungling witch Esmeralda in *Bewitched*. She made eccentric characters charming and funny. A Tony Award–winning actor, she also appeared in 1962's *To Kill A Mockingbird*, playing the neighborhood gossip. Alice had no problem being the strict shop teacher, Mrs. Murdock, dressed in auto mechanic coveralls—and no problem keeping the T-Birds in line.

Darrell Zwerling as MR. LYNCH

Darrell famously played Hollis Mulwray, the unfortunate husband of Faye Dunaway's character in 1974's *Chinatown*, who ends up drowned in a freshwater reservoir under suspicious circumstances. I was happy to have given him a less lethal role as Tod's high school teacher in *The Boy in the Plastic Bubble*. It was fun to have him back, as Mr. Lynch, one of Rydell High's teachers.

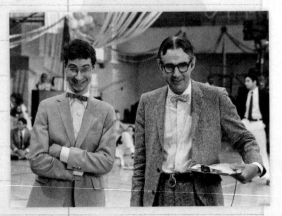

Dick Patterson as MR. RUDIE

As a teen, I remember seeing Dick in *The Absent-Minded Professor*. He often appeared on *Hollywood Squares* and *Password*, but those in the industry knew he could dance, sing, act, *and* write. He got a big break on Broadway when he took over for Dick Van Dyke in *Bye Bye Birdie* and was a classmate of Carol Burnett's at UCLA, performing with her and even becoming a regular on her TV show. He worked behind the scenes too, writing comedy for Las Vegas headliners like Rich Little. In *Grease*, we were fortunate to have him playing Mr. Rudie, one of the many clueless grown-ups trying to keep control.

Edd Byrnes as VINCE FONTAINE

As star of TV's *77 Sunset Strip*, Edd was "Kookie," one of the first teen idols of the initial TV generation. As a teenager I watched the show every week. I thought he was the ultimate cool guy as he traded quips with Roger Smith and Efrem Zimblast Jr. while parking their cars. (When I first came to Los Angeles as a film student, I went up to the Sunset Strip to see the location. It was next to Dino's restaurant, which has since been razed.) On the show, when he combed his hair, girls would swoon—and he even had a hit record, "Kookie, Kookie, Lend Me Your Comb." He was the perfect actor to play smooth-talking Vince Fontaine and channeled a bit of Dick Clark as he hosted our *National Bandstand* TV show.

The DANCERS

Instead of using regular Hollywood extras, it was Pat Birch's idea to use twenty key dancers to populate the school: ten girls and ten boys. She wanted them to be more than just background; they had to be able to portray characters in movement. We held open calls in New York and Los Angeles. At the Lunt-Fontanne Theatre on Broadway, Pat chose Barbi Alison, Helena Andreyko, Carol Culver, Dennis Daniels, Antonia Francheschi, Daniel Levans, Mimi Lieber, Sean Moran, Andy Roth, and Richard Weisman. And on a Paramount soundstage, she chose Jennifer Buchanan, Cindy DeVore, Larry Dusich, Deborah Fishman, John Robert Garrett, Sandra Gray, Greg Rosatti, Lou Spadaccini, Judy Susman, and Andy Tennant.

Pat asked each of them to come up with a name and a backstory. Several had been in the Broadway cast and were excited to be part of the movie version. In every scene, she worked out bits of business for them to do that was well thought out and specific. That way, the viewer could recognize these characters and connect with them at the end when they sing "We Go Together." In the big dance sequences—the contest and the carnival—she assigned each dancer to teach the choreography to the extras around them. Much of the nonstop energy in the film comes from the improvisations of these players in rehearsals that were picked up and choreographed carefully. If you watch these scenes in the movie, you can see every one of those dancers giving their all.

PAT BIRCH SUBJECT: "GREASE" – DANCERS/SINGERS
 CHARACTER NAMES

The following Chorus members have selected character names for themselves. They are listed from "Heavy" Greaser types progressing to the "Square", "Jock" types.

Mimi Lieber – "Sauce"
Greg Rossati – "Dago"
Lou Spadaccini – "Woppo"
Sandy Gray – "Big G"
Andy Tennant – "Arnold"
Deborah Fishman – "Babs" (intelligent Greaser)
Daniel Levans – "St. Vitus"
Antonia Fraucheschi – "Toni"
John Garrett – "Bubba"
Helena Andreko – "Trix"
Sean Moran – "Mouse"
Barbie Alison – "Midge"
Andy Roth – "Eddie"
Cindy DeVore – "Deana"
Richard Weisman – "Buz"
Jennifer Buchanan – "Jenny"
Larry Dusich – "Duece" – (Jock)
Carol Culver – "Cee Cee" – (Cheerleader)
Dennis Daniels – "Bart" – (Jock)
Judy Sussman – "Teddy" – (Cheerleader)

Pat Birch

THE REHEARSALS

WE HAD FIVE WEEKS OF REHEARSALS to capture the spark of the musical—an eternity if we had been shooting a TV show, which typically races through production, but a short time for a movie musical in which dancing and singing featured so prominently. We were assigned a soundstage on the Paramount lot where all the dancers and the principal actors would meet every day. In the mornings, I worked with the actors around the table on dialogue and Pat Birch worked with the dancers and the actors who could dance. In the afternoons, I took the cast to the soundstage to work out the transitions from acting to singing with Pat and Bill Butler.

I had watched the musical many times and gotten a sense of the laughs and beats, but I relied on Pat, who had been with the play from early on, to guide me. "We're all going to be one big, happy family," Pat told everyone on the first day—just before she started us on a rigorous warm-up of calisthenics and jumping jacks.

Pat and I became a team, working closely together from the time we first met at Paramount. She had studied with Agnes de Mille and Martha Graham and been nominated for four Tonys (including 1974's *Over Here!*, which happened to include Broadway newcomer John Travolta), and she was rapidly becoming an in-demand Broadway choreographer. On the stage, she had played one of the original Anybodys, the tomboy who ran with the Jets, in the New York production of *West Side Story*, which also impressed the hell out of me. Choreographing *Grease* was never about honing technically perfect dance steps, although the dancers she chose were exceptional and she demanded their best. Instead, she focused on how greasers, jocks, cheerleaders, and other schoolkids would interpret a dance. "I always need to find a context to choreograph," Pat has said. "I'm no good without a context." I found out how good she was the moment she began shaping the dance numbers, and I was excited to collaborate with her. This movie was a first for both of us.

Although I had no background in musicals and this was my first feature film, when I showed up on the *Grease* set, I didn't feel lost. When I went to USC film school, I worked as an extra in films and TV to pay for my student projects. I had appeared in many musicals; including *Hello, Dolly!*; *Camelot*; *Thoroughly Modern Millie*; and *Fireball 500* with Frankie Avalon. Probably the best training for directing *Grease* was working as an extra on three Elvis Presley musicals, where I got to watch Elvis up close as I danced with the other extras. He would show up with his entourage of good ole boys, and they would hang out on the set, often practicing karate. Elvis began to recognize me whenever I showed up on one of his sets. It was a thrill when the King would politely nod a greeting to me.

Before MTV and music videos, the only musical numbers accessible to the public were in feature film musicals. While working as an extra on the sets of these movies, I carefully watched how the numbers were filmed. The song would have been prerecorded by the singers and ready for the sound technician to play. Rather than running the song straight through, the directors would break a number into sections, sometimes into a phrase of lyrics. After lining up an angle for each section, the director would yell, "Playback!" and the actors would lip-synch that section. Watching was my training. Now I needed to put it into practice.

During the rehearsals, Pat, Bill, and I would plan where the camera would be to best capture the dancing and the acting. Bill had been hired for *Grease* before Pat or me, and his experience and inventiveness were integral to the movie's success. An award-winning cinematographer who had shot one of my favorite films, Francis Ford Coppola's *The Conversation*, as well as *One Flew Over the Cuckoo's Nest* and *Jaws*, he was unfazed by the loose, improvisational style that Pat and I encouraged with the actors. Bill used to follow Pat around during rehearsals, standing in front of her and looking at the dancers through a frame made with his thumbs and forefingers. She didn't get what he was doing, and it drove her crazy until he told her, "I'm looking at what you're looking at, imagining the best way to capture it."

OPPOSITE: Me and choreographer Pat Birch on the *National Bandstand* set

RIGHT: Rehearsal on the Paramount soundstage before shooting. Our musical director, Louis St. Louis, is on the piano, and Cubby O'Brien, one of the original Mouseketeers, is on the drums.

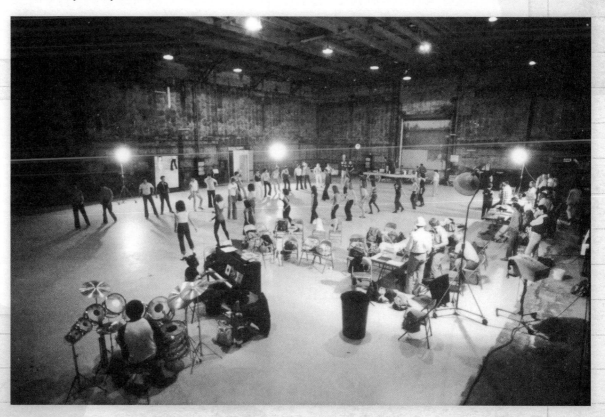

Pat came up with an ingenious plan to speed up the rehearsal process. On the soundstage, she organized an impromptu sock hop. Everyone was given a T-shirt with his or her character name or staff position printed on it and told to get in a big circle. Pat instructed everyone, two by two, to take a turn in the center and dance to the rock-and-roll music played on drums and piano. That way, she could analyze who were strong dancers and who was going to need a lot of help. This also began a bonding process, as everyone got to know each other during this fun event. It was during the sock hop that Pat saw how good a dancer Olivia was. We had planned for only Cha Cha to dance with Danny during the dance contest, but Pat started developing the choreography for Sandy and Danny as well.

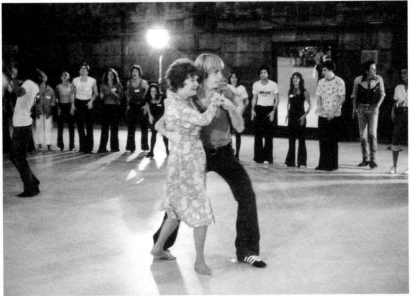

LEFT: Dody Goodman dances with dancer (and future director) Andy Tennant.

BELOW: Rehearsing "We Go Together" on the Paramount soundstage with the full cast.

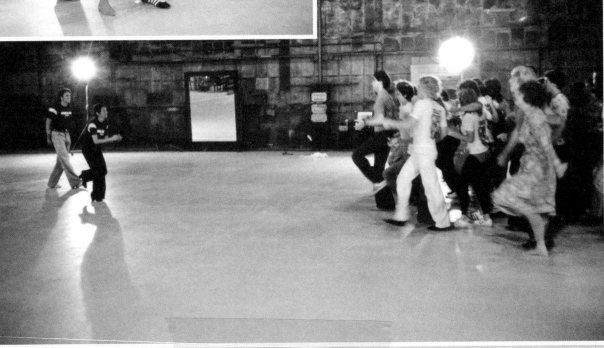

John had dance training. In fact, when we began shooting *Grease*, he had just finished shooting *Saturday Night Fever*. Pat and John had a shorthand and were able to try things back and forth and fine-tune the movements. For the other actors, Pat would watch them carefully and mold dance steps to each person. If they were not technically perfect but displayed character, she'd say, "Keep it in. It's great." This gave a loose energy to the actors' movements.

I encouraged the actors to play around in rehearsals to find moments that revealed the relationships of the characters. We had already seen in the auditions how far the actors would go to make these characters their own. During the morning sessions, if someone came up with an idea that seemed a little zany but felt right, we'd try it out. The fact that the studio was focused on bigger-budgeted movies at the time meant there wasn't a lot of pressure on us and we could do our own thing and take chances.

The noise from our musical rehearsals on the empty soundstage disturbed Jack Nicholson, who was prepping *Goin' South* in a nearby office. Warren Beatty was also on the lot, prepping *Heaven Can Wait*. As rehearsals drew to an end, we were told that Paramount executives, including CEO Barry Diller, were going to watch a run-through of all the songs. There was already a buzz about the movie around the lot. We got word out to Jack and Warren and invited them to the final run-through.

Finally, after five long weeks, we were ready.

Choreographer Pat Birch staging "Summer Nights"
at Venice High School

The
SHOOTING
SCRIPT

Radal Kleiser

GREASE

Screenplay by

Bronte Woodard

Screen Story by

Bronte Woodard and Allan Carr

Adapted from the Broadway musical by

Jim Jacobs and Warren Casey

A ROBERT STIGWOOD/ALLAN CARR PRODUCTION

Return to Script Department
PARAMOUNT PICTURES CORPORATION
5451 Marathon Street
Hollywood, California 90038

FOURTH D

June

My shooting script is the final version written by the screenwriters and delivered to me just before production began. There are dialogue changes, rewrites, and spur-of-the-moment revisions that occurred during filming that are not all reflected here. But that's the way movies are made, so apologies if some of your favorite lines are not included!

33

"Love Is a Many-Splendored Thing"

HIGH ANGLE + RUN
ON BEACH

TWO

SANDY

DANNY

FADE IN:

1 EXT. ~~SEASIDE RESORT~~ - DAY BEACH 1

OPEN with a small-screen ratio with a blue and white tint. ~~It is a fashionable resort.~~ SOUND of distant GULLS.

SANDY OLSSON, a lovely ingenue, in a Rose Marie Reid swimsuit lies alone on a beach towel. "LOVE IS A MANY SPLENDORED THING" PLAYS on her portable RADIO. She looks at her watch.

BEACH

2 EXT. ~~HAMBURGER STAND ON PIER~~ - DAY 2

DANNY ZUKO, a good-looking teenager, is wrapping up his day's work at a hamburger stand. Even though he wears a short order cook hat there is a look of a hero about him. His eyes glisten with unfulfilled romantic longing. The same SONG is PLAYING on a RADIO in the hamburger stand. He glances at the clock over the sink which reads six o'clock.

He finishes his work for the day and opens a closet where there are clothes hanging. A picture of James Dean is tacked on the inside of the closet door. He quickly grabs the clothes and begins to change.

wears jacket like Rebel without a cause

3 EXT. SEASIDE RESORT - DAY 3

Sandy sits alone looking forsaken, tears in her eyes as the SONG continues to PLAY on her RADIO.

4 EXT. BEACH 4

Danny dashes madly along the beach away from the pier, zipping up, buttoning up and trying to make himself presentable in what he thinks are fashionable clothes, but almost everything is a little bit off.

5 OMITTED 5
thru thru
7 7

CUT TO:

The Song

We wanted the audience to get the idea of a fifties-style summer fantasy right away, so over the montage of Sandy and Danny frolicking on the beach we played the classic romantic song "Love Is a Many-Splendored Thing" from the 1955 film of the same name. Written by Sammy Fain and Paul Francis Webster, this Oscar-winning song is over-the-top, but it set the tone and swept the audience right into *Grease*.

2.

8 EXT. BEACH COVE ~ DAY 8

Sandy rises, about to leave, just as Danny, breathless, slides down a sand dune toward her.

They rush into an embrace. Danny has to break off after a moment, still out of breath.

 SANDY
 I thought you'd forgotten.

 DANNY
 (still out
 of breath)
 How could I forget?

 SANDY
 You know what they say about
 summer romances.

 DANNY
 No, what do they say?

Sandy looks disappointed. He looks confused.

 SANDY
 I have to leave in the morning.
 My father wants to beat the
 Labor Day traffic.

They look at each other for a moment then Danny kneels to the sand and pulls her with him. He looks into her eyes, then kisses her urgently. After a moment she pulls away.

 SANDY
 (continuing)
 Oh, Danny, don't spoil it.

 DANNY
 This isn't spoiling it. This is
 making it better.

They sit side by side. He is about to put his arm around her. Then suddenly something is wrong. He stops. She opens her eyes.

 SANDY
 What is it?

He looks away in embarrassment. She turns his face to her.

The Scene

In the shooting script, there is a sequence that was not filmed. Sandy Olsson lies on a beach towel on a beach, listening to "Love Is a Many-Splendored Thing" on the radio. She looks at her watch—she's clearly waiting for someone, and he's late. The scene changes to a hamburger stand, where Danny Zuko is wrapping up his day's work as a short-order cook, with the same song playing on the radio. Then we see Sandy, her eyes filling with tears as she fears her relationship with Danny has ended.

In both the script and the movie, they meet one last time on that final day of the summer. In the shooting script, the romantic dialogue gets broken up by some jokes. For the movie, we cut a lot of the dialogue (and the jokes) to focus on shots of the two enjoying themselves. Then Sandy asks, "Danny, is this the end?" and he replies, "Of course not. It's only the beginning." The mood is jolted by the radio blasting in the animated title sequence.

My very rough storyboard sketches on the opposite page of the script show the simple shots of Danny and Sandy.

An adjustment we made: In the shooting script Danny has a picture of James Dean in his room. Instead, we had Danny wear a jacket just like the one the ultra-cool James Dean wore in *Rebel Without a Cause*.

8 CONTINUED: 8

 SANDY
 (continuing;
 tenderly)
 You can tell me.

 DANNY
 I'm left-handed.

 SANDY
 Huh?

He pantomimes changing positions. They change sides.

 SANDY
 (continuing; as if
 it were precious)
 Left-handed.

 DANNY
 In a world full of right-handed
 people.

They kiss again.

 SANDY
 I feel like this is the last
 time we'll ever see each other.
 Two different people from two
 different worlds. A chance
 meeting. X
 X
 X

They look at each other in sad acknowledgment of this
impossibility.

 SANDY
 (continuing)
 Oh, Danny, Danny, Danny. Is
 this the end?

He cups her face in both his hands and smiles gently
at her.

 DANNY
 Of course not, Sandy. It's only
 the beginning.

9 GO TO COLOR IMAGE AT THE CENTER OF THE SCREEN 9

10 INTRO KENICKIE 10

 CLOSE on an alarm clock radio.

 (CONTINUED)

The Location

We considered several locations for the beach scenes, including Marion Davies's beach house in Santa Monica, which would have stood in for a club where Danny had a summer job. After looking around at other options, we decided on shooting at Leo Carrillo State Park near Malibu. This is the ultimate Southern California beach, with rock formations, caves, white sand, and several intimate coves. Dozens of films have been shot there, including *Journey to the Center of the Earth*, *Beach Blanket Bingo*, *Attack of the Crab Monsters*, and, years after us, *The Usual Suspects* and *Inception*.

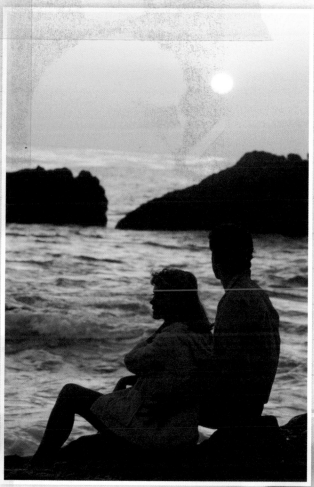

The Shot

This opening sequence was shot in one day with John and Olivia improvising the action. Olivia has said that it was a good way for them to get to know each other, and their clowning around suited their characters well. We arranged for Danny and Sandy to sit on a rock to watch the sunset. We set up the cameras and waited, not realizing that the tide was coming in. The right moment came and we began rolling when, suddenly, a huge wave smashed into them. Their surprised reaction was totally real.

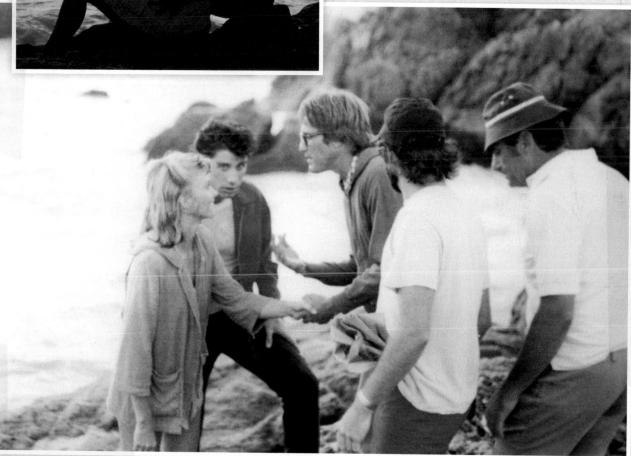

Although Olivia laughed off getting hit by the huge wave, John was very protective of her and worried about her safety, as you can see in this picture.

"Grease"

10 CONTINUED: 10

KENICKIE, a tough, macho-to-the-teeth teenager, sits
bolt upright in bed looking as if he has just been
electrocuted. The pillow where his head has been is
covered with grease stains. His hair stands out
wildly. He shuts off the alarm and pants for breath
as though he has been running.

The VOICE of VINCE FONTAINE is HEARD on the RADIO and
continues throughout the opening MONTAGE.

 VINCE FONTAINE (V.O.)
 This is the main brain... Vince
 Fontaine... beginning your day
 with the only way... Music, music,
 music... I gotta message for
 every scholar and fool... GET
 OUTTA BED; IT'S THE FIRST DAY
 OF SCHOOL... Don't be a slob...
 Don't get a job... Go back to
 class... You can pass... And to
 start this day off nice and fine
 ... I'm gonna play a new old
 favorite of mine...

The new title song GREASE BLASTS on the SOUNDTRACK as
each of the main characters is introduced.

NOTE: The background in each introduction is a sort
of limbo in which only the character and certain vital
props are used. As each character is introduced, they
will occupy a large portion of the center screen. At
the conclusion of their introduction, they will con-
tinue their actions in panels that frame the center
action. In this sequence the audience is the mirror
into which each of the characters is looking.

11 INTRO FRENCHY 11

CLOSE on a pink angora sweater. First disembodied
arms are SEEN protruding from the tight sleeves. The
hands hold the neck of the sweater, stretch it and
slowly, painfully -- loke something being born --
FRENCHY'S head appears. She is a basically plain teen-
aged girl, with close cropped hair. She reaches
OFFSCREEN and produces a flamboyant wig which she places
on her head, transforming herself. She begins to comb
out the wig.

12 INTRO DOODY 12

CLOSE on a Howdy Doody puppet.

 (CONTINUED)

12 CONTINUED: 12

Another ALARM GOES OFF as if in time to the music as
DOODY, a teenager who looks like Howdy Doody opens his
eyes and smiles at the puppet he has slept with. Then
his features set as if he is remembering who he is.
He throws the puppet aside and gets up.

The Script

The idea in the shooting script for the title sequence was conceived to be live-action footage. The personalities of the various characters would be shown by actions and different props. In the shooting script, Frenchy is the student who pops her head through the neck of a tight angora sweater ("slowly, painfully—like something being born") while in the animation, Rizzo gets to do that in a highly stylized fashion. The original idea was that the characters would be getting ready as if in front of a mirror, with the audience members being the mirror. John Wilson's animated sequence turned that idea of introducing the characters on their first day of school into a fun, surreal adventure.

The Animation

Animated by John Wilson, a renowned Disney animator who worked on *Lady and the Tramp*, the title sequence is loose and funky. Its shaky-line style and caricatures of the actors make it look as if a Rydell High student might have drawn it. When the radio starts jumping with the rhythm of Barry Gibb's "Grease," it kicks the movie into gear.

"It's the main brain . . . Vince Fontaine . . . beginning your day with the only way . . . Music, music, music!" says the DJ Fontaine, played by Edd Byrnes, a real-life teen heartthrob of the fifties and, in the movie, the *National Bandstand* host. "Get outta bed; it's the first day of school!"

Wilson then introduces animated versions of the characters. Getting ready for school, Danny Zuko squeezes out some Brylcreem. The greasy goop transforms into the title of the movie. (Note the hot pink shirt hanging in the animated Danny's closet—which the live-action Danny will later wear in the dance contest.) Sandy awakens in her bedroom, her innocence and naïveté shown by the Disney-like birds, deer, and rabbit cavorting around her. Always the rebel, Rizzo wriggles into a tight sweater typical of the fifties, then takes it off in favor of her trademark black shirt. The T-Birds, snapping their fingers in unison, show off their synchronized moves and the red hot rod from "Greased Lightnin'," which gulps down Kenickie working under the hood.

Mixed in with these mini characterizations is a time capsule of the era. Blink and you'll miss quick shots of fads such as a crammed telephone booth, Hula-Hoops, Davy Crockett hats; Eisenhower-era political mementos like "I Like Ike" and Jules Feiffer's "Sick Sick Sick" comic strips; glimpses of Stalin, General MacArthur, and, signifying the changing times, Martin Luther King Jr.

The T-Birds and the Pink Ladies race their cars through the town, passing by landmarks like the Frosty Palace and pop culture references, like a billboard showing a Roger Corman B movie and my favorite movie, *The Ten Commandments*. Chased by a motorcycle cop, the racing cars transition to live-action teens in front of Rydell High.

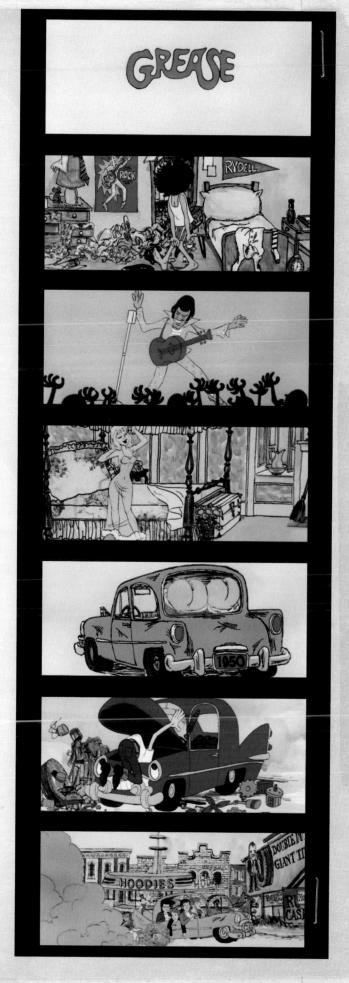

13 INTRO JAN 13

JAN, an overweight girl who has the posture of a hen
and wears baggy clothes, eats a piece of buttered-
jellied toast as she contemplates the grim reality of
her appearance. She turns sideways trying to hold in
her stomach and as she does a glob of jelly falls on
her jumper. She spits on a napkin and tries to rub
it out.

14 INTRO SONNY 14

If SONNY could choose to be any animal it would be
either a stallion or a prize bull. He blows the cob-
webs off his toothbrush, looks at it in distaste,
tosses it away, picks up a vicious looking long-handled
comb and rakes it through his greasy hair. There is
such a deposit of grease on the comb that there is
hardly any room for his hair to get through. He prac-
tices looking tough.

15 INTRO RIZZO 15

CLOSE on a head that looks like a minefield of torpedo
rollers. A long, lacquered nail is thrust into each
roller, deftly withdrawing it while another finger
holds the curl in place.

RIZZO looks like a cross between Ava Gardner and
Annette Funicello and she works hard at it. She
repeats the roller withdrawal with practiced precision.

16 INTRO PUTZIE 16

PUTZIE is a ruddy guy with an air of quiet derangement.
He brushes his teeth as if he were operating a pneuma-
tic drill, the foaming toothpaste encircling his mouth
like a clown's makeup.

17 INTRO MARTY 17

MARTY, a breathing pastry, looks at her reflection. She
is curvaceous every place but at the top. She grabs a
box of Kleenex and remedies that situation by stuffing
her bra.

 6.
 18 CLOSE ON VARIOUS SHOTS 18

 A hand reaches into a stuffed closet and pulls out a
 mass of crilolines.

 A tube of Brylcreme is squeezed directly onto an
 already greasy head. Hands begin to massage the grease
 into the hair.

 A can of spray net is held directly above a beehive
 hairdo and is sprayed like a crop duster.

 A Thunderbird jacket is taken from a closet.

 A brown bag lunch is picked up off a table, as a rapid
 tatto is HONKED out by a CAR HORN.

 CUT TO:

HIGH ANGLE - RYDELL HIGH

RIZZO'S CAR PULLS UP

OUT COMES... JAN RIZZO MARTY

PAN TO BACK

40

The Song

The title sequence was actually animated to a song written by Bradford Craig. Just as we were finishing post-production, the *Saturday Night Fever* soundtrack was becoming a hit. Robert Stigwood, who hadn't even heard Craig's demo, called Bee Gee Barry Gibb and asked him to write a song for our movie. When Barry heard the title, he replied, "Grease? What a word!" (He incorporated that comment into the lyrics as "Grease is the word," which became the movie's catchphrase.)

Soon after, while I was working in the editing room I was handed an audio cassette. When I slipped the cassette into the tape deck, I honestly didn't know what to expect—I had never heard a demo before. It was Barry Gibb singing the song accompanied by a single rough piano. The low-quality, scratchy sound didn't reassure me, and neither did finding out that Barry had neither read the script nor seen any footage. His angst-ridden lyrics weren't at all what I had envisioned for our lighthearted version of *Grease*.

Concerned that the lyrics didn't fit our movie, I asked Stigwood if Barry could change them. He told me to go meet with Barry, who was acting in *Sgt. Pepper's Lonely Hearts Club Band*, Stigwood's other film shooting at the same time. I went to the set, and Barry greeted me wearing one of the psychedelic quasi-military outfits from the Beatles' album. We went behind one of the flats to talk. I explained our movie was a feel-good musical and that the lyrics "This is a time of illusion, wrapped up in trouble and laced in confusion," were a bit serious. Could he possibly adjust them? He looked at me a moment, then said, "Why don't you shoot a serious scene?" I didn't know what to say to that.

But when we ran Barry Gibb's "Grease" over the title sequence, it was clear to us that it would start the movie off with a bang. And no one ever seemed to notice that the lyrics didn't reflect the tone of the movie. (For *Grease* freaks, we included Bradford's alternate title tune with the added content on the 2018 Blu-ray.)

```
18A    EXT. STREET                                            18A

       A carload of students drive along with the top down.

                                                CUT TO:

18B    EXT. STREET                                            18B

       Students on foot making their way to school.

                                                CUT TO:

18C    EXT. STREET                                            18C

       A yellow school bus filled with very active students
       drives along.

19     OMITTED                                                19
thru                                                          thru
29                                                            29

                                                CUT TO:

30     EXT. RYDELL HIGH SCHOOL                                30

       From HIGH POV the school is still and deserted.  An
       American Flag flutters in the breeze.  Suddenly, cars,
       bicycles, busses and students on foot APPEAR pouring
       down the driveway and into the parking lot in a
       rousing FINALE, a choreographed procession not unlike
       a Busby Berkeley production number.

                                                (CONTINUED)
```

The Voice

A quintessential musical icon was chosen to sing Barry Gibb's "Grease": Frankie Valli. He was already well-known for hits he had as the lead singer of the Four Seasons, like "Can't Take My Eyes Off You," "Walk Like a Man," and "Sherry." Gibb's song "Grease" was originally planned to run over just the end credits, since the title sequence had already been animated to Bradford Craig's demo. When we shifted Gibb's song to the title sequence, it came alive, encapsulating 1950s nostalgia as seen through a 1970s lens. The song became a huge hit and, being a big fan of Frankie Valli, I was overwhelmed when years later *he* thanked *me* for the opportunity.

OPENING

TITLES

RYDELL

Original live-action
opening concept, showing
the opening, characters,
and kids arriving at
Rydell High

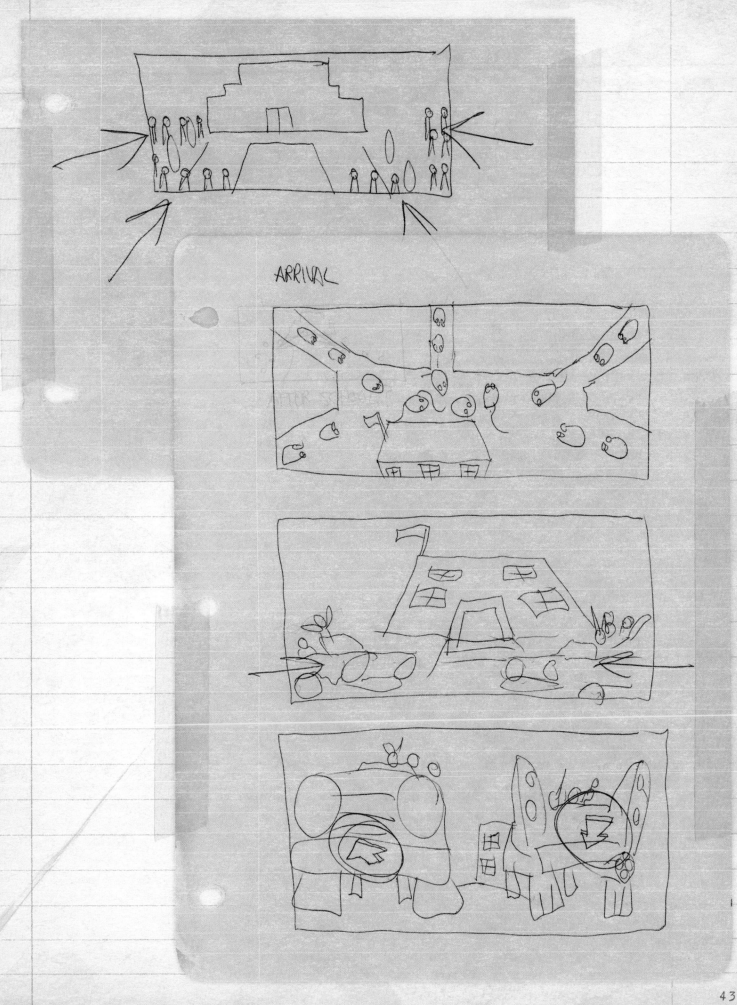

ARRIVAL

First Day of Shooting: Arrival at Rydell High

The Shot

The whirlwind five weeks of production began with filming the shot that opens the movie: the students arriving at Rydell High. This is an important scene because it sets up the main characters. My original sketches show all the students arriving for the first day of school: an overhead shot, a low angle, and one from street level. But because John Wilson had ended the animated title sequence with a view of the school that becomes the live-action shot, this sequence was not needed. We moved right into the introduction to the students.

On this first day, I looked through the camera and noticed the oblong shape of the Panavision screen. I had only directed TV shows, and in those days the shape of the TV screen was square. Seeing the image wide looked really cool—I was definitely in the big time. Bill Butler gave me a great education in widescreen composition and the staging we would need for a Panavision feature.

Cinematographer Bill Butler (pointing) and me discussing the "Summer Nights" number

"GREASE" - Rev. 6/22/77

RECEIVED
JUN 23 1977
Sandy Livingston

7.

30 CONTINUED: 30

The cars are decorated in 50's emblems and decals with glimpses of each of the major characters (except for Danny and Sandy).

Students hang out of car windows, sit on convertible backs, ride on hoods, roofs and running boards -- hooting and hollering with youthful energy as the finale reaches its crescendo.

31 EXT. PARKING LOT 31

As the production number ends, the students suddenly become real people again breaking into groups and heading toward the building.

A Studebaker pulls up and Rizzo gets out in her Pink Ladies jacket. She stands for a moment looking toward the school in bored resignation as the others rush around her.

Marty and Jan come walking up.

 MARTY
 Hey, Riz!

 JAN
 Great to be back, huh?

 RIZZO
 Sure, I'm overjoyed to be back
 for my 4th return engagement at
 the co-educational version of X
 Alcatraz!

Rizzo gives a world-weary sigh and starts toward the school. Marty and Jan adopt her air and the three of them walk along with their noses skyward as several excited younger girls rush past and look at them as though envying their exalted positions.

 CUT TO:

31A PUTZIE, DOODY AND SONNY 31A X

come down the steps greeting each other, full of high spirits. Sonny carries a lunch bag which Doody X
grabs and the boys toss it among themselves.

Doody opens the bag and pretends to gag at the fumes. X

 (CONTINUED)

31A CONTINUED:

> DOODY
> You're not supposed to eat this,
> you're supposed to bury it.
>
> SONNY
> Hey, that's a homemade lunch.
>
> PUTZIE
> Your old lady drag her carcass
> outta bed for ya?
>
> SONNY
> She does it every year on the
> first day of school.

Sonny snags the bag out of the air and opens it to
inspect the damage. Kenickie enters.

> KENICKIE
> Hey, where you at?
>
> PUTZIE
> Kenickie, where were you all
> summer?
>
> KENICKIE
> What are you my mother?
>
> PUTZIE
> I was just asking.
>
> KENICKIE
> I was working, which is more than
> you skids can say.
>
> SONNY
> Working?
>
> KENICKIE
> That's right, moron. I was
> luggin' boxes at Bargain City.
>
> SONNY
> Nice job.
>
> KENICKIE
> Eat me! I'm saving up to buy
> some wheels.
>
> PUTZIE
> (rubbing his hands
> together)
> Wanta hear what I did?

Introducing the T-BIRDS

KELLY WARD: In that opening scene, I was jumping up, like I was trying to catch the lunch. And I went right back over into those rose bushes.

RANDAL: You tripped?

KELLY: Michael pushed me over the hedge!

MICHAEL TUCCI: I'm sorry! I didn't mean to hurt you. Those were all rose bushes?

KELLY: Those are all rose bushes. I'm lying there on the ground, sure Randal's going to call, "Cut." But he doesn't call, "Cut." So I jumped back out of the bushes and kept going with the scene!

BARRY PEARL: That's hysterical!

KELLY: And I said to you, Randal, "You gotta reshoot that." And you said, "No, I love screw-ups!"

RANDAL: Everyone loves it.

The Scene

Jeff Conaway as Kenickie first appears in the background behind the rest of the T-Birds. To introduce his character, he knocks the books out of a student's hands just before greeting his buddies. This was one of the bits Jim Jacobs came up with in a memo to me about extra touches to add.

Kenickie's ducktail hairstyle, cigarette, and arrogant stance set up the fifties tough-guy vibe immediately. Jeff's familiarity with the play was especially helpful on this first day, when we wanted every moment to be specific to set the characters up right away.

45

The Shot

Bill and I wanted to introduce John Travolta as Danny Zuko in a dramatic way. In the scene, Zuko is in the middle of trying to seduce a girl when his name is called. As he turns, we zoomed into a big close-up. This is one of the few times a zoom lens is used in the picture. The shooting script describes Danny turning with the "self-assured slowness of an oscillating fan." John transformed that moment into a star turn.

 KENICKIE
 No.

He looks at them as though eager to tell, but one by
one the boys look away.

PAN with their gazes toward the side of the building
where Danny Zuko (almost unrecognizable from the boy
at the beach) is facing the building. One of his
hands is high above his head and he uses it for sup-
port. Between him and the building is a young, pretty
girl in a tight sweater whom he is casually feeling up.

The girl keeps taking sideway looks at another nearby
girl who is also giggling and slightly scandalized.

 KENICKIE (O.S.)
 Hey! Zuko!

With the self-assured slowness of an oscillating fan,
Danny turns full face to see his friends. He smiles
and nods at them as though giving them a benediction,
playfully pops the girl on the behind and winks at
the other and starts toward the boys.

 DANNY
 How's it hanging?

 KENICKIE
 See any new broads over there?

 DANNY
 Naw. Just the same old chicks
 everybody's made it with.

 DOODY
 What'd you do all summer?

 DANNY
 I been hanging around at the
 beach, lifeguarding and what
 not... you know what I mean.

 SONNY
 Yeah, I know what you mean. It's
 tough with all those chicks hanging
 around you.

 PUTZIE
 The only thing that won't let
 you alone, Sonny, are the flies.

 (CONTINUED)

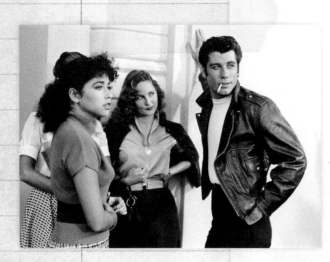

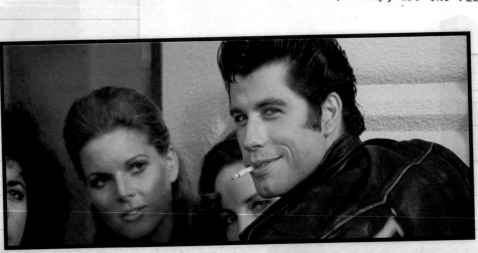

46

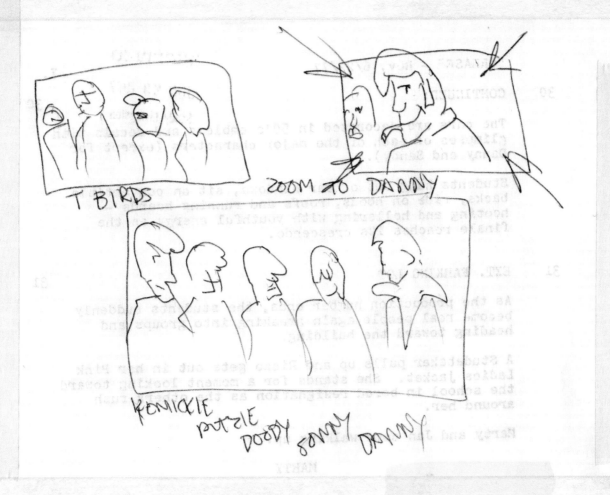

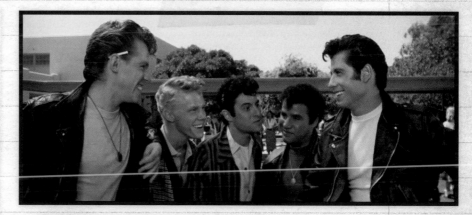

Sometimes the star will ask for a scene to be reshot. Having just finished shooting *Saturday Night Fever*, John now had an entourage of advisers and one of them convinced him that the left side of his face was much better than the right. From working with him on *The Boy in the Plastic Bubble*, I knew John looked good from any angle. When Danny is talking with his buddies, I had originally staged John on the left side of the frame and the T-Birds on the right.

He requested that we return the next day and shoot this introductory scene with him on the right, which we did. It was important that John knew I respected his opinion.

LEFT AND ABOVE: The original rehearsal staging, with Danny on the left, and the revised staging with Danny camera right

31A CONTINUED: (3) 31A

 KENICKIE
 How was the action down at the
 beach?

 DANNY
 Flippin. But there was one chick
 who was sort of cool.

 SONNY
 You mean she puts out?

 DANNY
 Is that all you ever think about?

 SONNY
 Friggin' A!

He heads toward the building trailed by the others
just as Frenchy and Sandy come walking up, barely
missing them.

 SANDY
 So this is Rydell High.

 FRENCHY
 You'll love it.

 SANDY
 I loved my old school. I don't
 know why my parents had to wait
 till my senior year to move to
 America... Well, I'm no stranger
 to heartbreak.

 FRENCHY
 Why? You got psoriasis?

SONNY & DANNY

GUYS EXIT TO REVEAL ...

32 INT. HALLWAY 32

Both sides of the hall are lined with lockers and
students are busily applying locks and decorating the
insides of them to match their personalities. There
is also a lot of ritualistic, un-selfconscious hair
combing, by members of both sexes.

Frenchy and Sandy come down the hall.

 FRENCHY
 You better check in the office to
 find out what home room you got.
 Pray you don't get old man Lynch,
 the math teacher.

32 CONTINUED:

 SANDY
 Is he bad?

 FRENCHY
 Bad? All I know is he flunks
 people in homeroom.

Sandy grimaces and heads for the office.

Introducing the PINK LADIES

The Scene

As the boys goof off heading into school, I staged Frenchy and Sandy emerging from the crowd behind them. When Sandy says, "I'm no stranger to heartbreak," Frenchy replies, "Why, you got psoriasis?" This was an in-joke for people who watched TV in the fifties and sixties, when a commercial had aired for Tegrin, a medicine to combat "the heartbreak of psoriasis." I wanted to cut this line because I thought only a handful of baby boomers would get it, and it certainly wouldn't work in other countries. In fact, Olivia's confusion is genuine—even she had no idea what Frenchy was talking about. I was outvoted by Allan Carr. I'm amazed that no one has ever commented on it.

The Pink Ladies drive up in a pink 1948 Studebaker Commander Regal. From the moment Rizzo, Marty, and Jan get out of the car, you know you're in the presence of high school royalty. As they walk by, we reveal on the back of their jackets that they are the "Pink Ladies." It didn't occur to any of us that these jackets would someday become staple outfits for Halloween and sing-along screenings.

FRENCHY AND SANDY

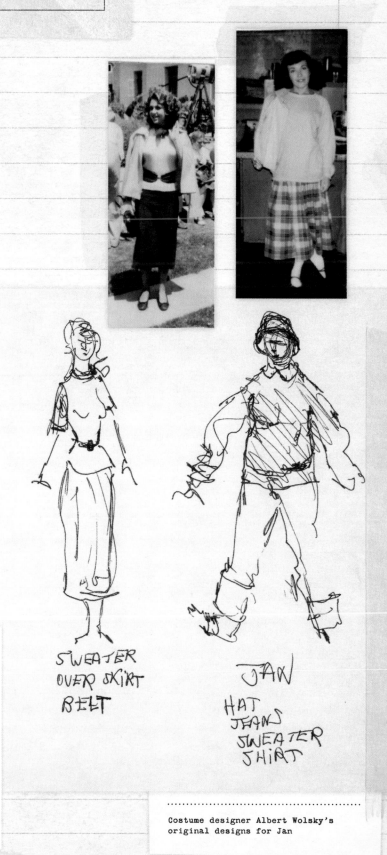

SWEATER OVER SKIRT BELT

JAN HAT JEANS SWEATER SHIRT

Costume designer Albert Wolsky's original designs for Jan

49

Form R2-4 ⓒ			**PLAYED BY** _Stockard Channing_
COSTUME FOR "Rizzo"			**PHONE NO.**

CHANGE	SCENE NOS.	SET	DESCRIPTION
# 1	31	Ext school blouse tucked into skirt, jacket - thrown around shoulder as she walks away	Blouse: black cotton roll- sleeve, pointed collar Skirt: black gab. straight - back slit Belt: black cinch - gold long clasp buckle
	51	Enter w. jacket around shoulders, puts it on back of chair after she sits - purse on table	Shoes: red flats - front laces Jacket: Pink Lady Windbreaker Jewelry: gold chain inside blouse neck. gold bangle ⓡ wrist
	54	carries jacket & purse ⓡ hand	

The Costumes

We were so fortunate to get the great Albert Wolsky as costume designer.
He was drawn to fashion and theater as a child growing up first in France
and then, after his family fled the Nazis, New York City. He's worked with
Bob Fosse, Paul Mazursky, Woody Allen, Sam Mendes, Alejandro G.
Iñárritu, Nora Ephron, and Mike Nichols, garnering multiple awards for his
designs, including Oscars for *All That Jazz* and *Bugsy*.

Albert is a meticulous researcher, and he said he began designing
the *Grease* costumes realistically, from pedal pushers and letter jackets
to chiffon gowns and pencil skirts. Then he started pushing the color, to
fit with a stylized, larger-than-life feel. All the extras and dancers—Pat's
"gang," who wore very specific outfits depending on their characters—had
to complement the principals, with black and hot pink the dominant colors
for the T-Birds and Pink Ladies. Albert was used to working in a realistic,
gritty way for his films, but for *Grease* it was as if he created a new palette:
all California colors. Albert told me that he used colors for *Grease* that he
hasn't used to this day. His work still dazzles.

Form R2-4

COSTUME FOR "Frenchy"

PLAYED BY Didi Conn

PHONE NO.

CHANGE	SCENE NOS.	SET	DESCRIPTION
#1	31	Ext school blouse tucked in, cardigan on - blouse collar out & turned up, sleeves pushed up, scarf sq knot (R) neck jacket on. sleeves pushed up	Blouse: yellow orange plaid sleeveless pointed collar, front zipper Skirt: orange wool straight Belt: red leather pull-thru round self color buckle Cardigan: orange mohair l.s. Shoes: pink ballerina flats Scarf: orange chiffon at neck
	51	Ext cafeteria enter w/ sweater carried w/ books jacket on sleeves pushed above elbow, zipped to (~~belt, jacket & blouse~~) just below belt jacket & blouse collar up	
	54	jacket on zipped to belt line, sleeves pushed up. sweater carried on books	

51

The Scene

The only adult figures in the play and the movie are the faculty and staff, so we needed to set them up quickly as characters in the school office. Each one has a quick line and we establish Tony-winning actor Alice Ghostley as Miss Murdoch, actor (and future novelist) Fannie Flagg as Nurse Wilkins, and TV stars Eve Arden and Dody Goodman as Principal McGee and her secretary, Blanche.

After the doors to the classrooms swing shut, the T-Birds are reintroduced. Bill Butler placed the camera over their heads and we dollied back as, one by one, they peel off from the lockers and head down the hall. Eugene appears; after the T-Birds harass him on the steps, we shot a moment where one of the boys steps on his white buck shoes and he immediately sits down and pulls out some white polish to cover the scuff. We dropped this for reasons of pace, but it is in the deleted scenes in the DVD and Blu-ray versions.

With the bongs of a xylophone, Principal McGee starts her announcements, which we play over the first day of class. Rizzo expertly shuffles cards but we actually had a string connecting them; I have no doubt Stockard would have been able to learn how to do it with dexterity, but we didn't have time. Another scene was cut for pacing, Kenickie dropping a frog into Patty Simcox's purse. The audience doesn't see how it got in her purse, but the moment gets across.

33 INT. OFFICE - CLOSE - PAIR OF BABY BLUE KEDS 33

PULL BACK SLOWLY TO SHOW a matching baby blue skirt, shirtwaist with a Peter Pan collar and the perky, smiling face of PRINCIPAL McGEE, an efficient looking woman with an air of ironic wit.

Teachers are clamoring around the counter and are taking sheets of paper out of their boxes and scanning them. The office is crowded with teachers pushing and shoving as much as their charges.

The teachers are born to the breed. They are as determinedly out of fashion as the students are in and they look as uniform. Among them are: X

MRS. MURDOCK -- the Automotive Repair teacher. She wears a jumper into which several tools are stuck. There is an amiable air about her as though she'd be a student favorite.

NURSE WILKINS, the crisp, efficient school nurse who wears a spotless uniform and a courageous looking cape.

MR. LYNCH, the Math teacher, is red-faced and bitter X
looking. There's a dry quality about him. X

The teachers stand in line for the time clock and groan over their student lists.

BLANCHE, the harried secretary, looks up from behind X
a mountain of forms.

 PRINCIPAL McGEE
 Blanche, do you have the new X
 schedules?

Blanche looks up nervously and smiles in desperation. X

 BLANCHE X
 I just had my hands on them.

 (CONTINUED)

BLANCHE McGEE

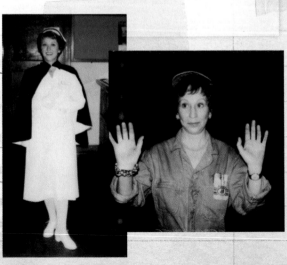

33 CONTINUED: 33

 PRINCIPAL McGEE
 Good. They'll be all nice and
 smudged.

 Blanche looks down at her hands which are covered in
 mimeo ink and carbon. She nervously rubs her hands
 against her skirt leaving prints on it. She then
 breaks into a smile and picks up a pile of papers.

 BLANCHE
 Here they are. Right here. If
 they'd been a snake they'd have
 bitten me.

 Principal McGee pauses, raises an eyebrow, almost makes
 a remark and decides not to do it. She looks down at
 the schedules and then looks back at Blanche with
 practiced disappointment.

 PRINCIPAL McGEE
 These are the schedules we never
 found for Spring semester... last
 year. Perhaps next Spring we'll
 find the ones we were supposed to
 use this semester.

 The teachers are lined up at the time clock.

 MR. LYNCH
 Ye Gods! I've got Kenickie again.
 He's been here longer than I have.

 MRS. MURDOCK
 Don't feel like the Lone Ranger.
 My homeroom looks like the
 Juvenile court hall of fame.

 NURSE WILKINS
 I'm sure they'll be lined up at
 the infirmary right after homeroom.
 Back-to-school fever. Well, I've
 got the answer for that. Paregoric!

 MRS. MURDOCK
 How many days till Christmas
 vacation? X

 SANDY (O.S.)
 Eighty six.

 Several teachers turn to look at her in surprise.
 Sandy blushes, realizing she's said the wrong thing.

 SANDY
 (continuing;
 embarrassed)
 I counted.

 Principal McGee looks up and smiles.

 PRINCIPAL McGEE
 Can we help you, dear?

 SANDY
 This is my first day.

MURDOCK LYNCH WILKINS

LEAVE FRAME TO REVEAL:

SANDY & McGEE

PRINCIPAL McGEE
Oh, yes. Welcome to Rydell.
Tell us a little about yourself.

SANDY
Well, I...

PRINCIPAL McGEE
Here you are, dear.

Sandy is cut off as Principal McGee hands her a sheaf
of forms, turns and heads toward the hallway. Sandy
sighs and looks at the forms, then looks over at
Blanche who is looking frantically through her desk.

SANDY
Do you have a pencil?

Blanche looks up, looks around to see if anybody is
watching, then gives her blankest look.

BLANCHE
(mournfully)
No!

Sandy is taken aback and looks away.

X

X

SANDY ALONE

34 INT. HALLWAY 34

The Thunderbirds come up the hall looking at their
schedules and groaning. Sonny puts his hand to his
head and sighs.

SONNY
Jeez! Every teacher I got has
flunked me at least once.

DOODY
If you don't watch out you'll
be spending all your time in
McGee's office.

SONNY
This year she's gonna wish she
never seen me.

In the b.g. Principal McGee steps out of the office and
overhears. Sonny doesn't see her, but the other boys
do.

DOODY
What are you gonna do?

SONNY
I'm just not going to take any
of her crap that's all. I don't
take no crap from nobody.

PRINCIPAL McGEE
Sonny!

Sonny's eyes go wide in chagrin as he slowly turns to
face Principal McGee. The other boys smile knowingly
and busy themselves at their lockers.

SONNY
Yes, ma'am.

PRINCIPAL McGEE
Aren't you supposed to be in class
right now?

SONNY
I... I...

PULL BACK - MCGEE CONFRONTS SONNY

SONNY

MCGEE

34 CONTINUED: 34

PRINCIPAL McGEE
You're just dawdling, aren't you?
That's a fine way to start the
new semester... Well? Are you
just going to stand there all day?

SONNY
No, ma'am.

PRINCIPAL McGEE
Then move!

SONNY
Yes, ma'am.

PRINCIPAL McGEE
And I think it would be a good
idea -- to develop your school
spirit --- if you joined the
Clean-Up Committee. You'll
meet after school in front of
the custodian's office.

PERHAPS A SESSION OF BANGING ERASORS AFTER SCHOOL?

SONNY
Yes, ma'am. Thank you.

Principal McGee turns and exits.

DANNY
I'm sure glad you didn't take
no crap off her, Sonny.

DANNY COMES FORWARD

Sonny is embarrassed, but the others find this funny.
They start down the hall just as EUGENE, the guy you
love to hate, comes toward them in a Robert Hall suit
and gleaming white bucks. Like a precision drill team,
the boys surround him -- spinning him around, blowing
on his glasses and messing his hair, then abruptly
leave and continue on down the hall.

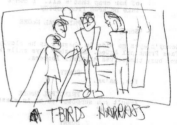

T-BIRDS HARRASS
EUGENE ON STEPS

Sonny, almost as an afterthought, stops, turns, comes
back and rubs his dirty boots all over Eugene's white
bucks.

Eugene watches his exit, then quick-as-a-wink pulls a
bottle of shoe polish from his book satchel and does
an on-the-spot touch-up.

SANDY RUNS DOWN HALL

A BELL RINGS and Danny walks past the office -- missing
Sandy only by steps as she comes out and heads in the
opposite direction.

35 INT. PRINCIPAL McGEE'S OFFICE 35

Principal McGee sits behind her desk in front of a
microphone. She looks at her watch in silent count-
down, then points to Blanche who sits in front of a
small xylophone. Blanche is daydreaming. Principal
McGee snaps her fingers. Blanche looks up frantic,
can't find the xylophone mallet, then remembers and
reaches into her hair and produces it and strikes out
several notes.

(NOTE: Several homerooms will be GLIMPSED throughout
the speech.)

PRINCIPAL McGEE
Good morning, boys and girls, and
welcome to the start of what will
be our greatest year at Rydell.

36 INT. AUTOMOTIVE REPAIR SHOP 36

Doody and Marty are in this homeroom. Most of the
students are talking while Mrs. Murdock reads an
automotive repair magazine.

 CUT TO:

37 MR. LYNCH'S HOMEROOM 37 X

Frenchy and Sandy are in this class. The room is
quiet. Mr. Lynch sits behind his desk glaring at X
them as if threatening them into silence. Sandy
coughs. Mr. Lynch looks at her fiercely. X

 PRINCIPAL McGEE (V.O.)
 Now for some news of forthcoming
 events. Flu shots and chest X-rays
 will be administered by our very
 capable Nurse Wilkins.

 CUT TO:

38 BIOLOGY LAB 38

The students sit at long tables that are set up for
dissecting.

Danny and Kenickie sit together. Across the room
Putzie is near a refrigerator. He opens it to reveal
partially dissected frogs. He takes one out and
dangles it in the air. Several students laugh, but
the teacher pays no attention.

17.

38

 PRINCIPAL McGEE (V.O.)
 Saturday night will be our first
 pop rally and bonfire. I want to
 see all you students out there
 with lots of spirit and support
 for Coach Calhoun and the Rydell
 Rangers as they go out to stomp
 and smear the Glendora Gladiators.

 PUTZIE
 If you can't be an athlete, be
 an athletic supporter.

 KENICKIE
 You putz.

Danny groans.

Putzie holds the frog aloft and begins to put it toward
the back of an unsuspecting girl. It grazes her shoul-
der. She brushes it away, then turns to see what it is
and lets out a bloodcurdling scream. The teacher rises
but Putzie tosses the frog to Danny who catches it and
hides it under the table.

39 INT. HOME ECONOMICS CLASS 39

There are lines of sinks, stoves and sewing machines.
Even an automatic ironer that failed to sweep the
country. Rizzo and Jan are in this class. Nurse
Wilkins enters, sweeps off her cape and looks around.

56

RIZZO
Well, look who's running the
Home Ec. Shop -- Florence
Nightingale!

X
X
X

NURSE WILKINS
Miss Atkinson has mysteriously
not returned from her vacation
to Italy. Latin lovers can be
very persuasive.

X

RIZZO
How would she know?

NURSE WILKINS
I haven't led as sheltered a life
as some of you girls may think.
I was once with the Red Cross.

CUT TO:

40 INT. PRINCIPAL'S OFFICE 40

Principal McGee is trying to fight off a sneeze, but
it's too late and she sneezes into the microphone.

CUT TO:

41 EXT. HALLWAY 41

LAUGHTER from different homerooms is HEARD in the
deserted hallway.

CUT TO:

42 INT. MR. LYNCH'S HOMEROOM 42 X

The class is silent as Mr. Lynch grimly faces them X
down. At her desk, Frenchy is almost doubled up in
silent laughter. She fights for control.

 PRINCIPAL McGEE (V.O.)
Now for some major economic news.
School lunches have been promoted
from 25¢ to 35¢! Sorry, kids.
Yearbook pictures to $2.50 a set.
And senior class rings have
graduated from $25 to $35. A
word of caution! Several of last
year's seniors have been offering
cut-rate buys on their used rings.
If any of you are rash enough to
try and economize in this manner,
remember, you'll go through life
with the wrong year on your finger.

CUT TO:

43 INT. BIOLOGY LAB 43

Danny tosses the frog to Kenickie who drops it in the
purse of PATTY SIMCOX, Eugene's female equivalent. X
She does not see it.

 PRINCIPAL McGEE (V.O.)
And now for the really good news
and probably one of the most
exciting things ever to happen to
Rydell High.

CUT TO:

MCGEE

PATTY FINDS DEAD FROG

44 INT. MR. LYNCH'S HOMEROOM 44

 PRINCIPAL McGEE (V.O.)
 The National Bandstand Television
 Show has selected Rydell as a
 representative American high
 school and will do a live telecast
 from our very own gym with winners
 in the National Dance-off! This
 is the first time in National
 Bandstand's history they've left
 the studios for a location show.
 This is our chance to show the
 entire nation what fine, bright,
 clean-cut, wholesome youth we
 have here at Rydell.

 CUT TO:

KEMACKIE PUTS FROG

45 INT. BIOLOGY LAB 45

 The boys watch in delight as Patty reaches into her
 purse, pulls out the frog, puts her hand to her mouth
 and rushes from the room.

 CUT TO:

46 INT. AUTOMOTIVE REPAIR HOMEROOM 46

 Students are going wild jumping up and down and cheer-
 ing. Mrs. Murdock does not even look up, but reaches
 out and gives a deafening blast from an air whistle
 that silences them and has most of them putting their
 hands to their ears. Mrs. Murdock continues to read
 as if nothing had happened. She looks up. X

 MRS. MURDOCK X
 This year, boys, I mean business. X

 CUT TO:

47 OMITTED 47

48 INT. PRINCIPAL'S OFFICE 48

 PRINCIPAL McGEE
 And in closing, I would like to
 say, on this, the first day of a
 new school year, we, the faculty,
 are here to help you.
 (MORE)

 (CONTINUED)

48 CONTINUED:

 PRINCIPAL McGEE (CONT'D)
 And if you need us·at any time,
 feel free. Because you've not
 only got a 'prince' in principal,
 there's a 'pal' there, too.

 CUT TO:

49 INT. HOME ECONOMICS CLASSROOM

 Rizzo holds her hand to her stomach as if about to be
 sick.

 RIZZO
 Urp, slop, bring the mop.

 CUT TO:

50 OMITTED

51 THE PINK LADIES TABLE

 Rizzo, Jan and Marty sit at the table with two chairs
 upturned. Marty wears ornate, rhinestone-studded
 harlequin glasses.

 RIZZO
 Did you girls get a look at Zuko
 this morning?

 MARTY
 I thought that was ancient history.

 RIZZO
 Well, you know, history sometimes
 repeats itself.

 Frenchy and Sandy walk up.

 FRENCHY
 Hey, you guys, this is Sandy
 Olsson. She just moved here
 from Sydney, Australia. This
 here's Rizzo and that's Jan
 and Marty.

 SANDY
 Hi.

RANDAL: Stockard, how did you decide to approach playing Rizzo?

STOCKARD CHANNING: I just told myself, "You're playing a seventeen-year-old kid who likes sex and she's from the other side of the tracks. She's insecure. And underneath all that shit, she's just a kid." And she's threatened by the new girl, by the middle-class proper thing.

.........................

JAMIE CONNELLY: When I tried out, I said I was interested in all roles but Jan. At that point, I knew everybody's lines in the play having done it eight times a week for six months.

RANDAL: I wonder why we didn't listen to you when you said you didn't want to play Jan?

JAMIE: Well, you said, "Hmmm, that's interesting. You don't like that part, hmmm. And that's the one you played. Wow." And then when I read it, everybody was like, "Oh yeah, that's Jan."

.........................

RANDAL: Dinah, what was it like when you heard you got the part of Marty?

DINAH MANOFF: I remember being completely terrified—it was my first movie. When I got the news, my first reaction was, "Yay, I won!" And then my second reaction was, "Oh, shit. Now I have to come up with the goods." But as long as I had that pretend Marilyn Monroe in me, I would forget that I was nervous. As soon as I dropped it, I was terrified.

OUTDOOR LUNCH TABLES

SANDY AND FRENCHIE ARRIVE

51 CONTINUED: 51

The girls sit down. Rizzo gives her a dubious look
and never stops chewing.

 RIZZO
 How are things down under?

 SANDY
 Fine, thanks.

 FRENCHY
 Hey, Marty, those new glasses?

 MARTY
 Yeah, I just got them for school.
 Do they make me look smarter?

 RIZZO
 No, we can still see your face.

 MARTY
 How would you like rice pudding
 down your bra!

 JAN
 I'll take it.

 SANDY
 Does somebody want my cole slaw?

 JAN
 Does the Pope wear a dress?

 RIZZO
 Go get it, Petunia Pig!

 SANDY
 It smells kinda funny.

 FRENCHY
 Wait'll you taste the chipped
 beef. Better known as turd on
 a bun.

 MARTY
 Don't mind her, Sandy. Some of
 us have halitosis of the vocabulary.

Frenchy and Sandy argue. Rizzo stops them.

 JAN
 How do you like school so far,
 Sandy?

 51

 SANDY
 It's different. .

 PATTY (O.S.)
 Hi, kids!

The Pink Ladies look up in disgust.

 RIZZO
 It's Patty Simcox, the bad seed
 of Rydell High.

Patty Simcox is all sincere aggression. She stands
over them for a moment just exuding.

 PATTY
 I just love the first day of
 school, don't you?

 RIZZO
 It's the biggest thrill of my
 life.

 PATTY
 They announced this year's nominees
 for Student Council. Any guess
 who's up for vice-president? Me!
 Isn't that the most to say the
 least?

 RIZZO
 The least.

 PATTY
 I hope I don't make too posh a
 showing.

 RIZZO
 Well, we sure wish you all the
 luck in the world.

 PATTY
 (to Sandy)
 I'm Patty Simcox.

Sandy shakes her hand and Patty puts a campaign
poster in it.

PATTY SIMCOX ARRIVES

 PATTY
 (continuing)
 Welcome to Rydell. I hope you'll
 be at the cheerleader tryouts.

 SANDY
 Well, I...

 PATTY
 We'll have such fun and get to
 be lifelong friends. Lemme see
 your schedule.

Sandy takes her schedule out and Patty looks at it.

 JAN
 Anybody with a vote is her lifelong
 friend...

 FRENCHY
 (whispering)
 Psst! How do ya like Sandy?
 Maybe we could let her in the
 Pink Ladies.

 RIZZO
 She looks too pure to be pink.

 MARTY
 Double do-do!

 RIZZO
 Pah-leeze!

 JAN
 What happened?

 JAN
What happened?

 MARTY
 (taking off her
 glasses)
One of my diamonds just fell in
the macaroni.

The girls look over the macaroni.

 RIZZO
 (rising; fake
 English accent)
I'm going to have a Viceroy on
the verandah!

 FRENCHY
Which means, Sandy, she's sneaking
behind the cafeteria garbage dump
for a ciggie-butt. You get caught;
you get suspended.

DIAMOND INTO MACARONI

 CUT TO:

52 EXT. BLEACHERS - DAY 52

The Thunderbirds have eaten their lunches in the sta-
dium bleachers. The football team jogs around the
track.

 KENICKIE
Dingleberries on parade.

 52 CONTINUED: 52

TOM CHISUM, the football captain, looks up to them and
makes a fist. He is carrying his helmet by the strap.
The strap gives way and the helmet falls in front of
it. He steps into the helmet and gets his foot caught.
He has to stop running and hop to the sidelines. Two
trainers run onto the field and begin tugging at the
helmet. The Thunderbirds love this.

 DOODY
You've really put your foot into
it this time, Chisum!

 PUTZIE
Try hop-scotch! *you hot dog!*

 KENICKIE
Did you see that tough-looking
new chick at registration? She
sure beats the foam-domes around
here.

 SONNY
You mean her jugs were bigger
than Annette's?

 KENICKIE
Nobody has bigger jugs than
Annette.

A girl walks up the bleachers past them. Putzie follows her leaning back and trying to look up her dress. Putzie's mouth is open. Danny reaches back and stuffs an apple into it. Putzie takes out the apple and looks at it seriously, then takes a voracious bite out of the apple. He smiles at them with apple on his mouth, his eyes wide in monstrous delight.

> DOODY
> You're a sick man, Putz. I want to hear what Danny did on the beach.

> DANNY
> It was nothing.

> DOODY
> Come on. Tell us about that girl.

> PUTZIE
> C'mon, Zuko. You know ya got in her drawers.

(CONTINUED)

GUYS ON BUNCHES

CHISM GETS FOOT CAUGHT

DIRECTION

FAST, LOOSE, MULTILEVELED OVERLAPPING ACTION

BUSINESS

tuff spitting

H water on back of head - sneeze

H locker - books fall on head - fan pictures taped up

O hiding cigarettes as teacher goes by
blow away smoke
then Sen Sen

O pitching pennies

H O pulling out shirtails pulling down pants

H O knocking books out of hand from behind

RF's
peanut butter on doorknob "Wash Me" in car dust
buying beer slapping on back "kick Me" sign
cemetery at night
string with newspaper

The Scene

"Fast, loose, multileveled overlapping action" is what I wrote in my production book. I wanted every frame to have layers of action from the students, based on how kids behave in high school. During my prep time I wrote down things I remembered happening at my high school. I have pages of lists in my production book as I racked my brain for props and items that would sell the period of the fifties. Today, I could do a simple Google search, but this was before the internet, so I had to use old-fashioned brainstorming.

Pat Birch did the same thing. She would work with her dancers before every scene and ask them to come up with bits of business from their high school days and weave them into the action.

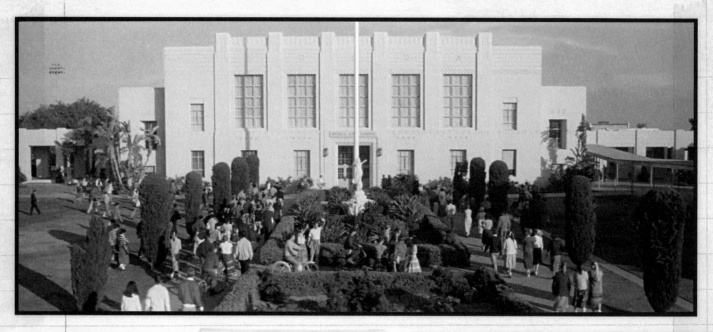

The Locations

Rydell High itself was portrayed by three different high schools in the Los Angeles area: Venice High School (above) for the opening and much of the outdoor scenes, Huntington Park High School (right) for the dance contest, and John Marshall High (below) for the carnival scene at the end.

The schools that became Rydell High fulfilled the vision of a fifties dream high school. Pat kept reminding me to "hang on to the grit" and "keep some East Coast" to retain a little of the edginess of the play. She really hated the palm trees.

The Choreography

Personally selected by Pat after a series of grueling auditions, her twenty dancers became integral in every group scene in the movie, including the sequence showing the first day of school. Pat called them "sub-characters," as they were much, much more than background. Greaser chicks had names like Babs (an "intelligent Greaser") and Sauce, who was chosen to be the girl flirting with Danny in the opening sequence of the film. Some of the guys had names that, while not very politically correct, had been used by gangs in the fifties. Cheerleaders were named Cee Cee and Teddy, while jocks were Bart and Deuce—the latter the dancer's actual nickname at UCLA, where he had been a student. The audience begins to recognize the dancers throughout the movie, from Rydell's hallways to the dance contest in the cafeteria to the carnival at the end.

Form R2-4 [C]

COSTUME FOR ___DANCERS "___

PLAYED BY _____

PHONE NO. _____

CHANGE	SCENE NOS.	SET		DESCRIPTION	
✳	SC 31	EXT SCHOOL			

Sandy

Jennifer Toni

Carol Helena
(should show blk. belt)

Mimi

Cindy Judy
(should show
pale blue
cardigan)

Deborah Barbie

65

"*Summer Nights*"

WHAT DID YOU DO THIS SUMMER?

52 CONTINUED: (2) 52

 DANNY X
 Aw, I don't want to bore you with X
 the horny details.

All the guys encourage him. X

INT. CAFETERIA 53

 FRENCHY
 What did you do this summer,
 Sandy?

 SANDY
 I spent most of it at the beach
 ... I met a boy there.

 RIZZO
 You hauled your cookies all the
 way to the beach for some guy?

 SANDY
 Well... He was sort of special.

 RIZZO
 Are you kidding --- There ain't
 no such thing.

Sandy hesitates then leans forward.

 SANDY
 It was real romantic.

EXT. BLEACHERS

 DANNY
 Okay, you guys. You wanna know
 what happened?

NOTE: The song "SUMMER NIGHTS (from the Broadway
show) will be sung alternating between the cafeteria
and the bleachers.

 DANNY
Summer lovin'! Had me a
blast.
 SANDY
 Summer lovin'! Happened
 so fast.
Met a girl crazy for me.
 Met a boy cute as can be.

 (CONTINUED)

 BOTH
Summer day, drifting away,
to uh-oh, those summer
nights.
 THUNDERBIRDS
 Tell me more, tell me more.
 Didja get very far?
 PINK LADIES
Tell me more, tell me more.
 DANNY
 She swam by me; she got a
 SANDY cramp.
He ran by me, got my suit
damp.
 Saved her life. She
 nearly drowned.

He showed off splashing
around.

 BOTH
Summer sun, something begun,
then uh-oh, those summer
nights!

 FRENCHY
Was it love at first sight?

 KENICKIE
Did she put up a fight?

 SANDY
We went strolling, drank
lemonade.

We both stayed out till
ten o'clock.

 PINK LADIES
Tell me more, tell me more!

 THUNDERBIRDS
Tell me more. Tell me more!

 DANNY
Took her bowling in the
arcade.

We made out under the dock.

 BOTH
Summer fling, don't mean
a thing, but uh-oh, those
summer nights.

(CONTINUED)

"SUMMER SUN"

DANCE ON BLEACHERS
THROW HANDS →

GIRLS SKIP

BARRY: At one point before "Summer Nights,"
 Michael was looking for a word to call Tom
 Chisum and used the word *gavone*.

RANDAL: What does it mean?

MICHAEL: *Gavone*. Say your father had a garbage
 truck. All of a sudden, his brother becomes
 governor of the state of New York, and
 now he's head of garbage. But he's still a
 gavone.

BARRY: A lowlife. So then Tom Chisum stepped in
 and I ad-libbed. I started to say "A gavone"
 too but, I'm like, "Michael's already said
 gavone." It became "Gumdrops, man." It means
 nothing. It means absolutely nothing!

MICHAEL: It's like that water pistol you pulled
 out in this scene too.

RANDAL: You were just being crazy.

BARRY: Gumdrops, man.

The Song

During the sing-alongs, all it takes to get the crowd cheering is the line, "So what did you do this summer, Sandy?" That's the kind of question a student would ask. Pat stuck close to this real-life honesty in her choreography—"kids don't buy artifice," she'd say.

This song sets up the two main characters' personalities. Wanting to be respected by their peers, Danny portrays his summer affair as raunchy to the T-Birds and Sandy relates it as romantic to the Pink Ladies. Then Danny and Sandy move away from their peers and harmonize their true feelings in a split-screen moment.

We didn't know it at the time, but "Summer Nights" would go on to be one of the top karaoke songs in the world.

My original split-screen concept, illustrating Danny's and Sandy's different perceptions of their summer

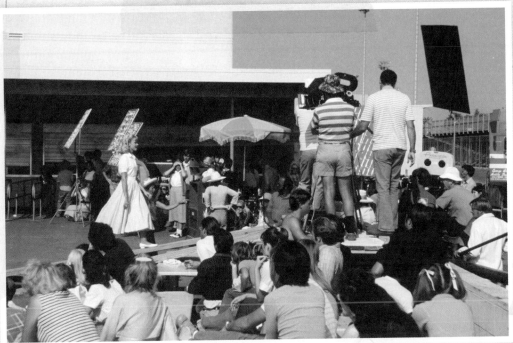

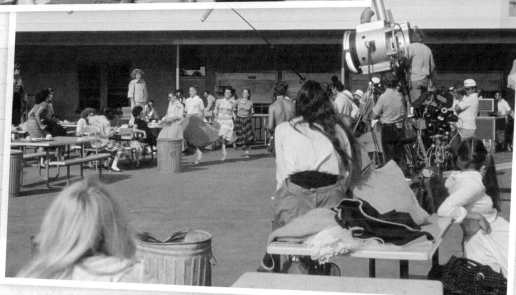

The Scene

When I saw the stage version, the boys were on the left side of the stage and the girls were on the right. In adapting this to film, it was clear that cutting back and forth between the two would be the way to go. This number has a natural build. We wanted to work with that and get the audience involved as soon as the guys start dancing on the bleachers and the girls step away from the cafeteria tables, so that by the climax of the song, they were hooked.

The cast gave it their all—the boys were sweating in their leather jackets under the summer SoCal sun. Their energy inspired the girls, who took breaks from their own rehearsals to watch them. The boys watched us shoot the girls too and cheered them on.

John described what everyone felt: "Imagine—you're on the set, you have the choreography down, you have the music blasting. The director says action and you're off! You take off like a balloon in this other dimension . . . you just feel alive."

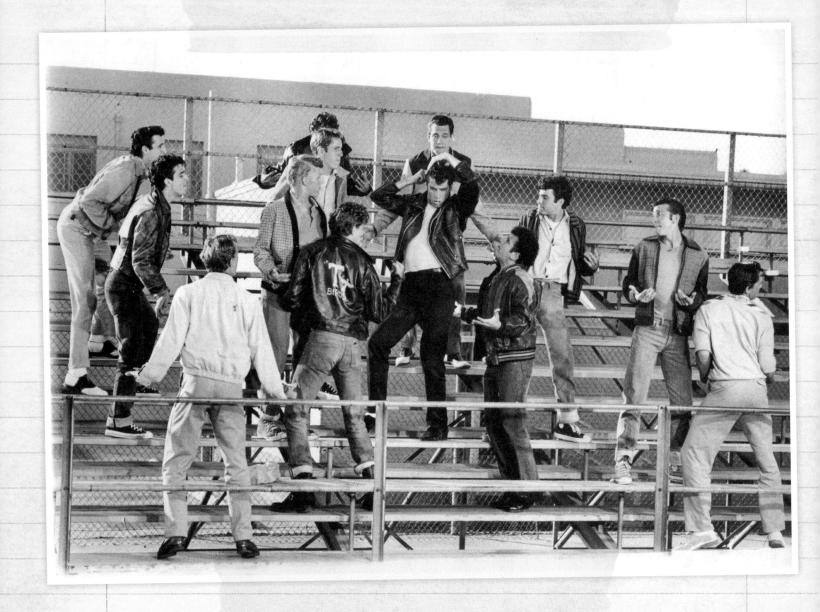

As both the girls and boys urge Sandy and Danny to reveal everything about their romance, Pat kept the storytelling going through movement, so by the song's end, each character has been firmly established. Pat's dancers appear in the background doing everyday activities, eating their lunches and other ordinary high school things. But then, on a certain musical phrase, everyone in the background simultaneously turns and goes into a choreographed routine.

There was a lot of improvisation during rehearsals that made it into this scene. When Rizzo pushes Patty Simcox (and Sandy) off the bench, Susan Buckner had wanted to dive headfirst into the garbage can. But that would have been too tricky to pull off and potentially dangerous for her. The "gag me" gesture by tough greaser girl Sauce may have been more from the seventies than the fifties but we used it because Mimi Lieber, one of Pat's dancers, timed it perfectly. The guys had all sorts of comedy bits in there, such as Kelly, as Putzie, looking up girls' skirts, which was something we came up with the day of the shoot. Kelly later said, "You could have picked a hotter chick." He was staying in character.

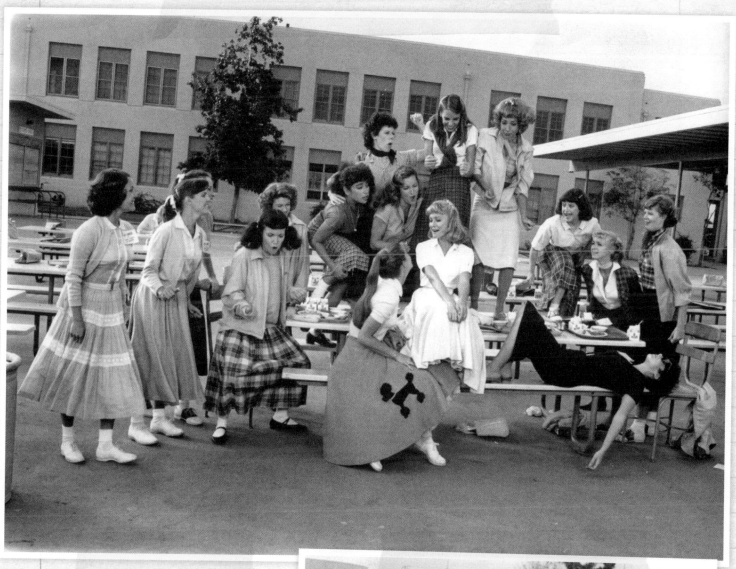

Associate producer
Neil Machlis (*left*)
outside on the set at
Huntington Park High
School with Kelly Ward
and Barry Pearl

A. ,8784

Series

Producer STIGWOOD/CARR

Director RANDAL KLEISER

Title "GREASE"

CALL SHEET

Prod. No. 31108

Day Wednesday, June 29, 1977
3rd Day out of 53 days
. Call 7:30A
Shooting Call 9:00A
Location Venice High School
390-3481

SET # SET	SCENES	CAST	D/N	PAGES	LOCATION
Ext. Bleachers	.52	1,3,6,8,10,16, 18, D11 Thru 20 X	D	1 3/8	Venice H.S. 13000 Venice Blvd.
Ext. Bleachers "Summer Nights"	53 pt.	1,3,6,8,10 D11 Thru D20	D	7/8	

CAST & DAY PLAYERS	PART OF	MAKE-UP/LEAVE	SET CALL	REMARKS
1. JOHN TRAVOLTA	DANNY	8:00	8:30A	p.u. at home @ 7:30A
2. OLIVIA NEWTON-JOHN	SANDY	Hold		
3. JEFF CONAWAY	KENICKIE	8:00	8:30A	Report to Location
4. DIDI CONN	FRENCHY	Hold		
5. JAMIE DONNELLY	JAN	Hold		
6. BARRY PEARL	DOODY	7:30A	8:30A	Report to Location
7. STOCKARD CHANNING	RIZZO	Hold		
8. MICHAEL TUCCI	SONNY	7:30A	8:30A	Report to Location
9. DINAH MANOFF	MARTY	Hold		
11. KELLY WARD	PUTZIE	7:30A	8:30A	Report to Location
12. Sid Caesar	Calhoun	Hold		
16. Eddie Deezen	Eugene	7:30A	8:30A	Report to Location
17. Susan Buckner	Patty	Hold		
18. Lorenzo Lamas	Tom	7:30A	8:30A	Report to Location
22. Dennis Stewart	Leo	Hold		
D1 Thru 10 (As Before)	female dancers	Hold		
D11 Thru 20 (As Before)	male dancers	7:30A	8:30A	Report to Location

Company Reports to Location

ATMOSPHERE AND STANDINS	SPECIAL INSTRUCTIONS
4 Standins (Lori to be sexy girl) 7:30A	Report to Location
20 football team 8A	↓ ↓ ↓
1 Wimpy Water boy 8A	↓ ↓ ↓
3 Students 8A	

ADVANCE SHOOTING NOTES				
SHOOTING DATE	SET NO.	SET NAME	LOCATION	SCENE NO.
Thurs. 6/30		Ext. Bleachers (D) "Summer Nights"	Venice H.S. 13000 Venice Blvd.	53 pt - continue
Fri. 7/1		Ext. School Track (D)		104
mon. 7/4		Holiday		
Tues. 7/5		Int. Gymnastics Gym (D)	Venice H.S.	93, 93B

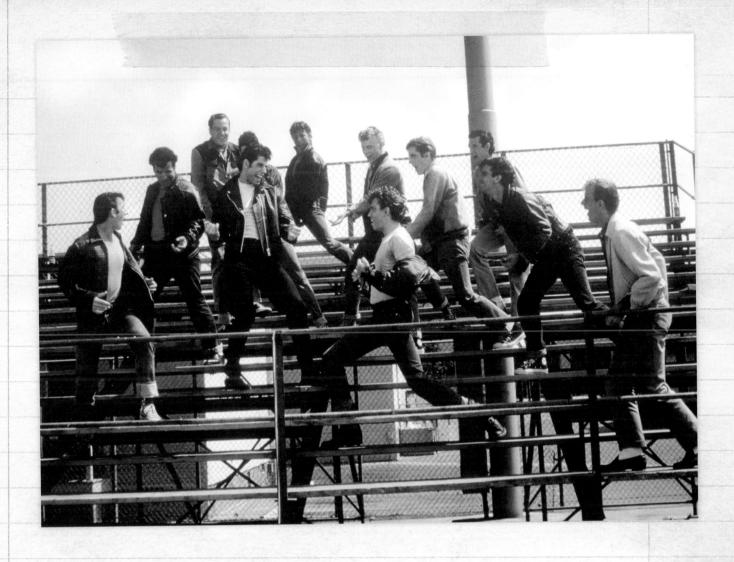

The Shot

Jim Jacobs and Warren Casey's original script had dialogue that eased effortlessly into the lyrics of the song; this was one of the numbers that was carefully storyboarded. Pat Birch, Bill Butler, and I developed a plan to intercut the two different sides of the story, finding visual ways to connect them. We were inspired by the number "Tonight" in *West Side Story*. We first decided which phrases of the song would be seen on each group. Pat choreographed movements that would continue across the cuts, such as when the boys jump up on "You know what I mean!" and we cut to the girls as they thump down in a group to sit on the cafeteria table. The result is probably our best example of how our choreography, camera, and editing came together.

Choreographer Pat Birch staging "Summer Nights" on the bleachers of Venice High School

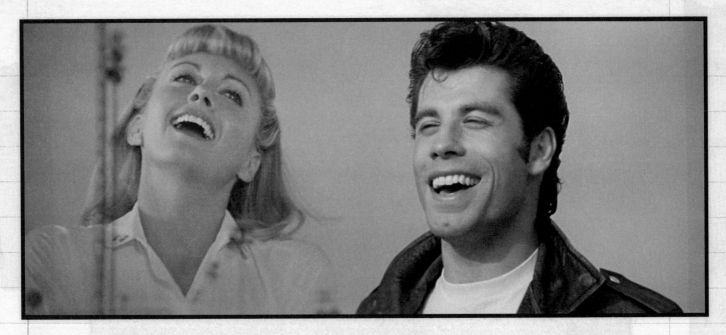

Days of Pat's choreography planning and rehearsal led to the sequence of John and Olivia singing together, John at the top of the bleachers and Olivia standing on a tabletop. I had storyboarded a split-screen moment at the end of the song, where both faces would be in close-up. When John sings, "Oh," there was a magical moment during one of the takes: as the camera pulled back, the sun came out from behind a cloud and lit up his face as he smiled. It's one of my favorite moments in the movie because it was a lucky accident.

We filmed a very wide shot for the end of this song, thinking that we might need a beat for the audience to react or applaud. The studio cut it, and they were right.

The Choreography

In rehearsals, Pat worked out the choreography of "Summer Nights" with the boys and the girls practicing side by side. By the time we shot the boys' scene on the bleachers at Venice High School, everyone knew precisely what their action would be. Throughout "Summer Nights" we kept moving between single close-ups of actors singing and shots of groups dancing with the same movements. "The audience loves disparate bodies moving together," Pat would say. Pat was used to performing to an audience seated beyond the proscenium. For the movie, she adapted to the eye of the camera.

The Cinematography

We wanted to showcase Olivia and John at key moments in "Summer Nights" but keep the storyline going as well, showing the actors and dancers head to toe. Bill Butler worked on syncing camera moves with the motion of the dancers. We used a dolly with the girls as they skipped through the outdoor cafeteria. We used a crane for the boys on the bleachers, following them up and down as they strutted. Somehow they never tripped. Riding high on the crane with the Panavision camera, two huge arc lights, and the cinematographer of *Jaws*, I thought to myself: I'm finally a Hollywood director.

Another important aspect of *Grease*'s cinematography was its crisp visual style, a throwback to the colorful Hollywood musicals I grew up watching, like *An American in Paris* and *West Side Story*. By the late seventies, Technicolor was out of style; movies like *Easy Rider* and *Annie Hall* had a soft and muted look. So the buoyant, colorful style might have been unpopular—Bill thought it was a "gamble to go sharp"—but we thought it was right for this picture.

 FRENCHY
 What was his name?

 SANDY
 Danny... Danny Zuko!

The Pink Ladies look stunned but Sandy doesn't notice.
Frenchy starts to say something, but Rizzo motions for
her to be quiet. Rizzo rises and puts her hand on
Sandy's shoulder in a sisterly fashion.

 RIZZO
 I think he sounds fab-o. If you
 believe in miracles, maybe Prince
 Charming will show up again
 somewhere... someplace 'unexpected.'

Rizzo gives the Pink Ladies a big wink.

 SANDY
 Oh, I don't know. I feel like
 my life is over.

The BELL RINGS. Everyone rises and heads for class.

 CUT TO:

OMITTED 55

EXT. RAMP 56

The Pink Ladies walk under a ramp as the Thunderbirds
climb over the top, not seeing each other.

 DOODY
 Her knockers. Tell me about her
 knockers.

Danny sculpts an overly endowed female form in the air
and Putzie pretends to grab them in the air. A flicker
of uncertainty crosses Danny's face as the others
laugh.

 PUTZIE
 What about her hinie?

 SONNY
 I'm a leg man myself.

 KENICKIE
 Yeah, chicken legs.

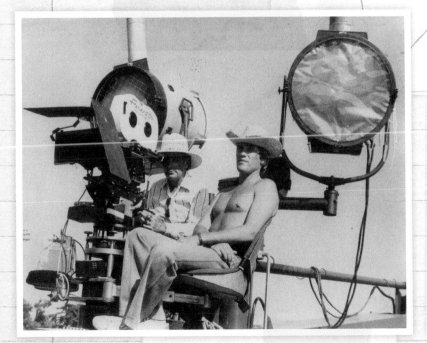

Cinematographer Bill Butler and me on
the crane for "Summer Nights"

The Pep Rally

56 CONTINUED: 56

 Doody imitates a chicken. X

 DANNY X
 (disgusted) X
 Come on, you guys. X

 They head off. X

57 OMITTED 57
thru thru
59 59

60 EXT. FRONT OF THE GYM - NIGHT 60

A bonfire has been laid and the effigy of a Gladiator
with a sign that says GRILL THE GLADIATORS, has been
lynched over the top of it. In the b.g. is a large
sign reading RYDELL RANGERS. A large, noisy crowd is
on hand.

Principal McGee, Blanche and various faculty members
stand at the top of the steps.

A microphone has been set up. Principal McGee steps
toward it, but Blanche taps her shoulder and hands her
several cards.

 PRINCIPAL McGEE
 Blanche, I've only done this a
 thousand times. I think I can do
 it without cards.

Blanche smiles sweetly, then turns and makes a face.

 PRINCIPAL McGEE
 (continuing; into
 the microphone)
 And now, boys and girls, the man
 of the hour! The coach who's
 struck fear into the heart of
 every team in the conference.
 Our very own... Coach Calhoun.

The football players -- in uniform -- come jogging out
and form a V-shaped line as the students cheer.

The CHEERLEADERS come running out after them -- Sandy
and Patty among them -- with their hands over their
heads shaking pom-poms.

A MAJORETTE with a flaming baton follows them and
struts toward the bonfire which she ignites.

 (CONTINUED)

PEP RALLY

60 CONTINUED: 60

COACH CALHOUN makes a spectacular entrance through an
arc of pom-pons, some of which get in his way so that
he has to practically claw his way through them ar-
riving at the microphone slightly punchy. He is a big,
blustering man who is trying to hang onto his youth and
physique.

He stands for a moment, almost sparring with his sha-
dow, and acknowledging the yells of the students.

 COACH CALHOUN
 Who's the best?

 STUDENTS
 (yelling)
 Rydell!

 COACH CALHOUN
 Give 'em hell, Rydell!

He turns to look at Principal McGee and the faculty
members.

COACH CALHOUN

 COACH CALHOUN
 (continuing)
 Sorry, ladies. Got a little
 carried away there.

He turns and looks back at the students, trying to
affect a solemn air.

 COACH CALHOUN
 (continuing)
 But, I just want to tell you,
 students, we've got a banner year
 coming up! A banner year! My
 boys are primed this year! Primed!
 I primed 'em!

He strikes his palm in emphasis and winces with the
pain of his own blow which he tries to mask.

 COACH CALHOUN
 (continuing)
 And we're going out there to rip
 'em and yank 'em and tear 'em
 apart! And after the slaughter
 we'll be back here for the
 ringing of the victory bell!

Tom and Sandy are exchanging appreciative glances
throughout this speech. As it ends, the school band
launches into the Victory Song.

 (CONTINUED)

The Scene

I went to Radnor High School in Radnor, Pennsylvania, and every year we had the big Lower Merion game. Each time, the entire student body showed up with lots of school spirit. The band played our school song at the bonfire and the coach riled up the crowd. This sequence is based on those experiences.

Rydell High's pep rally opens with one of Pat's dancers, Dennis Daniels as Bart, twirling fire batons. Dennis was an actual 1974–75 United States World Baton champion. Once Pat heard about this, we had to include him in the pep rally.

Sid Caesar in his role as Coach Calhoun needed no direction. He was what I call an aim-and-shoot actor: as soon as I aimed the camera at him, he started doing his thing, in this case firing up the student body. Meanwhile, working with Dody Goodman as Blanche and Eve Arden as Principal McGee was a blast. They came up with great comedy bits whenever they improvised together; one that ended up in this sequence was when Blanche was getting into Coach Calhoun's bloodthirsty speech while Principal McGee watched her, a bit appalled. All we had to do was just pick the best take.

"GREASE" - Rev. 6/14/77 31A.

60 CONTINUED: (2) 60

Putzie, Sonny and Doody appear at the sidelines in a clumsy parody of the Cheerleaders.

 PUTZIE, SONNY AND DOODY
 Do a split
 Do a yell
 Shake a tit
 For old Rydell.

PULL BACK TO SEE that they are being watched by Danny who shakes his head in mild amusement, then methodically unrolls a pack of Luckies from his T-shirt sleeve, lights up and surveys the crowd from a distance.

There is the SOUND of an approaching CAR. It is some-where between a WHEEZE and an AVALANCHE.

The Thunderbirds turn to see Kenickie pulling into the parking lot in a battered late 40's or early 50's convertible. The car doesn't actually stop, it just kind of winds down.

Kenickie, beaming with pride, opens the door and gets out. The door hinge gives way and hangs at an angle. Without losing his smile, Kenickie gives it a yank and lifts it into place.

 KENICKIE
 Whadda ya think?

 DANNY
 What a hunk of junk.

The others look at the car dubiously. Kenickie looks defensive and puts his arm across the hood as if to protect it.

 (CONTINUED)

60 CONTINUED: (2) 60 X

 KENICKIE
 Wait till I give it a paint job
 and soup up the engine. She'll
 run like a champ. I'm racing
 her at Thunder Road.

 DOODY
 Thunder Road?

 KENICKIE
 Yeah! You wanta make something
 of it?

 SONNY
 I wanta see you make something
 of that heap.

 The others' attention is taken away as Hell's Chariot,
 a hotrodder's dream of heaven -- black and mean look-
 ing with flames painted along the side spelling out
 Hell's Chariot -- comes cruising down the entrance to
 the parking lot.

 LEO, a tough but flashily handsome guy in his late
 teens, drives and half-hangs out the window. Several
 other guys are also in the car each wearing jackets
 with SCORPIONS written on the sleeves.

 Hell's Chariot cruises slowly, almost tauntingly around
 the area of the bonfire.

 The Thunderbirds watch them, tensing up like male
 animals whose territory has been invaded.

 SONNY
 (continuing)
 Hey, whadda the Scorpions don'
 here? This ain't their territory.

 KENICKIE
 Think they wanta rumble?

 DANNY
 If they do we'll be ready.

 Hell's Chariot turns and drives close to the Thunder-
 birds. The Scorpions are looking at them hard but no
 one makes a move. Hell's Chariot suddenly turns on
 the speed and turns rubber out of the parking lot.

 CUT TO:

61 OMITTED 61 X

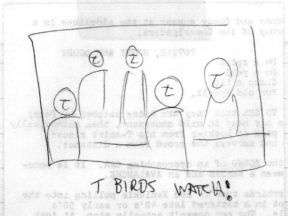

T BIRDS WATCH!

When we see the T-Birds—Putzie, Sonny, and Doody—they're doing a riff on the Three Stooges. During rehearsals, I found out that these guys were all fans of the Stooges and had imitated them before. I arranged for Columbia to send over some Stooges shorts and screened them with the guys. They worked out this routine, which shows their friendship better than any line.

Kenickie drives up in a 1948 Ford Deluxe junker. With a cracked windshield, missing headlight, and in need of a good paint job, it's all he can afford after a summer job lugging boxes. His jalopy is just one of the many period-specific cars in the movie, from the Pink Ladies' 1948 Studebaker Commander Regal and Danny's 1949 Dodge Wayfarer at the drive-in to the mid-fifties Cadillacs, Oldsmobiles, and Chevrolets crowding the parking lot of the pep rally.

Because we wanted to have a climactic race sequence at the end of the movie, we needed to set up the opposing gang early in the movie. We named them the Scorpions and had them drive by in this sequence with their hot rod, Hell's Chariot, a custom-built, flame-spewing 1949 Mercury Series 9CM. When they see the rival gang, the actors provided some great improvisation that made it into the movie: Jeff Conaway pulls out a switchblade and Barry Pearl pulls out a squirt gun.

62 ANOTHER ANGLE 62

The Pink Ladies have been standing nearby as the pep
rally breaks up and the crowd heads toward the stadium.

Sandy lags behind the other Cheerleaders. The other
Pink Ladies push Frenchy forward.

 FRENCHY
 Oh, Sandy...

 SANDY
 Hi, Frenchy.

 FRENCHY
 You were real good. Your split
 was divoon.

 SANDY
 Thank you. I was so nervous.

 RIZZO
 We gotta suprise for ya.

 SANDY
 What is it?

 JAN
 You'll see.

They lead her across the parking lot.

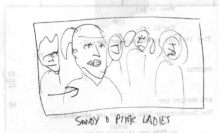

SANDY & PINK LADIES

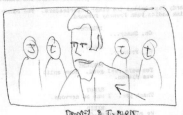

DANNY & T-BIRDS

 CUT TO:

63. OMITTED 63
and and
64 64

65 THE PARKING LOT 65

The Thunderbirds lean against the car smoking.

 DANNY
 -- This car is going to be...
 Make Out City...

 SONNY
 A girl is going to have to be
 willing to go... three-quarters
 of the way before she can even
 get in it...

He gestures expansively as the Pink Ladies and Sandy
walk up in the b.g.

 RIZZO
 Oh, Danny... we gotta surprise
 for you.

Danny turns as the Pink Ladies step aside and leave
Danny and Sandy staring at each other.

Sandy blinks her eyes in bewilderment.

 SANDY
 Danny?

Danny is so glad to see her that his tough facade
dissolves into a genuine smile.

I GOT A SURPRIZE

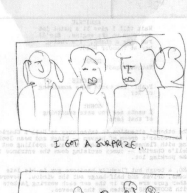

GIRLS ENTER FROM LEFT

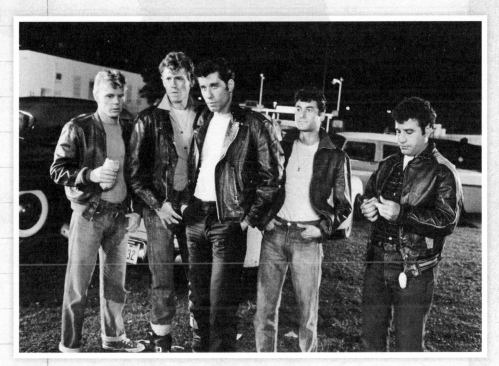

The Shot

One of the key moments in the movie is when Sandy and Danny meet again. I storyboarded this sequence with Sandy in the foreground and the Pink Ladies behind her, and a matching shot of Danny with the T-Birds behind him. In this reunion with Sandy, Danny's delighted to see her again, but then he notices the looks from his gang. With a flip of his collar, Danny reverts to his trademark "That's cool, baby, cool . . . I mean you know how it is . . ." Sandy calls him for what he is, "a fake and a phony." Danny is upset as she storms off, and he catches Rizzo smiling at his discomfort. You see a glimpse of John's more vulnerable side. Having worked with John before, I knew he would nail this moment, and I had him walk into a big close-up, with the others in soft focus behind him. He almost, but not quite, goes after Sandy. Then he turns his back on her and saunters to his gang. That sequence was all John. Not only can he hit the comedy beats but his innate vulnerability comes through no matter what kind of tough guy he plays. It helped that John and Olivia had on-screen chemistry. Their close working relationship turned into a lasting friendship.

When Frenchy tries to comfort the sobbing Sandy, she launches into a tirade against men: "Men are rats . . . They're fleas on rats." At a *Grease* sing-along I heard the audience recite Frenchy's lines word for word. They'd memorized her speech! The movie's become like *The Rocky Horror Picture Show.*

```
                    DANNY
    Sandy?  Wow!  It's so good to
    see ya.

                    SANDY
                 (bewildered)
    I don't believe it.

                    DANNY
    I don't believe it either.

He stops short, looks around and sees his peers looking
at him closely.  In an instant he snaps back to his
T-Bird posture, doing almost a riff of cool and nervous
trying desperately to hang onto his image, rocking back
and forth.

                    DANNY
                 (continuing)
    But that's cool, baby, cool, you
    know... You know how it is...

Sandy looks at him as though he has lost his senses.

                    SANDY
    Danny!

                    DANNY
    ... It's cool... You know...
    Cool.  Cool, cool.

                    SANDY
    Danny!

                              (CONTINUED)
```

65 CONTINUED: (2) 65
 X

He looks at the boys and nods toward Sandy as though
implying she's just one of the many who pursue him.

 SANDY
 (continuing)
 What's the matter with you?

 DANNY
 What's the matter with me, baby?
 What's the matter with you?

 SANDY
 What happened to the Danny Zuko
 I met at the beach?

 DANNY
 Maybe there's two of us. Was he
 short? Was he tall? X
 X

Sandy has to bite her lip to keep from crying.

 DANNY
 (continuing)
 That don't give me much to go on.
 Look in the Yellow Pages... Take
 out a Want Ad... Try Missing
 Persons.

The boys laugh and Sandy looks away as Danny edges
toward the boys.

 SANDY
 You're a fake and a phoney and I
 wish I'd never laid eyes on you!

She turns and runs across the parking lot.

The boys are around the car. Danny looks after Sandy
as if he'd like to go after her.

 SONNY
 I'll bet that's not all she laid
 on you.

Danny looks at Sonny as if he's ready to slug it out.

 DOODY
 Hey! I swiped my brother's I.D.
 Let's chip in for a six-pack.

 PUTZIE
 Looks like Danny's got his mind
 on that chick.

 KENICKIE (CONTINUED)
 Danny doesn't need her. He X
 doesn't need anybody. Let's get X
 the suds. X

 DANNY
 Yeah. Here's my quarter. You X
 cheapos ante up. X

The boys walk toward the car. As they get in, we SEE
Danny's expression change, revealing his real emotions,
hidden from the others.

 CUT TO:

DOLLY BACK WITH DANNY

EDGE OF THE PARKING LOT 67

Sandy stands sobbing at the side of a building.

In the b.g., the Pink Ladies walk up, stand watching her for a moment, then push Frenchy forward. Frenchy approaches cautiously.

 FRENCHY
 Come on, Sandy. It's not as bad
 as all that.

 SANDY
 It is.

 FRENCHY
 Men are rats. Worse. Fleas on
 rats. Worse than that. Amoebas
 on fleas on rats. Too low for
 the dogs to bite... The only man
 a girl can depend on is her daddy.
 Come on. What you need is a
 night with the girls. We're
 having a sleep-over at my place.
 You'll love it.

Sandy looks up and blinks through her tears.

 CUT T

Costume designer Albert Wolsky's original sketches for Rydell High students

The Costumes

"All you need is the spirit," Albert Wolsky told me. "You've got bobby socks and you're halfway there." Albert designed the look of the teachers and staff and the students using a combination of custom-made costumes in period fabric, repurposed costumes from earlier productions, and street clothes. Great costumes need a vision, but a smart costume designer knows what absolutely must be made for the production and what can be found and put together more inexpensively and quickly.

A costume like Coach Calhoun's baseball cap and Rydell High jacket looks simple, but every detail is considered and matched with the other athletes to create a cohesive look.

The T-Birds' jackets were made for the movie, but their black shirts and jeans could be bought pretty cheaply. One thing Albert did not skimp on was the period fabric for the principal actors' costumes—he knew that fabric from the fifties hangs and moves in a certain way that is unmistakable.

At the time, Paramount didn't have a large workroom but they had a fabric room left from the days of the great Edith Head. There were bolts of fabric there from the fifties that Albert used for key costumes, like Sandy's and Rizzo's outfits, while other costumes he pulled from the wardrobe room and repurposed. That was a common practice, and one of the reasons why there are so few costumes left from *Grease*. At the Paramount costume archives I saw Marty's Pink Ladies jacket and a Rydell High cheerleader outfit restored and on display, but little else seems to remain. I've kept a Rydell letter jacket, for special occasions. Olivia kept her skintight "Bad Sandy" pants (and auctioned them off to raise funds for charity). Barry Pearl has his authentic T-Bird jacket. I'm not sure who else kept what, but any items would probably do well on eBay.

"Look at Me, I'm Sandra Dee"

The Scene

Peer pressure is a big part of teenage life. In this scene, Sandy is trying to fit in and become a Pink Lady. This is her hazing moment, when she is offered cigarettes, alcohol, and the ritual of having her ears pierced. Rizzo, being the tough chick who runs the group, makes fun of Sandy behind her back when Sandy disappears into the bathroom, feeling ill after drinking and smoking and getting her earlobe jabbed by Frenchy. Sandy finally emerges from the bathroom and discovers Rizzo's taunt, and her scripted line was, "Who do you think you are, making fun of me?" Olivia changed it to, "You're making fun of me, Riz?" which made her seem more sympathetic. Stockard came up with the retort, "Some people are so touchy," while sinking down in embarrassment at being caught.

SANDY & FRENCHIE

68 EXT. FRENCHY'S HOUSE – NIGHT 68

It's a middle-class, two-story, frame house that has a roof that slopes toward a large old tree. A light is on in an upstairs bedroom.

69 INT. FRENCHY'S BEDROOM – NIGHT 69

CLOSE on a bottle of Italian Swiss Colony wine.

PULL BACK TO SEE that Rizzo is pouring from the bottle into the outstretched jelly glasses held by Marty, Jan and Frenchy. Sandy sits somewhat removed from the others looking unhappy. The girls are in baby-doll pajamas, mules and hair rollers, the room a typical girl's room of the period. A large picture of Vince Fontaine is framed above the bed. He's a good looking man with sharp features and an elaborate hairdo. The room is full of wigs and hair driers.

Both the RADIO and TV are ON.

 JAN
 Jeez, look what Loretta Young
 is wearing!

 RIZZO
 I can't stand her. I keep waiting
 for her to get her dress caught
 in the door. Hey, Frency, throw
 me a ciggie-butt, will ya?

 MARTY
 Me too, while ya got the pack
 out.

 FRENCHY
 Ya want one, Sandy?

 SANDY
 Oh, no thanks. I don't smoke.

 RIZZO
 Go on, try it. It ain't gonna
 kill ya. Give her a Hit Parade!

Frenchy lights the cigarette, Sandy inhales and coughs.

 RIZZO
 (continuing)
 Oh, I shoulda told ya, don't
 inhale if you're not used to it.

 FRENCHY
 Hey, I'll show ya how to French
 inhale. It's really cool. Watch.

 JAN
 Phtyyaaagghh!! That's the ugliest
 thing I ever saw!

 (CONTINUED)

FRENCHY
Nah, the guys really go for it.
That's how I got my nickname,
Frenchy.

RIZZO
Sure it is.

JAN
Italian Swiss Colony. Wow, it's
imported! Hey, I brought some
Twinkies, anybody want one?

MARTY
Twinkies and wine? That's real
class, Jan.

JAN
It says right here, it's a dessert
wine!

RIZZO
Hey, Sandy didn't get any wine.

SANDY
Oh, that's okay... no, thanks.

RIZZO
Hey, I'll bet you never had a
drink before either...

SANDY
Sure I did. I had some champagne
at my cousin's wedding once.

RIZZO
Oh, ring-a-ding-ding.

She hands an uncertain Sandy the bottle.

JAN
What's wrong? We ain't got
cooties.

Sandy takes a big swig.

FRENCHY
Sandy, wouldja like me to pierce
your ears for ya? I'm gonna be
a beautician, y'know.

JAN OFFERS WINE

TRIES TO PIERCE EARS

SANDY
(swallows)
Isn't it awfully dangerous?

RIZZO
You ain't afraid, are ya?

SANDY
Of course not!

MARTY
Here, Frenchy, you wanta use my
virgin pin?

JAN
Nice to know it's good for
somethin'.

MARTY
What's that supposed to mean?

SANDY
Ouuch!

JAN
Nothin', Marty, nothin'... I was
just teasing.

FRENCHY
Come on, Sandy, let's go inta
the john.

MARTY
Yeah, well go tease somebody else.

FRENCHY
My mother'll kill me if we get
blood all over this rug.

SANDY
Huh??

FRENCHY
It only bleeds for a second.
Come on.

SANDY
Listen, I'm not feeling too
well... I...

RIZZO
Don't worry if she screws up.
She can always fix your hair so
your ears don't show.

(CONT'I:

Jan opens a second package of Twinkies as Frenchy
leads Sandy out.

 JAN
 You know, they've got peppermint
 candy cigarettes now.

 MARTY
 If you don't want out, you'll
 look like the Goodyear Blimp.

 JAN
 Oh yeah? Well, at least I don't
 have a complexion like pimento
 cheese.

Marty looks into the mirror.

 MARTY
 You can't see it through the
 pancake.

 RIZZO
 You can't see you through the
 pancake.

O.S. SANDY YELLS OUUCH!!

 FRENCH (O.S.)
 Sandy, Sandy. Beauty is pain.

Frenchy sticks her head in through the door.

 FRENCHY
 (continuing)
 Hey, Marty, get me some ice cubes
 to numb Sandy's earlobes.

 MARTY
 Just let the cold water run
 awhile and then stick her ear
 under it.

 FRENCHY
 Oh??

 MARTY
 (putting on robe)
 It's getting chilly in here.

 RIZZO
 Hey, what's that?

 MARTY
 From Bobby in Korea.

 JAN
 You engaged to a Korean?

 MARTY
 No, dummy, he's a Marine. You
 wanta see a picture?

 RIZZO
 You're turning into a one-woman
 USO.

MARTY SHOWS PIX

COSTUME FOR _____ "Jan"

PLAYED BY _____ Jamie Donnelly

PHONE NO. _____

CHANGE	SCENE NOS.	SET	DESCRIPTION
#3	69	int Frenchy's bedroom sweatshirt on - p.j. collar out of sweatshirt neck stands up	Pyjamas: 2 pc white w. blue ballet slipper print flannel shirt style top - long sleeve peter pan collar w. blue piping - straight leg trouser
			Sweatshirt: grey long sleeve crew neck XL
			Slippers: bright pink furry full foot flat scuff
		"Brusha, brusha, brusha . . ."	(hair in pigtales NO RIBBON)

The Script

While rehearsing the scene, we noticed a few lines slowed down the pace, so we cut or changed them. For example, in the shooting script, the character Jan looks at the TV and exclaims, "Jeez, look what Loretta Young is wearing," but Jamie thought that Jan probably wouldn't care about the Oscar-winning actress. She proposed replacing it with a line from the play that had always gotten a good laugh: "No shit, Bucky Beaver." She pointed out to me that she has large front teeth, and I instantly flashed on a commercial from my childhood: Ipana toothpaste. It had a cartoon character named Bucky Beaver as its spokesman. We had the research department at Paramount track the commercial down and ran it on the vintage TV for the scene. With her "brusha brusha, brusha" along with the TV commercial, Jamie got her laugh again.

FRENCHY
(returning)
Sandy's sick. I did one ear and
she saw the blood and BLOUGH!!

MARTY
(showing Rizzo)
That's him. Right next to Ricky
Nelson.

JAN
(to Frenchy)
You're not gettin' your hands
on my ears.

FRENCHY
You'll be sorry. I been accepted
at the La-Cafury Beauty School.

JAN
You dropped outta Rydell??

FRENCHY
I don't look at is as dropping
out. I look at it as a very
strategic career move.

RIZZO
(to Marty)
Why is it torn in half?

MARTY
His old girlfriend was in the
picture.

FRENCHY
(at bathroom door)
Sandy? Here's your toothbrush.

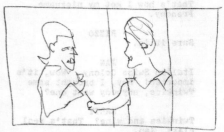

INTO BATHROOM

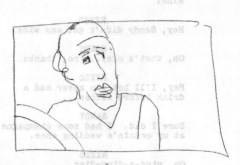

MARTY

JAN & TV — BUCKY BEAVE IPANA AD

MARTY DOES BUST EXCERCISE

SANDY SMOKES

The Shot

From the shooting script's simple phrase "a typical girl's room of the period," our art department created the ultimate bedroom of every fifties girl, including a paint-by-number painting of a horse and photos of teen idols pinned to the walls. Created on a soundstage, the set gave the feeling of an intimate bedroom, even though there was a crew of forty right outside the open fourth wall.

The scene was the Pink Ladies' last day together on our shoot, and the mood was infectious—Olivia, Stockard, Jamie, Didi, and Marty had become real-life friends and got into the slumber-party vibe. In fact, they were having so much fun that it was hard to get them to concentrate on the scene. Didi even said that she spontaneously closed the bedroom door when Stockard pulled put the bottle of wine as Rizzo, so her "parents" wouldn't hear them. But Pat Birch was a taskmaster during the music number and got them to focus and perform the loose and playful choreography. When I announced, "That's a wrap!" everyone cheered and celebrated. We had the feeling that we might not see each other together again. And we were so wrong, as our friendships have lasted for decades.

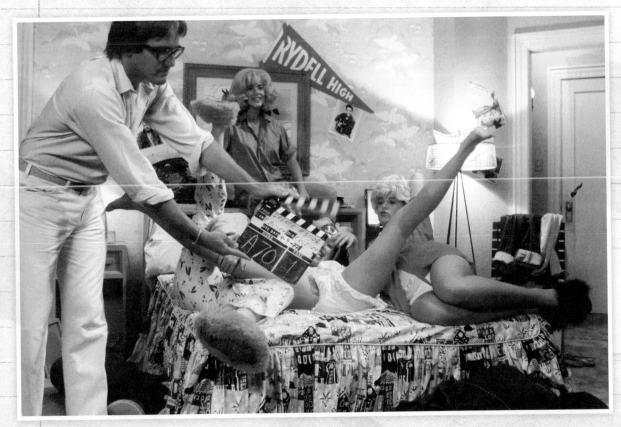

Last day of production; I stepped in to slate the shot.

89

69 CONTINUED: (5)

> SANDY (O.S.)
> I'm sorry about this, Frenchy.
> It's starting to bleed again.

Rizzo makes a face in the direction of the bathroom.

> RIZZO
> Miss Goody-Two-Shoes makes me
> wanta barf.

She rises and goes into a razor-sharp imitation of
Sandy, and begins to sing LOOK AT ME, I'M SANDRA DEE
(from the Broadway show). The Pink Ladies gradually
get involved and do back-up, using Frenchy's wigs
and other beauty parlor accessories.

> RIZZO
> (continuing;
> singing)
> Look at me, I'm Sandra Dee
> Lousy with virginity
> Won't go to bed till I'm legally
> wed.
> I can't. I'm Sandra Dee.
>
> Watch it, hey, I'm Doris Day
> I was not brought up that way
> Won't come across, even Rock
> Hudson lost
> His heart to Doris Day.
>
> I don't drink or swear
> I don't rat my hair
> I get ill from one cigarette
> Keep your filthy paws off my
> silky drawers
> Would you pull that stuff with
> Annette?

Sandy re-appears in the bathroom door and overhears
the last part of the song.

> RIZZO
> (continuing;
> singing)
> As for you, Troy Donahue
> I know what you wanna do
> You got your crust, I'm no object
> of lust
> I'm just plain Sandra Dee.
> (MORE)

The Song

One of the original songs from the play, "Look at Me, I'm Sandra Dee" compares Sandy to the real-life Sandra Dee, an actress who played popular Goody Two-shoes roles in fifties teen romances like *Gidget, A Summer Place*, and *Tammy Tell Me True*. Bad girls like Rizzo would have loathed Sandra Dee.

From the moment Stockard as Rizzo swivels to face her friends with a sharp gleam in her eye, she lets the audience know they'll be in for a bumpy ride. Rizzo skewers Sandy with "Look at me, I'm Sandra Dee, lousy with virginity" and ends with the Americanized Italian expletive "Fangool!" before proclaiming one last time, "I'm Sandra Dee!"

The original stage lyrics included "No, no, no, Sal Mineo, I would never stoop so low," which you can still see in the shooting script. Tragically, the actor Sal Mineo had been murdered a little more than a year before we began *Grease*, so we changed the lyrics to "Elvis, Elvis, let me be, keep that pelvis far from me." But in an eerie twist of fate, Stockard sang these lyrics to the picture of Elvis on August 16, 1977, the day he died.

RIZZO SINGS

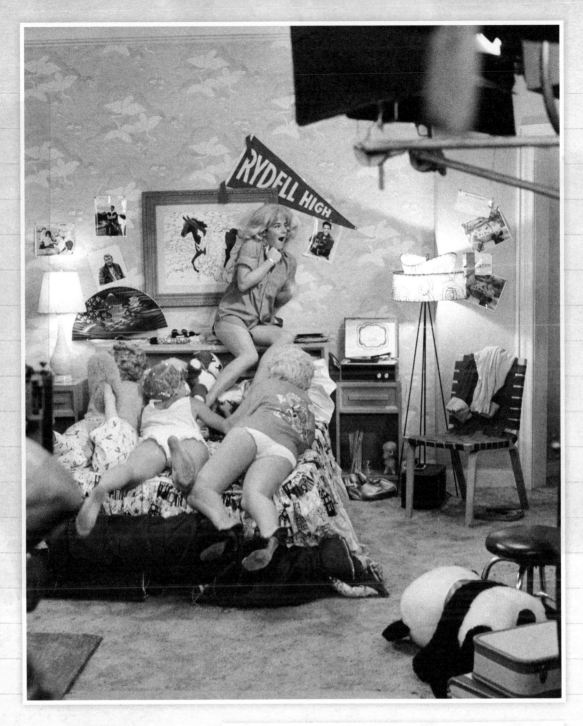

SANDY COMES OUT OF BATHROOM

GIRLS POINT

69 CONTINUED: (5) 42.

 69

 RIZZO (CONT'D)
 No, no, no, Sal Mineo
 I would never stoop so low
 Please keep your cool, now you're
 starting to drool
 Fongool!
 I'm Sandra Dee.

Sandy walks back into the room and stands behind Rizzo
who turns and finds herself face to face with Sandy.

 SANDY you
 ~~Who do you think you are~~ making
 fun of me? Riz,

The girls stop, surprised and a bit embarrassed.

 RIZZO
 Some people are so touchy! CUT TO:

70 EXT. THE STREET IN FRONT OF FRENCHY'S HOUSE - NIGHT 70

The car pulls up and the Thunderbirds sit smoking and
finishing a beer. Kenickie and Danny are in front
and the others are in back. Danny looks as if he
wishes he didn't come.

 DANNY
 I changed my mind.

 SONNY
 Whadda you mean?

 PUTZIE
 A wise man changes his mind. A
 fool never does.

 DOODY
 I see you keep Reader's Digest
 in your bathroom, too.

Sonny nudges Putzie.

 SONNY
 You do it.

Putzie rolls down the back window and sticks his head
out.

 PUTZIE
 Oh, Sandy!

 (CONTINUED)

T-BIRDS ARRIVE

FRENCHY WATCHES

92

70 CONTINUED: 70

Danny turns as if to slug him, but Kenickie catches
his arm and calms him down.

 DANNY
 (fiercely)
 Knock it off!

Danny is about to get back into the car when the girls'
faces appear at the window.

 CUT TO:

71 INT. BEDROOM - NIGHT 71

 FRENCHY
 They can't come in here. My
 folks'll flip.

Rizzo walks to the window, looks out then turns to
the others.

 RIZZO
 You goody-goodies are too much
 for me. I'm going to go out
 and get some kicks while I'm
 still young enough to get 'em.

Rizzo grabs her clothes and climbs out the window. X

 FRENCHY
 What's she gonna do? Shinny
 down the drainpipe?

 CUT TO:

72 OMITTED 72

73 EXT. STREET IN FRONT OF FRENCHY'S HOUSE - NIGHT 73

Rizzo is indeed shinnying down the drainpipe and having
great difficulty doing it.

The boys stand on the sidewalk watching.

Rizzo drops into the shrubbery and emerges wiping her
clothes off.

 Kenickie drives and Rizzo is wrapped around him.
 Sonny, Doody and Putzie are in the back seat. Rizzo
 nudges Kenickie and motions for him to stop. The car
 stops. Rizzo lights a cigarette, turns, takes a Bette
 Davis drag and blows a stream of smoke on the boys in
 the back seat. A 50's SONG PLAYS on the RADIO.

 RIZZO
 Whadda ya think this is? A gang
 bang?

 KENICKIE
 Okay, fellas, hit the pavement.

 Sonny, Doody and Putzie pile out and stand in the
 street watching as the car pulls away with much noise.

 SONNY
 When a guy chooses a chick over
 his friends, something's gotta
 be wrong.

"Hopelessly Devoted to You"

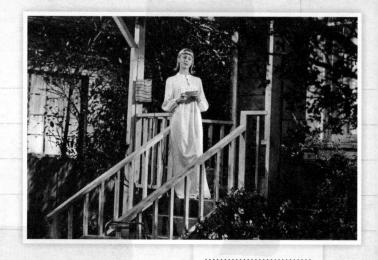

The Song

This song, one of the last things we shot, hadn't even been written when we began production.

When Olivia signed on to do the movie, her contract stated that she would have a solo song as well as approval over it. We watched for it in preproduction, but nothing arrived. This made everyone nervous. We started shooting and still no song. There wasn't even a place for it on the production schedule. Then, halfway through the shoot, John Farrar, who had written "Have You Never Been Mellow" for Olivia, came up with "Hopelessly Devoted to You."

John told me recently that he had wanted to write something like one of his favorite songs, "The End of the World," an early sixties country hit sung by Skeeter Davis. The word "devoted" was used a lot in songs from the fifties and sixties, so he started composing with that in mind. The melody followed pretty quickly over a couple of days, and then he spent three weeks refining the rhyme scheme to make it work. He recorded the demo tape and sent it over to us.

Being unfamiliar with listening to demos, I couldn't imagine what it would sound like when it was fully produced. On the demo tape, John was singing in a falsetto voice with a simple piano accompaniment. I ventured an opinion based on what I was hearing: "I'm not sure about this. Doesn't it sound like a country-western song?" Olivia gave me a withering look. She was quite familiar with listening to demos. "Well, I like it!" she said. She was absolutely right. It went on to get an Oscar nomination for Best Song.

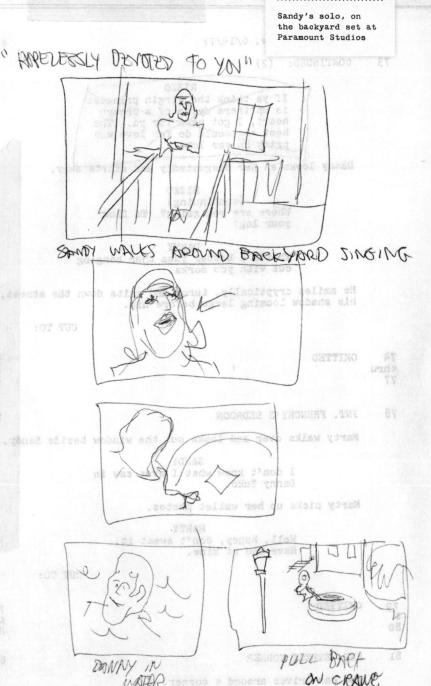

SANDY WALKS AROUND BACKYARD SINGING

DANNY IN WATER

PULL BACK ON CRANE

94

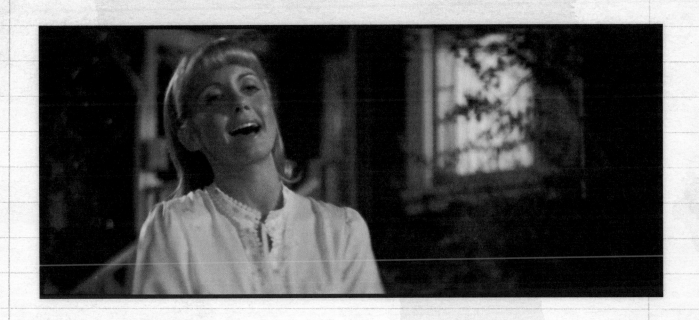

The Scene

For six weeks, just the words "Olivia's Song" were a placeholder in the shooting script. Only after "Hopelessly Devoted to You" was selected could we really explore what the scene would involve. But even with the set constructed at the last minute, and the choreography and camerawork worked out the day of the shoot, what came out is a nice character moment in an otherwise frenetic movie.

Because we had a promotional deal with Pepsi, I had been assigned to undo the set decorator's boo-boo of putting Coke signs all over the Frosty Palace set (see page 112). I carefully placed a wooden Pepsi carton right behind Sandy when she sits down on the porch and sings. It's subtle, but it calmed Allan Carr down, who'd been having a rough time smoothing things over with the Pepsi reps.

The others nod in agreement and they start down the street, their shadows stretching out in back of them.

Olivia's Song. "HOPELESSLY DEVOTED TO YOU" BACK YARD SET KID'S SWIMMING POOL

EXT. LOVER'S LANE - NIGHT

The car pulls off the street and into a wide alley where the cars are parked bumper to bumper. Each car contains a necking couple.

INT. THE CAR - NIGHT 83

Rizzo sits entwined around Kenickie who is trying to park. It is a fairly tight space and he bumps the cars front and back getting outraged reactions from both couples.

 RIZZO
 We can see who don't have drive-
 in money tonight.

Kenickie parks the car, switches on the RADIO and they come to each other in a clinch. Original 50's SONG begins to PLAY. Kenickie and Rizzo are enthusiastic lovemakers. They hold onto a clinch and without ever taking their lips off each other, negotiate the diffi-cult movement of climbing over the front seat to the back without any break in their smooching.

 (CONTINUED)

The Location

When we listened to the demo of "Hopelessly Devoted to You" in the middle of our shooting schedule, we first had to figure out where to place it in the story. Pat Birch pointed out that the young audience we wanted would probably not like to sit and watch a slow ballad, no matter how great the song was. Poring over the screenplay, we landed on the idea that after the slumber party, Sandy goes outside to Frenchy's backyard and pines for Danny. Pat thought the scene would work well after the "raunchy stuff" (as she called it) between Rizzo and Kenickie. And I also discovered one of the advantages of shooting a feature at a major studio. From the porch to the lawn and bushes and fireflies, the entire backyard set of Frenchy's house was built overnight.

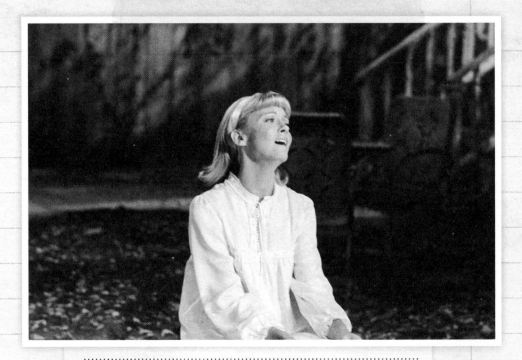

Olivia sang "Hopelessly Devoted to You" in one continuous take

RANDAL: When I first heard "Hopelessly Devoted to You," I had never heard a demo before, so I thought, "I don't know what this is. It sounds like a country-western song."

OLIVIA NEWTON-JOHN: You didn't love it in the beginning, I recall.

RANDAL: But you said, "Well, I like it." I thought, "I guess she knows better than I do," and you certainly did. It got an Academy nomination and you sang it on the Oscar broadcast.

The Shot

Our crew showed up in the morning with a newly constructed set, the song, and Olivia. It was the hardest number for Pat to choreograph, because there was no action or dancing. What could Sandy do? Climb the fence? We decided to film the scene in one continuous shot. The kiddie pool gave Pat a prop to motivate Olivia's character to move there to connect again with Danny, shown as an imagined reflection. For Olivia, this approach felt very natural, because she got to perform the way she does in concert, without stopping for additional angles. Electric fireflies were added to the set to give it a romantic mood. Bill Butler kept the camera moving all the way to the crane shot at the end.

73 CONTINUED:

 RIZZO
 A swell bunch you are... rushing
 to help a lady.

 DOODY
 (looking around)
 Lady? I don't see any ladies
 around here.

Rizzo casually flips him the finger and looks at Danny
and Kenickie who are leaning against the car.

 RIZZO
 What's up, Kenick?

 KENICKIE
 One guess.

 RIZZO
 You sure got a lot to offer a
 girl.

 KENICKIE
 You better believe it.

Rizzo gives him a lifted eyebrow and looks at Danny
with interest.

 RIZZO
 What say, Zuko?

 DANNY
 You're lookin' good.

 RIZZO
 ~~It's called maturity.~~ *Eat your heart out*

Kenickie looks from Danny to Rizzo then steps in and
puts his arm around her somewhat possessively. Rizzo
looks at him for a moment then leans against him.

 RIZZO
 (continuing; to
 Danny)
 This ain't the old days, you
 know. You gotta wait your turn.

 DANNY
 Sloppy seconds ain't my style.

 (CONTINUED)

Stockard and Jeff clicked right away, and their improvisations during a take were sometimes better than the screenplay's lines. "Eat your heart out" was all Stockard. And "Your chariot awaits" was pure Jeff. Sometimes the lines were taken out for other reasons. Rizzo was supposed to say, "Keep a cool tool, fool. I'm wise to the rise in your Levis." That was considered too much even for our movie.

With his longtime experience in the Broadway production (playing Danny Zuko for two years), Jeff wanted to keep the grittiness of the original *Grease*. "Can't be bubblegum," he'd say. "If you don't believe that these guys would get into a fight, then you won't believe *Grease*." He'd tell stories on the set about being a "mascot" for his sister's tough friends when he was a little kid, following them around. They'd stick him under a car when they fought with other gangs. He picked up how to be a tough greaser and used this to convey fifties bravado and cockiness.

RIZZO & T-BIRDS

DANNY WALKS AWAY

97

73 CONTINUED: (2) 73

 RIZZO
 If ya think the virgin princess
 is up there dying of a broken
 heart, I got news for ya. The
 best she could do for love was
 prick an ear lobe.

 Danny looks at her disgustedly and starts away.

 RIZZO
 (continuing)
 Where are you going? To flog X
 your log? X

 DANNY
 That's a better idea than hanging
 out with you dorks.

 He smiles cryptically, turns and exits down the street,
 his shadow looming large before him.

 CUT TO:

74 OMITTED 74
thru thru
77 77

78 INT. FRENCHY'S BEDROOM 78

 Marty walks over and looks out the window beside Sandy.

 SANDY
 I don't know what I ever saw in
 Danny Zuko.

 Marty picks up her wallet photos.

 MARTY
 Well, honey, don't sweat it.
 Have one of mine.

 CUT TO:

79 OMITTED
&
80

81 EXT. STREET CORNER

 The car drives around a corner.

MARTY & SANDY

The Shot

Grease was always meant to be a wide-screen color musical with its Southern California setting, colorful costumes, and fun music. The interactions between tough-girl Rizzo and the T-Birds definitely had an edge though, and the relationship of Kenickie and Rizzo gave us the opportunity to provide drama and vulnerability, something both Jeff and Stockard could convey.

The shoot for Lovers' Lane took all night. Jeff could have done a few takes more on the make-out scene, but his respect for Stockard (combined with her husband visiting the set while we were shooting the scene) kept things professional. As a joke, Jeff taped porno pictures to the inside of the car before Stockard got in for the shoot. Stockard was a good sport about it, but we made him take them down. Jeff and Stockard were close friends. Long after the movie, they'd still greet each other at parties, shouting from across the room, "Hey, Rizz!" and "Kenicks!"

The Lovers' Lane sequence was shot on Mulholland Drive at the top of the 405 Freeway—the area is now the Skirball Cultural Center. Dennis Stewart, who played the Scorpions' leader, Leo, and Annette Charles, who played his girlfriend, Cha Cha, were the perfect biker types to contrast with Jeff Conaway and Stockard Channing. Jeff came up with the nickname "Craterface" based on Dennis's pockmarked complexion. I was worried Dennis might object, but he thought it was cool.

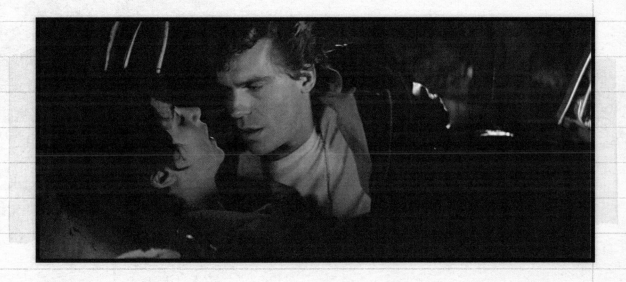

83 CONTINUED: 83

As they lie on the back seat -- both of them with their
eyes closed, Kenickie manages to free half his mouth so
that he can dislodge a wad of gum which he sticks on
the car light. They kiss a moment more.

 RIZZO
 (continuing; still
 kissing)
 What happened to the gum?

 KENICKIE
 It was gettin' in the way.

Rizzo opens her eyes and looks at him meaningfully.

 RIZZO
 Keep a cool tool, fool. I'm
 wise to the rise in your Levi's.

 KENICKIE
 You still thinking about Zuko?

 RIZZO
 I got one thing on my mind, baby,
 and that's you.

 KENICKIE
 (passionately)
 Oh, Rizzo. Rizzo.

 RIZZO
 You could at least call me by X
 my first name. X

 KENICKIE
 (he has to think)
 Yeah... uh... Betty! Betty!

 RIZZO
 (responding huskily)
 You got something?

Kenickie takes out his wallet and opens it.

 KENICKIE
 My twenty-five-cent insurance
 policy.

 RIZZO
 Big spender.

 (CONTINUED)

CONDOM BREAKS

100

83 CONTINUED: (2) 83

He starts to remove it from his wallet, then his face
slacks in disbelief.

 RIZZO
 (continuing)
 What?

 KENICKIE
 (long pause; pained)
 It broke.

 RIZZO
 How could it break?

 KENICKIE
 I bought it when I was in seventh
 grade.

 RIZZO
 You dip...

He looks pained. She looks into his eyes.

They go into a clinch as a 50'S SONG (possibly "Why
Do Fools Fall in Love?") begins to PLAY on the RADIO.

84 EXT. LOVER'S LANE - LONG SHOT - PARKED CARS 84

Hell's Chariot is parked near the car. Hell's Chariot
cranks up and begins to back up.

 CUT TO:

85 INT. THE CAR - NIGHT 85

The empty front seat of the car is SEEN as heavy
BREATHING is HEARD.

 KENICKIE
 (huskily)
 Oh, Rizzo, Rizzo.

 RIZZO
 (huskily)
 Please -- Call me Betty.

 KENICKIE
 Oh, baby.

 RIZZO
 Betty!

 KENICKIE
 Yeah!

Suddenly there is a loud SLAM and Kenickie is pitched
over the front seat.

EXT. LOVER'S LANE - NIGHT 86

Hell's Chariot has backed into the car.

Kenickie sticks his head out of the car.

 KENICKIE
 Hey! What the hell you think
 you're doing?

 LEO
 (leaning out
 the window)
 Ya parked in a No Parking zone,
 creep!

 KENICKIE
 The whole place is a No Parking
 zone, pinhead.

"It broke": one of the
many "adult" moments
that went over most
children's heads

101

Leo gets out of the car and examines Hell's Chariot.
It is in pristine condition.

Kenickie gets out of the car. The back fender is
dented in so that it will have to be pulled out to
be driven.

Kenickie and Leo look at each other angrily.

> KENICKIE
> (continuing)
> You're gonna pay for this.

CHA CHA DI GREGORIO, an Amazonian girl, looks out the
window of Leo's car, sees Kenickie and smiles, at the
same time removing her bra from the rear-view mirror.

Rizzo has gotten a good look at Leo and is interested.
She gives a slight smile.

Leo looks from Rizzo to the car to Kenickie, then walks
back to Hell's Chariot and gets in.

> LEO
> I'll give ya seventy-five cents
> for the whole car... including
> your girl.

Rizzo is open-mouthed as Leo burns rubber out of the
Lover's Lane.

> CUT TO:

INT. AUTOMOTIVE REPAIR CLASSROOM - DAY 87

Danny, Kenickie, Sonny, Doody and Putzie stand looking
gravely at the damaged car.

> KENICKIE
> We gotta do something.

> PUTZIE
> It's a hopeless case.

Kenickie gives him a dirty look.

> SONNY
> Junk it.

> DOODY
> Won't have to do much to do that.

Kenickie turns and looks imploringly at Danny who
approaches the car and contemplates it seriously while
walking around it.

> DANNY
> I don't think it's so bad. In
> fact, it's okay. It's pretty good.
> No, I don't even think it's good.
> It's a major piece of machinery...
> I said a major piece of machinery.
> We can't 86 it.

> KENICKIE
> Yeah! Tell 'em!

> DANNY
> Look at the lines. Look at the
> lights. It needs a little work,
> sure. But it's all here! It's
> Hydramatic... Systematic...
> Automatic... Aristocratic...

He begins to slide into an Elvis imitation as he speaks
and moves.

TAIL PIPES
SHOOT FIRE

"Greased Lightnin'"

The Scene

"Why this car could be systematic . . . it's ultramatic!" Every adolescent guy has visions of being popular and powerful. Having the ultimate driving machine is very American as well. Danny's character as a leader comes out in this scene, where he motivates his buddies to help fix up the car. This song was one of the two that had fantasy sequences built in (the other being "Beauty School Dropout"). We decided to give each fantasy sequence a seamless white background and vibrant colors to make it stand out from the rest of the movie.

Danny sliding under Kenickie's battered 1948 Ford Deluxe and coming out in the dream version seemed like a slick way to make the transition. After the number, we pop back to reality, where the guys are perched on the junker car. John improvised the line, "Come on, guys, let's get to work."

BARRY: All this dialogue before the song "Greased Lightnin'" was improvised.

MICHAEL: "Your mother" was totally improvised.

BARRY: "I drive" was improvised.

KELLY: I remember trying to figure out different words for types of transmissions. The "automatic"—

MICHAEL: "Systematic."

KELLY: "Hydromatic . . ." Randal, you gave us free rein.

RANDAL: I remember trying to figure out how to go from the garage to the fantasy.

BARRY: I said, "Have him go under the car and when he comes out the other end, we're in the fantasy."

KELLY: That was my suggestion! My grandfather had one of those creepers, the little boards that a mechanic uses to go under your car and work on it. I said to Pat, "Why don't we have him use a creeper to go underneath and come out the other side."

BARRY: I wonder if I had the idea and expressed it to you, and you talked with Pat—or, okay, okay, we might both have talked to Pat at the same time.

RANDAL: And that idea became this! Whoo-hoo!

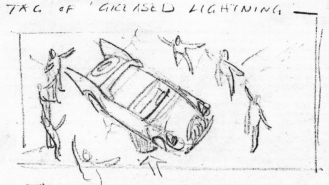

TAG OF 'GREASED LIGHTNING'

— THE MAGICALLY CREATED 'GREASED LIGHTNING' RISES TOWARD US ON HYDRAULIC LIFT

AS IT ALMOST FILLS THE SCREEN —
— ON THE FINAL NOTE —
IT INSTANTLY BECOMES THE ORIGINAL CAR —
— AND IN THE AUTOMOTIVE SHOP — SAME ANGLE —
IT WHEEZES AWAY FROM US — ON THE HYDRAULIC LIFT — AND SETTLES SADLY TO THE FLOOR —

..............................
Production designer
Phil Jefferies's idea
for ending the number

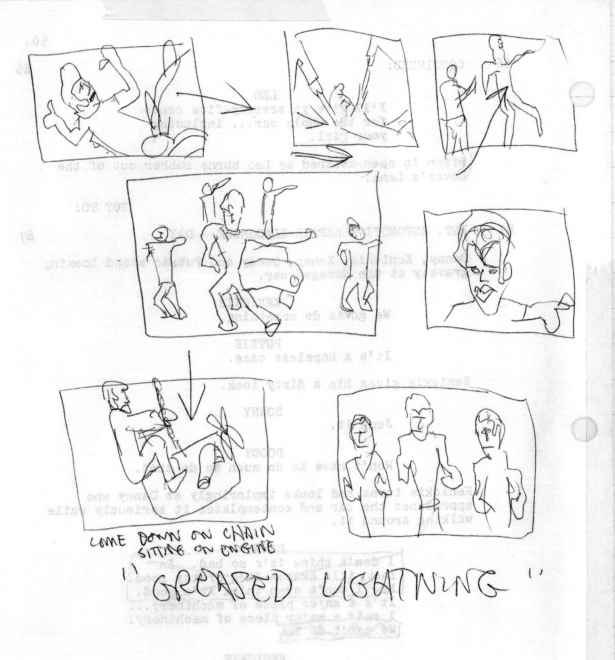

COME DOWN ON CHAIN
SITTING ON ENGINE

" GREASED LIGHTNING "

MATCH OUT

My concept sketches for the
"Greased Lightnin'" number

104

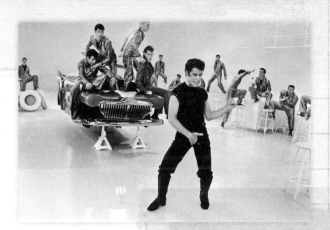

87 CONTINUED:

 DANNY
 (continuing; getting
 carried away)
 ... Yeah, the best. I tell you
 what it is!... It's Greased
 Lightning!

 KENICKIE
 Greased Lightning.

Kenickie and Danny go through a hand-slapping ritual
of enthusiasm as the others move in on them.

 DANNY
 Greased Lightning! Dual exhaust!
 A good transmission! Fluid drive!
 Out, in and overdrive. We can do
 it! We can fix it! Greased
 Lightning!

As the others circle the car Danny goes into GREASED
LIGHTNING (from the Broadway show). As he sings, an
all-white fantasy production number is built around
the car which is taken away from the grimy repair
shop and into an imaginary limbo where it is trans-
formed bit by bit into the car of every boy's dreams.

As the song ends, they return to the gritty reality of
the classroom and the battered car stands before them.

The Song

Only grease monkeys or hot-rod aficionados might know what "overhead lifters," "four-barrel quads," "fuel-injection cutoffs," and "chrome-plated rods" are, but once the song moves into "You know that ain't no shit, we'll be getting lots of tit," the real meaning behind the song becomes clear. "Greased Lightnin'" is as much about getting the girls as souping up a car. A G-rated version of the lyrics has been performed in high schools around the world, with lines like "You know that ain't no crap, we'll be getting lots of that." It doesn't have the same feeling.

In fact, when people find out that I'm the director of the movie *Grease*, they sometimes bring over their kids and say, "My kid can sing every single number in the show." With the lyrics including lines like, "You know that I ain't braggin', she's a real pussy wagon," I'm disappointed when the kids always get stage fright and clam up.

An interesting side note for those who know cars: Danny sings about "four on the floor," a term for manual transmission, but in the Thunder Road race scene, I seem to remember John using a column shift.

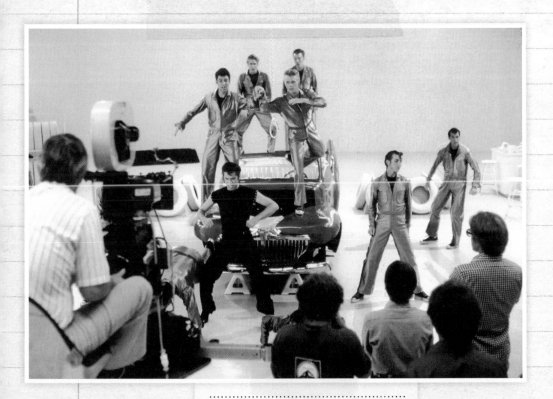

Shooting "Greased Lightnin'" on Stage
23 at Paramount Studios

105

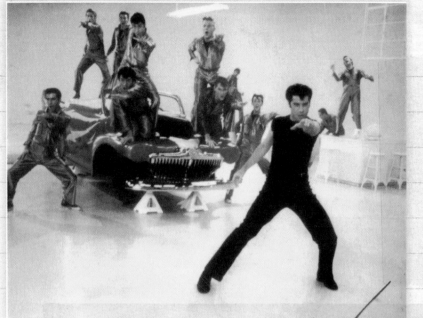

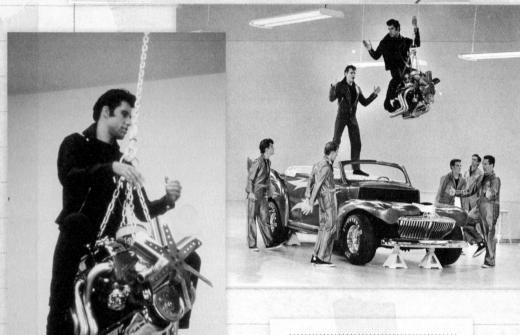

Choreographer Pat Birch and me
watching John descending

The Shot

This scene was as dramatic behind the cameras as it was in front of them. "Greased Lightnin'" was sung by the character Kenickie in the Broadway production, but as John was the star of the movie, he got the song. This made for some tension, but everyone was a professional. Jeff might have missed singing this song, but he got into the lines he had and his energy amped up the others. On the day we began shooting this number, *People* magazine came out with a cover story article on John. He was upset because it featured the death of his girlfriend, Diana Hyland. (She had been cast as his mother in *The Boy in the Plastic Bubble*.) He had been promised that this personal story would not be emphasized, but there it was on the cover of the magazine. Thankfully, John rose above it, jumping into the energetic number.

He developed a block against one of the lyrics, however. When he lip-synched to the phrase "heat lap trials" in the song, his mouth kept forming the phrase, "heap lap trials." I stood by the camera and yelled "Heat!" over the playback each time the phrase was about to come up, but the playback was loud and John was concentrating on his choreography. He ended up saying, "Heap lap trials," every time. And if you rewind it and look, you'll see it: the "p" in heap.

DANNY SINGS

GUYS JOIN

The Choreography

The song's distinctive choreographed arm movements—pointing and sweeping the arm across with "Go, Greased Lightnin', you're burning up the quarter mile" and pumping the arm up and down with "Go, Greased Lightnin', go, Greased Lightnin'"—were original to the stage version of *Grease*, as some of those actors had been better actors than dancers. The choreography stuck, and these are some of the most imitated moves whenever people hear the song even today.

Pat Birch added moments like passing the handfuls of grease to Kenickie, who rubs it into his hair. Other moves came straight from the actors. Channeling Elvis, John threw off his jacket effortlessly, and it landed, as if on cue, on that high shelf. We loved that shot and kept it in. The jacket doesn't appear in the next shot as we hadn't planned it.

Like many of the movie's songs that took their cues from the Broadway show, in this number the plastic wrap reference that John wraps around the car is a holdover from the play, where it is referred to as a prophylactic. By using it as a prop, John managed to sneak in a suggestive shimmy with the sheet of plastic wrap without affecting our rating—another place where the edginess of the stage musical crept in.

The Cinematography

This number we shot with three cameras. The lighting that Bill Butler chose helped shift the sequence out of the reality of the high school garage and into the fantasy sequence. Once John disappears under the car and reappears, there is no direct light—everything is bounced—so there are no shadows. Bill did keep the sharpness that he used throughout.

There is a section in this number where John runs toward the camera, then backs up. This was a tricky job for focus puller Earl Clark to achieve. If he made the slightest mistake, the scene would be ruined. Anything out of focus could not be fixed later. Luckily, the dailies came back crystal sharp.

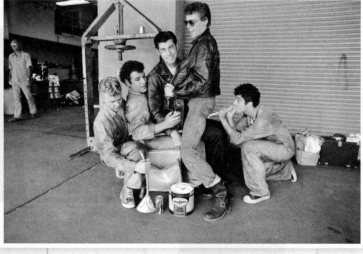

The Car

The fantasy car in this sequence is the most famous of the four *Grease* cars (Kenickie's broken-down jalopy and the two stunt cars we used for the Thunder Road race being the other three). Our prop and art departments turned the 1948 Ford Deluxe convertible into the ultimate cherry chariot.

They imagined how a group of kids would fantasize about their car to add customized details like peanut headlights and cutaway fenders. They took out the back seats and chopped the windshield, finishing the car off with painted white lightning bolts along the metallic red sides and matching white leather upholstery. The clear plastic hood—one of the most challenging parts to create, requiring a specialized mold—showcased the gleaming chrome-plated V-8 engine that Danny rides down from the ceiling.

George Barris, the "King of Kustomizers," who worked on the cars with our art department, transformed this car into a flight of fantasy that, at the end of the movie, literally took flight.

The cast was always goofing off on the set.

One idea was to have the car filled with babes at the end of the number.

The Frosty Palace

88 EXT. FROSTY PALACE - DAY 88

The Scorpions cruise the street in Hell's Chariot.

Danny and Kenickie are standing in front of the Frosty
Palace which is crudely built to resemble an igloo and
has a drive-in area on the side. Hell's Chariot turns
around in the parking lot with insolent slowness. Leo
drives and the others partially hang out the windows.

 KENICKIE
 Those Scorpions are asking for it.

 DANNY
 Don't worry. Greased Lightning
 will give it to 'em.

Hell's Chariot drags back down the street as Danny and
Kenickie go into the Frosty Palace.

SCORPIONS DRIVE PAST FROSTY PALACE

DANNY & KENICKIE

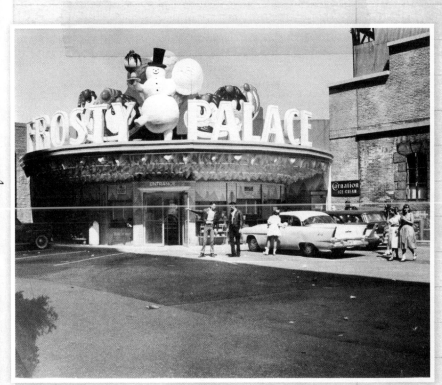

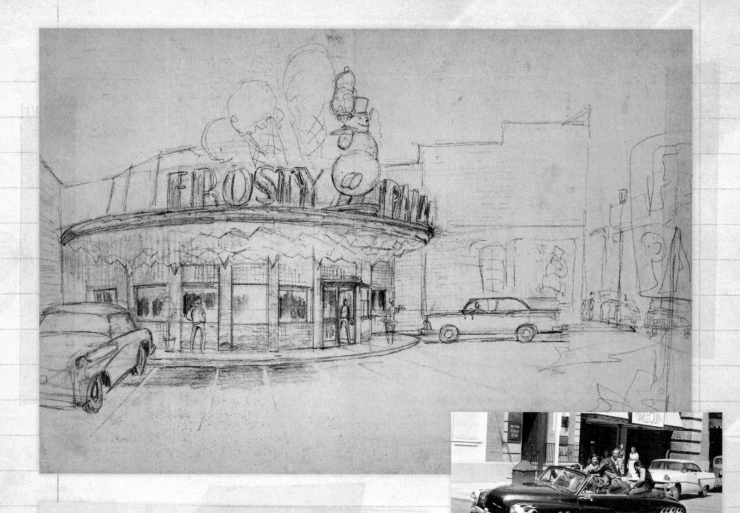

The Scene

This hangout for the kids at Rydell High is another set where the production went all out to make it true to life. We shot both its exterior and interior on the lot.

The Frosty Palace's over-the-top exterior was first seen in the animated title sequence with the credit "Dances & Musical Sequences Staged & Choreographed by Patricia Birch." It comes to life when the Scorpions careen down the main street in Hell's Chariot, scattering pedestrians and whooping it up. The car belches fire as it passes by the diner's awning with its dangling icicles and the gigantic snowman holding ice cream cones and its trademark "Dog-Sled Delites."

Kenickie and Danny stand outside the Frosty Palace, and some sharp-eyed fans have spotted that in this sequence Kenickie can be seen pointing to the Scorpions twice, once from a distance and once from closer in, when the two are talking about the Scorpions. We were often changing some of the lines or shifting them for pacing and to make the scenes better. In the shooting script, the line "Still thinking about this chick?" is inside the Frosty Palace, but in the film Kenickie says it outside on the street. John's strut as he gathers his cool and enters Frosty Palace was another place where he was channeling Elvis.

TOP: Production designer Phil Jefferies's sketch for the Frosty Palace came vividly to life. • ABOVE: Hell's Chariot on the back lot of Paramount Studios

Ritchie Valens's 1958 hit "La Bamba" on the jukebox sets the rock-and-roll tone of the setting. While Danny can't stop staring at Sandy sitting with Tom (and wearing his letter jacket), the T-Birds have a rapid-fire discussion about "chicks"—another place where improvisation boosted scripted lines. During production, both on and off camera, I paid attention to any chemistry that was starting to develop, to see if I could work it into the script.

Lorenzo Lamas as Sandy's boyfriend, Tom Chisum, was perfect for the role. He didn't have any lines in the script but he made the most of every second he was on camera. His silence is a great contrast to the chattering of the other high schoolers.

At the jukebox, Sandy remains coolly distant while Danny tries to explain himself, leading up to Sandy's challenge "I'll believe that when I see it." Danny's reaction after her line is pure Travolta.

89 INT. FROSTY PALACE 89

FLOW with Danny and Kenickie as they enter the Frosty Palace where the igloo effect is carried out with the booths looking like chunks of ice and the brightly-hued juke box looking like the Northern Lights. The waitresses wear short fur-trimmed skirts with hoods and look like bouffant Eskimos. The place is crowded. The Pink Ladies are in one booth -- Putzie, Sonny and Doody in another -- miscellaneous students in another and, in the middle are Sandy and Tom. She is lost in his oversized football jacket, sees Danny out of the corner of her eye and gives Tom her undivided attention.

The boys greet each other like long-lost friends, but Danny can't take his eyes off Sandy and Tom. He collides with VI, the tough/tender waitress who's seen it all. Vi carries a loaded tray which almost dumps on the floor. They barely catch it, but Vi is a precision waitress who manages to hold the tray on one palm.

> DANNY
> Great save, Vi.
>
> VI
> I used to be with the Ice Follies, honey. It prepared me for life at the Frosty Palace.

She gives him a smile and he turns toward the booth.

> KENICKIE
> Are you still thinking about that chick?
>
> DANNY
> The only thing on my mind is Greased Lightning.

Danny and Kenickie slide into the already crowded booth.

Vi turns from serving a table and stands over the Pink Ladies' booth resting the tray on her hip.

> JAN
> How about an Aurora Borealis?
>
> MARTY
> What's that?
>
> VI
> The same as the Eskimo Surprise except it has colored sprinkles.

(CONTINUED)

Jeff Conway and John, best friends on and off the screen

CONTINUED:

53.

The JUKE BOX PLAYS an original 50's SONG -- "POOR LITTLE FOOL."

Danny looks toward Sandy and Tom.

 DOODY
 The fuzz had Thunder Road staked
 out last year and everybody got
 hauled to the clink.

 KENICKIE
 Nobody's gonna catch Greased
 Lightning. But nobody.

Rizzo walks out of the ladies' room and sees Danny looking at Sandy and Tom.

 RIZZO
 Somebody snaking you, Danny?

 DANNY
 Bite the wienie, Riz.

 RIZZO
 With relish.

Rizzo walks past and Danny slides into the booth.

 DANNY
 Chicks! Who needs 'em?

 KENICKIE
 Yeah. They ain't good for but
 one thing. And what are you
 supposed to do with 'em for the
 other twenty-three hours and
 forty-five minutes of the day.

 PUTZIE
 Is that all it takes? Fifteen
 minutes?

The others give him withering looks.

Danny's lips move silently, mouthing the words, "You Putz."

Danny cannot take his eyes off Sandy and Tom. Vi arrives with their order -- a single giant sundae with two spoons. This is too much for Danny who rises, looks around the room and spots Patty Simcox entering.

 (CONTINUED)

The Pepsi Promotion

Allan Carr was a genius at generating publicity. One of his many ideas for the movie was in its marketing. He made a deal with Pepsi-Cola to help promote the movie during the summer of '78. Unfortunately, he never mentioned this to the set decorator, who covered the Frosty Palace set with Coke paraphernalia.

Pepsi ticket giveaway

Allan went nuts when he saw on the dailies a big Coke poster right behind Olivia in the Frosty Palace. With our budget, reshooting the sequence was out of the question. The poster was painstakingly blurred frame by frame to mask the error, using primitive late-seventies technology. For the 2018 release and Blu-ray, I researched and found a fifties-era Pepsi sign to position behind Sandy and Tom. We were finally able to digitally fix the set decorator's blunder with twenty-first-century technology.

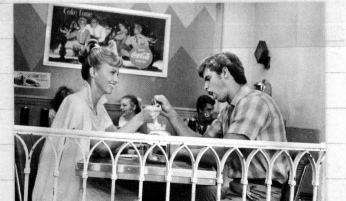

A photo from the set showing the original Coke poster

TOP: The poster blurred for the 1978 release

BOTTOM: The digital fix with the fifties-era Pepsi poster for the 2018 rerelease

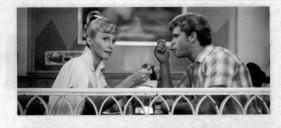

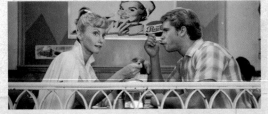

89 CONTINUED: (2) 89

Danny takes her arm and swirls her into an empty booth.
She is surprised and flattered. He gives her a false
smile and looks to see if Sandy is watching. She
rises and walks to the jukebox where she pauses and
stands looking over the selections.

90 OMITTED 90
& &
91 91

92 WIDER 92

Patty turns out to be a lot hotter than anyone has
given her credit for and she leans against Danny.

Danny rises and Patty almost falls out of the booth.

Danny walks by the jukebox as if he has not seen Sandy.
She is pointedly ignoring him. He unsuccessfully tries
to get her attention, then leans across the jukebox and
looks at her as if surprised she's there. During the
scene he lowers his voice and continually looks around
to see if they are being observed.

 DANNY
 Oh. Hi. How's it going?

 SANDY
 (coolly)
 Oh, wonderful. I just love
 Rydell. I've got so many new
 friends.

 DANNY
 Look, Sandy, I've been wanting
 to talk to you.

 SANDY
 About what?

 DANNY
 The way I acted. I mean that
 wasn't me. I mean it was and
 it wasn't. I've got this image
 to live up to.

 SANDY
 That's why I'm so glad Tom is
 such a simple person.

 (CONTINUED)

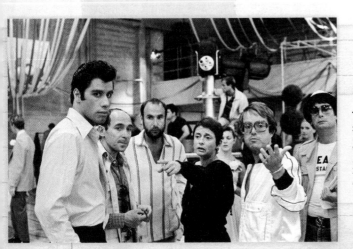

LEFT TO RIGHT: John,
costume designer Albert
Wolsky, casting director
Joel Thurm, choreographer
Pat Birch, and producer
Allan Carr

The Location

Unlike most of the other exteriors in
the movie, Frosty Palace wasn't shot
on location but on a street on a back
lot of Paramount. We populated the
street with period cars and signs—and
the Scorpions driving by to weave in
the rivalry between gangs and help
set up the climactic Thunder Road
race.

Using Stage 16 at Paramount for
the interiors meant that Bill Butler
didn't have to do extensive work to
prepare the location, such as blacking
in windows for a night effect or setting
up a generator and cables, as he had
to do in the Huntington Park High
School gymnasium for the dance
contest. Meanwhile, Phil Jefferies,
the production designer, added the
flavor of the era to the interiors with
all sorts of fifties-specific touches. He
had designed the set so that Frenchy
would see the Teen Angel "beyond
the soffits." "Beyond the what?" I
asked him. He explained that soffits
are an architectural touch near the
top of a wall. As Frankie appeared, he
wanted the ceiling to disappear.

One exception to the fifties-era
touches that sharp-eyed fans have
pointed out was the jukebox, which
appears to be a Wurlitzer 1050 from
1973 that copied the design of a
classic 1950s-era jukebox. It could
have been an oversight, but I doubt
it. Phil was tremendously talented,
having worked in *Butch Cassidy
and the Sundance Kid* and *The
Manchurian Candidate* (and gone on
to do *An Officer and a Gentleman*).
He always had a good reason for
anything he did; in this case, he might
have been channeling the seventies.

92 CONTINUED: 92

 DANNY
 Too bad all his brains are in
 his biceps.

 SANDY
 Jealous, are you?

 DANNY
 Don't make me laugh! Ha! Ha!
 Ha! Ha!

 SANDY
 What have you ever done?

 DANNY
 (a beat)
 I can run circles around those
 jerks.

 SANDY
 I'll believe that when I see it.

 She smiles over-sweetly, punches a button for a song
 and returns to her booth. Danny makes a motion to go
 after her, sees the others are watching him, does a
 cool-gathering motion turn towards the jukebox.

92A OMITTED

The Music

To find the right songs to play on the jukebox during this scene, we assembled a huge fifties wish list and then pared it down. "La Bamba" is heard in the background as Sandy and Danny studiously avoid each other. Later in the scene, I was able to add "It's Raining on Prom Night" from the stage production as Danny apologizes to Sandy.

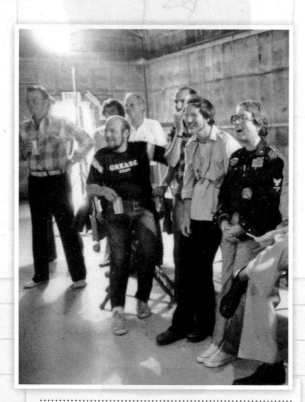

LEFT TO RIGHT: Production designer Phil Jefferies, screenwriter Bronte Woodard, casting director Joel Thurm, John's manager Bob LeMond, and producer Allan Carr

114

| COSTUME FOR | "Rizzo" | | PLAYED BY | Stockard Channing |
| PHONE NO. | | | | |

CHANGE	SCENE NOS.	SET	DESCRIPTION
#5	106	int Frosty palace shirt tucked into levis. levis cuffed to just below knee collar up	Blouse: kelly green cotton short sleeves cuffed pointed collar front buttons
			Trousers: dk blue denim levis - legs cuffed
		HAS KINICKIE'S JACKET AROUND SHOULDERS (black leather motorcycle style w, T Bird & emblem on back)	Shoes blue kid very low wedge - string bow center front
			Purse: black rounded envelope clutch

Danny as a Jock

In the shooting script, Danny was generally portrayed as being very bad at sports, or, in the case of basketball, being a bit too "dazzling" to be believable. As we rehearsed, I could tell this idea was not working. Casting director Joel Thurm suggested having Danny use his street smarts and tough-guy attitude to plow through the various sports.

Once we came up with the concept of Danny bringing his greaser vibe to sports, it was easy to work with Sid and John to come up with the bits and add a bit of comedy.

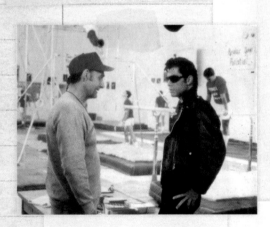

Sid Caesar as Coach Calhoun: "To begin with, you gotta change . . ."

INT. GYM

Danny, in his Thunderbird outfit, stands in front of Coach Calhoun who checks him from stem to stern.

The Coach is definitely underwhelmed, but gives an over-hearty smile. Danny has a cigarette hanging from his lips which the Coach casually flips away.

> COACH CALHOUN
> Let's start with the first rule, cutting down to two packs a day.

There is a pause. There is no expression on Danny's face to give the Coach any encouragement.

> COACH CALHOUN
> (continuing)
> What sports do you like?

> DANNY
> I'm kinda interested in cars.

> COACH CALHOUN
> In athletics, son, you are the car.

He looks around the gym. Gym equipment, including rings, is set up.

> COACH CALHOUN
> (continuing)
> Now -- how about the rings?

> DANNY
> Yeah. I installed a set of rings and valves a coupla weeks ago.

The Coach rolls his eyes.

> COACH CALHOUN
> To begin with, you gotta change.

> DANNY
> That's what I'm trying to do.

> COACH CALHOUN
> Your clothes!

58.

93A EXT. BASKETBALL COURT - DAY 93A

Danny and Coach Calhoun stand to the side watching four boys run through a pickup game of basketball. They play with high spirits and agility. Danny watches intently.

> COACH CALHOUN
> Dribbling is an art, son. It's like yo-yoing without a string. Think you can do it?

Danny watches a moment more then gives a single, abrupt-affirmative nod.

Coach Calhoun blows the whistle which is on a lanyard around his neck.

The game stops and the boys look at him.

> COACH CALHOUN
> (continuing)
> Trying out a new man... Hit it,
> son.

The boys look at Danny as if he is a new lamb to the slaughter. Feeling self-conscious but trying not to show it, Danny shuffles onto the court. There is a moment of silence as the boys regard him, then one of them throws the ball at him hard. Danny catches it, stands motionless for a moment, gives the ball a few dribbles as if getting used to the feel of it, then starts downcourt, getting faster and fancier as he goes. The others try to block him, but Danny is dazzling.

Coach Calhoun stands to the sidelines smiling.

Danny makes it down under the net. He shoots. Another boy jumps up and blocks it, but Danny gets the ball back and tries again. Again the block. Danny gets the ball again, does more fancy dribbling then lines himself up under the net when the boy jumps up again. This time Danny trips the boy. He crumples. Coach Calhoun blows his whistle.

> DANNY
> (innocently)
> What did I do?

> CUT TO:

93B INT. GYM 93B

Wrestling mats are down and several wrestlers are wrestling.

WRESTLING

93B CONTINUED: 93B

Danny, in wrestling pants, is in the beginning kneeling position with another WRESTLER. They begin. Danny's strong and agile though outweighed by his nefty opponent who finally clips him over and sprawls on top of him. Danny isn't pinned, but he can't budge the other's weight.

> WRESTLER
> Give?

> DANNY
> Yeah.

He manages to free his arm, draw back and punch the Wrestler in his face. The Wrestler looks at him in disbelief and closes his eyes and rolls off.

Coach Calhoun blows his whistle.

BASKETBALL

117

97 EXT. BASEBALL DIAMOND 97

 Coach Calhoun leads Danny -- in a baseball outfit --
 to the diamond.

 A player is at bat and an umpire stands behind him.

 The player hits a pop fly that is easily caught.

 COACH CALHOUN
 I think you'll like baseball.
 The contact is not as close.

 CUT TO:

98 DANNY 98

 stands behind the plate shouldering a bat and looking
 at the pitcher.

 CATCHER
 Come, babe! Come, boy!

 The pitcher winds up and throws.

 (CONTINUED)

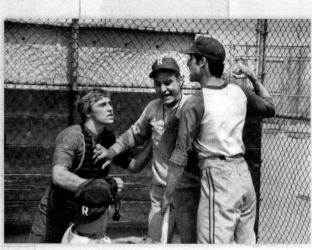

DANNY PULLS REF'S MASK

 98

 Danny swings and misses.

 UMPIRE
 Strike!

 Danny narrows his eyes at the UMPIRE.

 The pitcher winds up and throws again.

 Danny knocks the ball far into left field -- a stand-
 up double.

 Coach Calhoun beams.

 UMPIRE
 (continuing)
 Foul ball!

 Danny looks down at the Umpire with murder in his eyes.
 He pulls the Umpire's face guard away from his face,
 stretching the elastic band that holds it. Then, he
 lets it snap back in place.

99 COACH CALHOUN 99

 leads Danny away. In the b.g. the Umpire sits dazed
 on the ground.

 CUT TO:

101 EXT. FRONT OF THE GYM - DAY

Danny, in track shorts, stands with the Coach.

 COACH CALHOUN
 There are other things than
 contact sports.

 DANNY
 Such as?

Coach looks at him for a moment, the smiles.

 COACH CALHOUN
 Track.

 DANNY
 You mean running?

 (CONT

 COACH CALHOUN
 Not just running... long-distance
 running. Something that requires
 stamina, endurance...

 DANNY
 (incredulous)
 Me? A long-distance runner?

 COACH CALHOUN
 Other than yo-yoing, it's all
 that's left...

 DANNY
 (letting it
 sink in)
 A long-distance runner.

 CUT TO:

102 SERIES OF SHOTS 102

 of Danny running.

103 EXT. FROSTY PALACE 103

 The Thunderbirds and Pink Ladies are dancing when
 Danny jogs past. A SONG is HEARD from the JUKE BOX.
 He stops momentarily to look in, which is just enough
 time for them to see him. They run into the street
 hooting and yelling. "What are you doing in your
 underwear? Where do you keep your Wheaties!"

 CUT TO:

104 EXT. TRACK 104

 Danny is out on the track doing warm-up exercises.
 There are several other athletes on the field prac-
 tising for field events -- throwing the shotput,
 javelin and on the track the low hurdles are being
 set up.

 Tom Chisum is standing at the far end of the hurdles
 talking to Coach Calhoun and getting some pointers.

 Sandy stands to the side as Tom takes off and runs the
 low hurdles leaping them with style and speed.

 (CONTINUED)

We also needed a moment for Danny to be embarrassed and have Sandy come to the rescue. I thought about when I ran the 180-yard low hurdles in high school and how I often tripped and fell flat on my face. I adapted it into the story.

I'm second from the left, running hurdles at Radnor High in '64.

In the script, Danny falls and is knocked out, and Sandy wakes him up and helps him get back to his feet. We felt it would be stronger for Danny's character to jump back up and be in control, quick to put down Tom watching them from the bleachers. During preproduction, John wanted to get familiar with running hurdles. He had his stand-in, Peter Collister (production assistant and future cinematographer), drive him to Fairfax High School to practice. Because he wore a hat, no one recognized him on the track.

104 CONTINUED: 104

Danny stops his workout and looks from Tom to Sandy, tries to look away, but turns back as Tom completes his run and a Coach checks his stop watch and comes over to congratulate Tom as do several others.

Tom walks around the end of the track huffing and flexing, getting his breath and pawing the ground like a racehorse.

Danny hesitates, makes up his mind then strides toward the far end of the hurdles. He contemplates them for a moment, then backs away several yards.

Several athletes see that Danny is preparing to attempt the hurdles and gather toward the sidelines.

Danny begins to run.

He takes the hurdles in a fine stride, equalling Tom's run.

Just as the last hurdle is coming up his concentration breaks and he sees Tom and Sandy standing at the end of the run.

His eyes go wide as he and Sandy see each other just as he makes his final leap.

Danny's foot drags over the top of the final hurdle and the hurdle falls, spilling Danny ahead on the cinder track.

The Coaches rush toward him as he lies sprawled.

Danny sees the cleated shoes surrounding him and looks up at the faces above him.

 COACH CALHOUN
 You okay?

Danny painfully rises and shakes himself all over.

 DANNY
 I'm all right.

 COACH CALHOUN
 You were going good there.

 DANNY
 For a while.

He walks away, picks up his gear and heads toward the gym.

Sandy comes up beside him.

 SANDY
 Are you hurt?... Danny, talk
 to me! Are you all right?

He struggles up looking faraway.

 DANNY
 Sure.

Danny looks away.

 DANNY
 (continuing)
 Where am I?

 SANDY
 What's the matter?

He sits up. She grabs his arm.

 DANNY
 Who are you?

 SANDY
 It's me. Sandy.

She looks at him anxiously as he seems to fade.

Danny stops and looks at her as if he has never seen
her before.

 DANNY
 Sandy. You're very pretty.

He holds the faraway look and she begins to laugh, then
looks at him with concern.

 SANDY
 Oh, come on, Danny. Snap out
 of it.

 DANNY
 Do I know you?

 SANDY
 Stop kidding me... Danny!...
 Come on... Don't you remember
 anything?

Danny sits up and looks around.

 Sandy laughs and pushes him.

WALK AND TALK

 DANNY
 (continuing)
 Who are you going with?

 SANDY
 Well, Tom asked me.

 DANNY
 So, you're going with him.

 SANDY
 Well, that depends

 DANNY
 On what?

 SANDY
 On you!

Danny beams.

 DANNY
 He can stag it.

They join hands and walk off the field.

The Frosty Palace BY NIGHT

106 INT. FROSTY PALACE - NIGHT 106

The place is packed and the JUKE BOX PLAYS a 50'S SONG.
Several couples are dancing. Others sit in booths,
table hop or stand in groups talking. V1 and the other
waitresses move through the crowd with loaded trays. 65. X

 106

The Thunderbirds and Pink Ladies are scattered through
the crowd.

Sandy and Danny appear in the doorway. She smiles with
the pride of possession while Danny stands nervously,
his face lighting up from moment to moment as he has to
revert to his macho image to greet friends.

 DANNY
 Why don't we just go somewhere
 else?

 SANDY
 Danny.

Another couple is getting out of a booth. Danny grabs
Sandy's hand and yanks her across the room, barely
beating another couple to the booth. They sit down.

107 THE MAIN BOOTH 107

as Sandy and Danny slide in.

 SANDY
 You almost pulled my arm out of
 the socket.

 DANNY
 I didn't want us to miss the
 booth.

He gives her a disarming smile and she smiles back. He
reaches out, picks up several menus and stacks them
around the edge of the table.

 SANDY
 What are you doing?

 DANNY
 Just giving us a little privacy.
 That's all.

He leans low behind the menus and V1 appears above them.

 VI
 We're pushing the Artic Girl
 Special tonight. One of the
 freezers is on the blink. If
 it's mushy you get five cents
 off.

 (CONTINUED)

The Scene

Danny rushes Sandy to a table and stacks two menus to shield them from prying eyes. It's nighttime at the Frosty Palace and it's packed with people dancing to "Whole Lotta Shakin' Going On" performed by Sha Na Na. In a nod to her days at Warner Brothers, when she would play roles like a tough-talking waitress or a gun moll with a heart of gold, Joan Blondell takes Danny's and Sandy's orders.

Shooting the Thunder Road sequence
at the Los Angeles River, the day
before the Frosty Palace scene

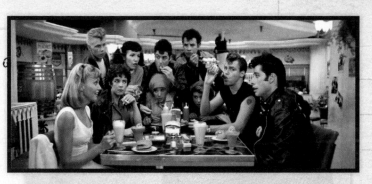

107 CONTINUED:

 SANDY
 I just want a cherry soda. You
 wanta share?

Danny looks at her in some exasperation. He tries to
give her a secret nod "no."

 DANNY
 Lemme have a Polar Burger with
 everything.

 SANDY
 Two straws with the soda.

 DANNY
 One!

Vi exits and Danny leans low behind the menu. Sandy
puts her head down to his level. Their chins are
practically on the table and they look at each other
with growing amusement.

 SANDY
 You really are funny, you know?

 DANNY
 (smiling)
 No, I'm not. You are.

They settle into giving each other tender looks when a
low, rumbling BELCH is HEARD and a menu is taken off
the table. They look up to see Kenickie and Rizzo.

 KENICKIE
 How's it going. Zuko?

For a moment Danny is about to lapse into his macho
strut of the bonfire scene.

 DANNY
 Yeah, man... it's cool... it's
 swinging... you know.

Sandy catches his eye and gives him a tough look.

Danny straightens up and looks back at Kenickie who is
wolfing down the last of a hamburger.

 RIZZO
 Well, well... Danny's back...
 and Sandy's scratching it.

 SANDY
 How are you, Rizzo?

 RIZZO
 Peachy keen, jellybean.

Kenickie grabs her arm and pulls her into the booth
beside him.

 KENICKIE
 You got a couple quarters? We
 could split an Eskimo Pie.

 RIZZO
 My Dutch treat days are over.

The Shot

The Frosty Palace scenes as a whole were
challenging to stage—and not just because of the
complicated blocking and cues. The day before, we
had shot the Thunder Road sequence at a section
of the Los Angeles River near downtown. I was
working barefooted, cut my foot, and it became
infected by bacteria in the water. On the day we
were scheduled to shoot the Frosty Palace scenes,
I had a fever of 102. I went to my dressing room
and couldn't even sit up on the couch. The whole
production came to a stop for an entire day.

 I sent production assistant Peter Collister out for
a vat of chicken soup. The medic was sent for, but
before she arrived, John Travolta entered to try a
cure called a "touch assist" based on Scientology
teachings. I was lying on the daybed and John sat
in a chair beside me. He pressed one finger on my
chest and said, "Feel my finger?" A bit confused, I
answered, "Yes." He then began moving his finger,
inch by inch, around my fevered body asking the
question over and over. I answered, over and over,
and I must say, in my dazed state, I wondered if this
odd ritual was really happening or if it was a dream.

 The next day, I had recovered and we went
back to the Frosty Palace set and picked up
shooting its scene. Was it the touch assist? Or the
antibiotics the medic gave me? For me, shooting
these scenes was a blur, as I was still not feeling
my best. I asked the actors to help. The way
Kenickie, Rizzo, and the rest of the gang talk over
each other, cutting in and finishing one another's
lines, was really the way the actors interacted in
real life. I always wanted the characters to have
a looseness to them—as if they were not just
repeating dialogue. A lot of their improvisations,
like Stockard's Rizzo affectionately messing up
Kenickie's carefully greased-back hair, made it
into the movie.

 KENICKIE
 You must plan on staying home a
 lot.

 RIZZO
 You ain't the only barracuda in
 these waters.

Sandy reaches across the table and takes Danny's hand
and begins fondling it. Danny enjoys this for a mo-
ment, then pulls another menu in front of them.

The newly placed menu is picked up by Sonny who leans
against the booth with Frenchy, Doody and Marty.

 SONNY
 Greetings, pals and gals... I
 got twenty-three cents. Let's
 chip in for a Dog-Sled Delite.

 MARTY
 I swear, I don't know where the
 money goes. A dime here.
 Fifteen cents there.

 DOODY
 Hey, Frenchy, another couple of
 months and you'll be taking us
 out. A working girl with income.

Frenchy is a bit removed from the general air of pande-
monium. She wears a scarf over her hair.

 FRENCHY
 Well, they don't pay you too
 much to start with.

 DOODY (CONTINUED)
 That's still more than we make.
 Ante up. I don't get my allowance
 till Friday.

 KENICKIE
 You still get an allowance?

 DOODY
 When I'm a good boy I do.

 SONNY
 Hey, Vi, a Dog-Sled Delite with
 four spoons.

 KENICKIE
 And an Eskimo Pie, with a knife.

Putzie and Jan come up.

 JAN
 Hi, gang!

 PUTZIE
 Let me have an order of fries.
 What do you want?

 JAN
 Ice water. Otherwise you're
 gonna have to roll me home with
 a stick.

Jan and Putzie pull up a nearby table.

Vi leans across the table with Sandy's soda and Danny's
polar burger. All eyes follow the food. Kenickie
snaps the burger off the plate and takes a bit of it.
Danny reaches across the table and snatches it back
after rubbing it across Kenickie's mouth.

124

Kenickie has food all over his mouth. He turns to Rizzo
and makes a face.

 RIZZO
 You pig.

 KENICKIE
 Oh, I love it when you talk dirty.
 ... What's with you tonight?

 RIZZO
 I dunno. I guess I'm growin'
 up faster than you are.

 KENICKIE
 There's only one thing you're
 faster at than me, baby.

 RIZZO
 There are some times, Kenick,
 when speed ain't what it's all
 about.

 KENICKIE
 Huh?

Sandy puts the second straw in her soda and extends it
to Danny who looks up to see if he is being watched,
then quickly takes a surreptitious sip, then just as
quickly sits back up as though he would never do such
a thing.

 SANDY
 My folks want to invite you over
 for afternoon tea, this weekend.
 You want to come?

 DANNY
 Naw, I don't like tea.

 SANDY
 You don't have to drink tea.

 DANNY
 (aware of the others
 listening)
 I don't get along with parents
 either.

Vi re-appears at the table with a loaded tray.

 VI
 Grab it and growl.

Food is lifted off the tray and passed along.

108 PUTZIE AND JAN 108

They are both drinking water.

 PUTZIE
 You sure are a cheap date. Uh...
 that didn't come out the way I
 meant it.

 (CONTINUED)

 JAN
 Oh, I understand.

 PUTZIE
 I always thought you were a very
 understanding person... You sure
 you don't want anything to eat?

 JAN
 Positive. I'm tired of being
 the only girl at Rydell with
 form-fit crinolines.

 PUTZIE
 Some fat girls are nothing but
 plain old fat, but you're more
 than that... you know?

 Jan doesn't know how to take this, but sees it's well
 intended.

 JAN
 Thanks, and I don't think you're
 as weird as everybody says.

 PUTZIE
 You got a date for the dance-off?

 Jan shakes her head "no."

 PUTZIE
 (continuing)
 Want to go?

 She nods. They beam.

For the shoot, Stockard had practiced tossing her strawberry milk shake at Jeff, using an empty glass. The idea was that some of it would get on Frenchy, providing her for the motivation to take off her scarf and reveal her bright pink hair. But once we filled that glass with the strawberry shake, Stockard's aim unfortunately hit Jeff smack in the face each time, with nothing on Frenchy. Take after take, he'd get cleaned up and into a new costume, only to do it again until we finally got it right. Maybe Stockard was getting back at Jeff for giving her a real-life hickey for the scene.

109 BACK AT THE MAIN BOOTH 109

 DOODY
 Vocational Guidance Day is coming
 up... I don't even know what I
 wanta be when I grow up.

 MARTY
 If you grow up.

 DOODY
 Maybe a senior forever.

 MARTY
 I'm gonna be a senior forever if
 I don't pass that chemistry
 quiz tomorrow.

 She nudges Sonny who slides out of the booth.

 SONNY
 (putting his arm
 around her)
 You're in luck, luscious, you
 got an armed escort home.

 MARTY
 It's not the arms I'm worried
 about, Tiger, it's the hands.

 SONNY
 Aw, Marty.

 DOODY
 (rising)
 Coming, Frenchy?

JAN & PUTZIE

 FRENCHY
 I think I'll hang around a
 while longer.

They exit as Frenchy stares into space. In the b.g.
people are clearing out.

110 PUTZIE AND JAN'S TABLE 110

 JAN
 (rising)
 I've been dieting for six hours.
 I've just gotta go home and have
 some apple pie. You wanta piece?

 PUTZIE
 (not sure)
 Sure... You bet.

They exit.

 SONNY
 Hey, Putzie... Fifteen minutes.

111 OMITTED 111

112 BACK AT THE MAIN BOOTH 112

 SANDY
 You know, Danny, I'm kind of
 worried about this dance contest.
 (MORE)

 SANDY (CONT'D)
 American dances are different
 from the way we dance at home.

 RIZZO
 Don't worry about it. Maybe
 we'll make up the kangaroo hop.

Danny looks at Rizzo for a beat and then slides out
of the booth.

 DANNY
 Come on, Sandy, let's get outta
 here.

 SANDY
 Bye, Frenchy.

 FRENCHY
 So long.

Kenickie is glaring at Rizzo.

 KENICKIE
 Hey, Riz, what is it?

 RIZZO
 I've got so many hickeys people
 think I'm a leper.

 KENICKIE
 A hickey from me is like a
 Hallmark card... when you care
 enough to send the very best.

Rizzo seethes, picks up his milkshake, turns it upside
down on his head. A lot of the pink goo splashes onto
Frenchy.

A Deleted Scene

When studio head Michael Eisner watched our rough cut he liked it, but after the screening he requested that we explain what Rizzo and Kenickie were fighting about in the Frosty Palace. But when we screened the whole film again, the new, added scene stood out like a sore thumb. The seriousness of it was so out of tune with the rest of the movie that Allan Carr called it "the Martin Scorsese scene." It had to go. The studio execs agreed and out it went. We looked for this scene in the Paramount vaults to add to the Blu-ray edition, but when it ended up on the cutting room floor in 1977, the studio janitor no doubt swept it into the dumpster.

RANDAL: Stockard, do you remember when [studio head] Michael Eisner requested we shoot a scene outside the Frosty Palace to explain why you threw the milk shake into Kenickie's face?

STOCKARD: No!

RANDAL: He asked, "Why does she do that?" We told him, "Well, we don't know." So he said, "Please write a scene and shoot it." And we did, but it was cut out. You don't remember it either, huh?

STOCKARD: I don't remember it at all!

RANDAL: That's funny . . .

STOCKARD: Nobody ever seemed to question why I threw the milk shake.

RANDAL: No, only Michael Eisner. So, we're okay.

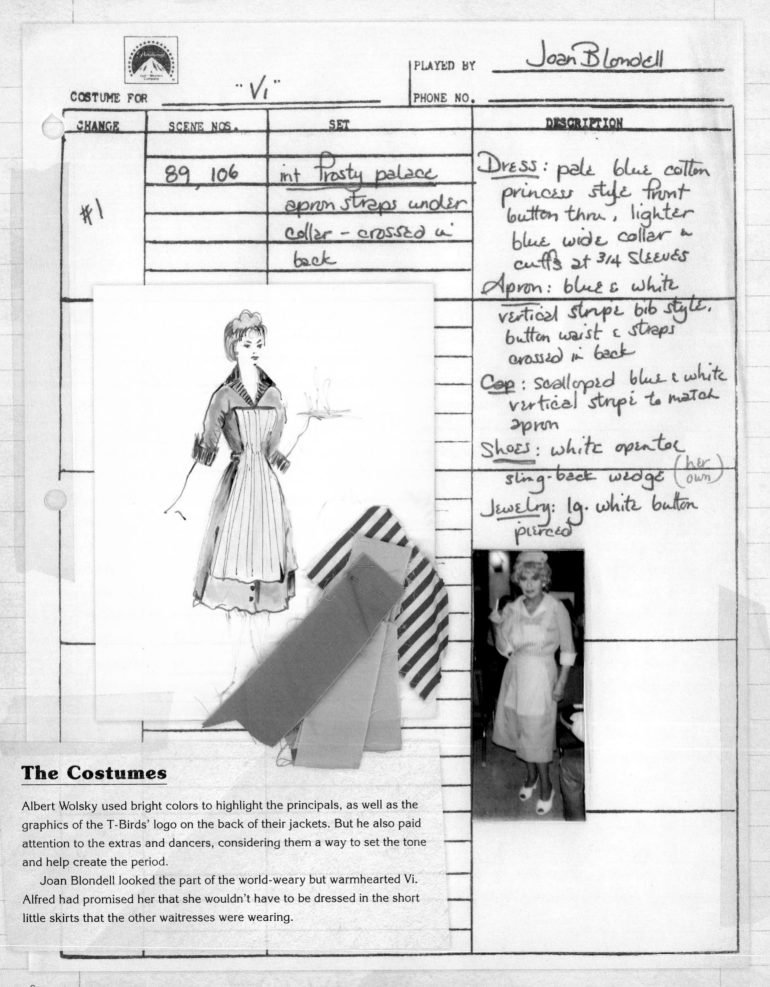

| COSTUME FOR | "Vi" | | PLAYED BY | Joan Blondell |
| | | | PHONE NO. | |

CHANGE	SCENE NOS.	SET	DESCRIPTION
#1	89, 106	int Frosty palace apron straps under collar — crossed in back	**Dress**: pale blue cotton princess style front button thru, lighter blue wide collar & cuffs at 3/4 sleeves **Apron**: blue & white vertical stripe bib style, button waist & straps crossed in back **Cap**: scalloped blue & white vertical stripe to match apron **Shoes**: white open toe sling-back wedge (her own) **Jewelry**: lg. white button pierced

The Costumes

Albert Wolsky used bright colors to highlight the principals, as well as the graphics of the T-Birds' logo on the back of their jackets. But he also paid attention to the extras and dancers, considering them a way to set the tone and help create the period.

Joan Blondell looked the part of the world-weary but warmhearted Vi. Alfred had promised her that she wouldn't have to be dressed in the short little skirts that the other waitresses were wearing.

```
                    RIZZO
                  (rising)
      To you from me, Pinky Lee.
                  (as she starts out)
      Sorry, Frenchy.

Kenickie is stunned.  With pink shake all over him.

                    KENICKIE
      Rizzo!!

He rises and exits after her.

Vi walks over with a rag and begins to clean up the
mess.

                                        (CONTINUED)
```

Frenchy and Vi

Frenchy responds to Vi's "heart of gold" by confiding that she dropped out of beauty school. Didi wanted to show Frenchy's humiliation over her ridiculous pink hair—this was way before wildly colored hair became stylish. By the time she confides in Vi and wishes for a guardian angel, the audience is feeling for her. Frenchy mentions Debbie Reynolds in *Tammy*, a reference that baby boomers would catch. Debbie Reynolds's role of Tammy in this movie was rooted in the idea that a simple girl facing a dilemma can, through determination, find a happy ending.

Most viewers notice the obvious light switch snafu as Frenchy and Vi walk down the steps into the kitchen of the diner. Vi tries to hit the switch with her elbow and misses it by six inches, but the lights go off anyway. This has been pointed out by dozens of internet posts. My excuse is I was still recovering from my bout with fever that day.

```
                    VI
      No use crying over a spilt
      milkshake.

She looks at Frenchy who looks really blue.

                    FRENCHY
                  (taking off her
                    scarf)
      Oh, I'll be all right.

                    VI
      Wow!

                    FRENCHY
      What?

                    VI
      If you don't mind me saying so
      your hair looks like an Easter
      egg.

                    FRENCHY
      Oh... I ran into a little trouble
      in tinting class... In fact, I
      ran into trouble in all my classes.
      Beauty school sure isn't what I
      thought it would be.

                    VI
      Nothing ever is.

                    FRENCHY
      Well, I dropped out... What do
      you think of waitressing?

                    VI
      You're too young to know.

                    FRENCHY
      Maybe I could be a telephone
      operator, but I wouldn't want
      to wear those little things over
      my ears... Boy, it would be so
      neat if I had a guardian angel
      to tell me what to do just like
      Debbie Reynolds did in Tammy.

                    VI
      If you find one, give him my
      phone number.

                                        (CONTINUED)
```

"Beauty School Dropout"

112 CONTINUED: (2) 112

She pushes through the swinging door into the kitchen.

Frenchy sighs and looks up toward the skylight.

SPOOKY ANGELIC GUITAR CHORDS are HEARD.

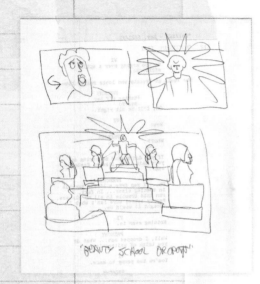

'BEAUTY SCHOOL DROPOUT'

 TEEN ANGEL (O.S.)
 (singing)
 Your story's sad to tell.

Frenchy looks around stunned, takes a few steps then
looks up amazed toward the skylight as the TEEN ANGEL,
a Donny Osmond-like rock singer in a gem-encrusted
jumpsuit, lands on the top of the juke box.

This is the FANTASY SEQUENCE. After the first verse,
the set becomes a white limbo with a staircase on
which stands a celestial choir of Angelettes in plastic
smocks and torpedo rollers. Set pieces are abstracts
of beauty salons. They sing BEAUTY SCHOOL DROPOUT
(from the Broadway show).

 TEEN ANGEL
 (continuing;
 singing)
 A teen-age ne'er-do-well
 Most mixed-up non-delinquent on
 the block
 Your future's so unclear now
 What's left of your career now?
 Can't even get a trade-in on
 your smock.

 Beauty School dropout
 No graduation day for you
 Beauty School dropout
 Missed your midterms and flunked
 shampoo

 Well, at least you could have
 taken time
 To wash and clean your clothes up
 After spending all that dough to
 have
 The doctor fix your nose up
 Baby, get movin'
 Why keep the feeble hopes alive?
 What are you provin'?
 You got the dream but not the
 drive
 (MORE)

 (CONTINUED)

A genuine teen idol: Frankie Avalon
as the Teen Angel

130

"BEAUTY SCHOOL DROPOUT"

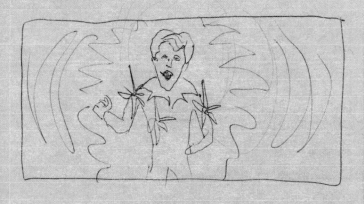

"BEAUTY SCHOOL DROPOUT"

— OR —

Ron Hays - 656-5413

My initial idea for this number was to have Frenchy look into the jukebox and see the Teen Angel appear there, singing on a record. He would then become life-size. We ended up dropping the jukebox intro and had him appear as if out of the ceiling—our version of heaven.

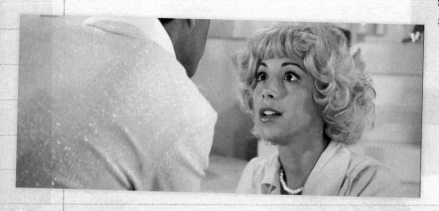

DIDI CONN: Randal, it wasn't three months after *Grease* that punk came in, and you saw blue hair, green hair, rainbow hair.

RANDAL: Maybe you started a trend.

DIDI: The day of the "Beauty School Dropout" shoot, it was lunch and I was all dressed up and I snuck off the lot, which you're not supposed to do in costume and wig and the whole business. I drove to see my drama coach, Mr. Pardo. He lived in an apartment in Beverly Hills, and boy, driving there with my pink hair, did I get some looks. When he opened the door, he almost fell over backwards. When he caught his breath, he said to me, "Don't do anything. Don't act on top of this. Just say your words. Because you look so goofy that anything on top of this would be over the top."

131

The Song

Since 1959, Frankie Avalon's best-known hit was "Venus," but after he performed "Beauty School Dropout" it has become his most requested song. Part of the original stage production, "Beauty School Dropout" was a parody of the rock-and-roll songs of the fifties. It also poked fun at someone who couldn't even succeed in beauty school. Didi did a lot of research for the part, including going to beauty schools in the Los Angeles area to find out what their students actually studied. She learned there was a lot more science and psychology than she thought— beauty school isn't a cakewalk at all. I loved Didi's earnestness and her crestfallen reactions to being called "most messed-up nondelinquent on the block," and a "slob."

Shooting "Beauty School Dropout" felt doubly surreal, because as a USC film school student, I appeared as an extra behind Frankie Avalon and Annette Funicello in one of the low-budget *Beach Party* spinoffs. And ten years later, here I was directing him on a huge set on a soundstage at Paramount Studios.

Production designer Phil Jefferies's original sketch for "Beauty School Dropout"

The dramatic entrance of the Teen Angel

" - Rev. 6/21/77

UED: (3)

 TEEN ANGEL (CONT'D)
If you go for your diploma you
 could join a steno pool
Turn in your teasing comb and go
 back to high school.

Beauty School dropout
Hangin' around the corner store
Beauty School dropout
If is about time you knew the
 score.

Well, they couldn't teach you
 anything
You think you're such a looker
But no customer would go to you
Unless she was a hooker.

Baby, don't sweat it
You're not cut out to hold a job
Better forget it
Who wants their hair done by a
 slob?
Now your bangs are curled, your
. lashes twirled,
But still the world is cruel
Wipe off that Angel Face and go
 back to high school.

RECEIVED

JUN 23 1977

Sandy Livingston

WIPE ON GUYS

The Scene

Frenchy dreams up a father figure to help her decide whether to drop out of school. The Teen Angel's message is clear: "Go back to high school."

The harp music, flickering light, and zany staging were both an homage to and parody of Busby Berkeley spectacles. The Teen Angel appears at the top of a white deco staircase, surrounded by Pat Birch's dancers and the other Pink Ladies sitting in beautician chairs, wearing silver smocks and pyramids of silver curlers. Their movements are not perfectly synchronized, which Pat did to avoid a slick look.

The Teen Angel strides down the steps (his confidence belying Frankie Avalon's actual nervousness about the height of the staircase). With the dancers draping themselves over the white banquette, Rizzo and Marty are front and center as a part of the ensemble, both with snarky expressions.

Didi reminded me that I asked her to blow a big bubble, and she had to chew an entire pack of bubble gum to achieve it. After popping that bubble, a metaphor for the song, the Teen Angel ascends to the "big malt shop in the sky," the ultimate in cool. And then the ultimate in kitsch appears: three T-Birds fly over the ensemble as an angelic finale. Throughout it all, you can see by Didi's expression she was genuinely in awe of Frankie Avalon's looks and charm. She's always said that this was her favorite scene in the movie, and who can blame her? She had two whole days on set with none other than her real teen idol.

The Choreography

The guiding principle behind the choreography for "Beauty School Dropout" was telling the story of Frenchy getting carried away by her vision of a guardian angel. In this dream sequence, synchronizing the dancers and the cumbersome beautician's chairs was a bit of a nightmare, but we weren't going for perfection. (Each chair was actually swiveled by a crew member hidden below.) Pat Birch managed to stage the other Pink Ladies in among the dancers. Dinah Manoff admitted that she was not a dancer, but we put her in this number. I find it endearing that if you watch her face closely, you can see her counting the beats in her head. I asked her about this and she admitted with a laugh that's what was going on. I had always believed that negotiating the steep steps in high heels had been the major challenge for all the dancers, but when I asked Pat about this she said dismissively, "Oh, the heels weren't that high."

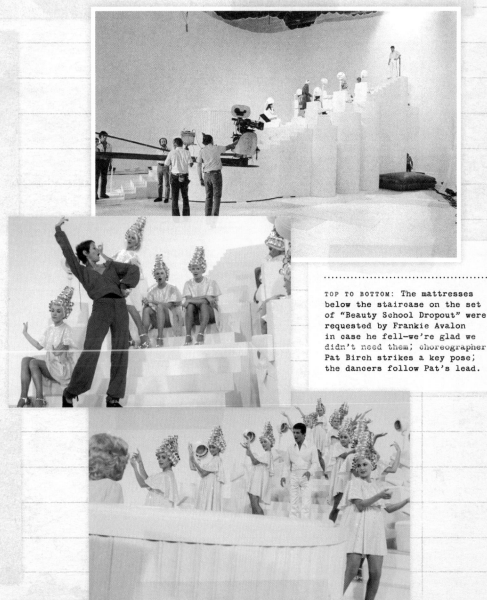

TOP TO BOTTOM: The mattresses below the staircase on the set of "Beauty School Dropout" were requested by Frankie Avalon in case he fell—we're glad we didn't need them; choreographer Pat Birch strikes a key pose; the dancers follow Pat's lead.

The Shot

Frankie Avalon turned down the part of the Teen Angel at first. He had seen a stage version of *Grease* and didn't want to fly in on a rope and have Elvis-style sideburns. He considered himself a singer now, his teen-idol days in the past, and didn't want to be the butt of a joke. When I met with him to talk him into the part, I assured him we would treat him with respect and he wouldn't look uncool. But then when he showed up on the set, he was again hesitant to shoot the number. The set had a narrow staircase with a thirty-foot drop to the concrete soundstage floor—and no railings. Our assistant director, Jerry Grandey, quickly ordered up some mattresses from the prop guys to put on the floor in case Frankie fell.

The number begins with one of the first digital effects to appear in a feature film: the Teen Angel with a glowing halo around him. During the shoot, I met multimedia artist Ron Hays at a party in West Hollywood. He had worked on *Demon Seed* starring Julie Christie and had done some experimental digital effects to show the inner workings of a computer. I asked him to create a cool introduction for the Teen Angel. He created the rays-of-light effect and we filmed it off a black-and-white monitor. In postproduction, our editor John Burnett added color and superimposed it over Frankie's entrance.

Bill Butler was also keen to create the magic of an Old Hollywood film musical. As in the "Greased Lightnin'" sequence, we used a seamless white backdrop to give the number a dreamlike feel. His biggest challenge was filming a vertical set with the horizontal Panavision camera. Phil Jefferies relished working this number because he got the opportunity to go "completely bizarre," as he said. Everyone got into the swing of creating the illusion. The boys were very excited about flying in at the end of the song like Peter Pan until they found themselves hanging above the soundstage for half the day with the harnesses digging into their legs and cutting off their circulation. (Today this would definitely be done digitally.) Michael's ropes got caught in one of the beams overhead, and he had to wait for us to get a ladder that was tall enough to reach the beam to be rescued. As the boys were dangling uncomfortably for hours they looked down and saw looking back up at them two random visitors Allan Carr had brought to the set: spoon-bending magician Uri Gellar and Russian ballet star Rudolf Nureyev.

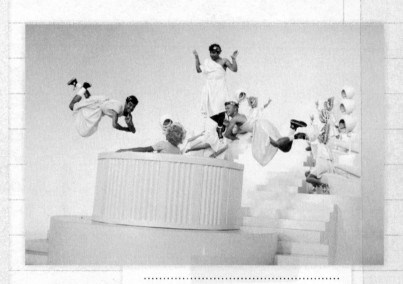

Didi Conn working the slate

The T-Birds ended up hanging on these wires for hours. Today this would be handled by computer graphics

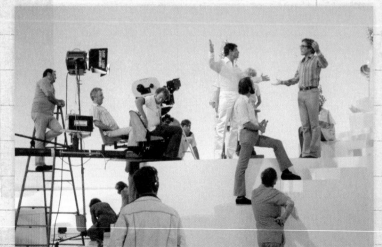

A surreal moment directing Frankie Avalon after being an extra in one of his earlier films

Form R24 [C logo]

COSTUME FOR _____ DANCERS _____

PLAYED BY _____

PHONE NO. _____

CHANGE	SCENE NOS.	SET	DESCRIPTION
	112	FANTASY "Beauty School Dropout"	(ALL 10 GIRLS IDENTICAL TO STILLS)

Dress: silver lamé empire miniskirts, sleeveless, vertical rows of silver sequins

Cape: dress fabric covered w/ cellophane woven w/ mother of pearl sequin edging at neck & bottom edge

Shoes: silver sandals 4" lucite heel white soles

Headpiece: silver rollers pyramid shape built on silver lamé turbans

(Dress worn over white leotard)

The Costumes

Everyday items from a beauty school: hair curlers and the smocks people wear as they sit in the chairs getting their beauty treatment. Albert Wolsky transformed them into weirdly wonderful costumes that people re-create and wear at *Grease* screenings around the world. Real hair curlers Albert calls "hideous," so he sketched up some ideas that softened their lines, stacking them up in silver pyramids.

The smocks he made oddly fashionable, glitzy haute couture. In the midst of this surreal fantasy number, Frankie Avalon's Teen Angel is dressed in radiant white. I'd promised Frankie that he would look cool, and Albert came through. "Costumes have to become a part of the actors," he told me. The girls in "Beauty School Dropout" certainly look at ease in these bizarre contraptions.

Buildup to the *National Bandstand* Dance Contest

The Shot

To the quick montage of scenes building up to the big moment of the dance contest, we added in a shot of the boys fixing up Greased Lightnin' to keep the momentum of that storyline going. Rizzo and Kenickie have yet another spat, with Kenickie angrily vowing he'll have the "hottest date at the dance" as Rizzo attracts the eye of Leo from the Scorpions. The "Rudy from the Capri Lounge" line was improvised on one of the takes and seemed suitably seedy, so we kept that in.

Jeff, John, and I had worked on the character of Kenickie right before shooting began. He had based his characterization on his uncle and a friend who had actually once punched him in the mouth.

Rizzo and Marty climbing into Leo's car is another place where we could showcase Albert Wolsky's flair for fashion. The girls' figure-hugging pencil skirts and high-waisted belts are gorgeous and of the era.

TV DIRECTOR'S TRUCK

WCAU TV

112A EXT. STREET - DAY 112A

A car is parked in front of a meter. Sonny approaches, looks around, rips off the rear-view mirror and runs.

112B INT. SHOP - DAY 112B

Putzie, Sonny and Kenickie are working on the further developed Greased Lightning.

113 EXT. GYM - DAY 113

A camera crew is unloading equipment in front of the gym. Students are clustered around excitedly. X

The Thunderbirds and Pink Ladies stand to the side.

Kenickie walks around the side of the TV truck and comes face to face with Rizzo. They both immediately look the other way.

Danny walks up to Kenickie.

 DANNY
 Are you two still broken up?

 KENICKIE
 I lost track.

 DANNY
 I got to go home and change X
 clothes for the dance. X

 KENICKIE
 I'm gonna have the hottest date X
 there.

He chuckles mysteriously and walks away.

Rizzo and Marty head up the driveway toward the street.

 MARTY
 The biggest thing that ever
 happened to Rydell High and we
 don't even have dates.

 RIZZO
 How about ~~Howdy Doody and the~~ *Rudy from the*
 ~~Putz?~~ *Capri Lounge.*

 MARTY
 Get serious.

At this moment they reach the street and Hell's Chariot goes roaring by with Leo at the wheel.

Rizzo catches Leo's eye and gives a flamboyant stretch.

There is the SCREECH of BRAKES and HORNS BLOWING.

Marty looks at Rizzo in amazement.

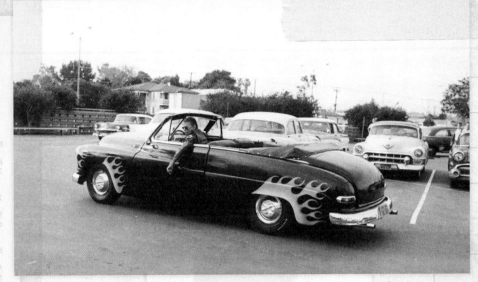

Craterface and his wheels

 RIZZO
 Looks like the luck is changing.

 MARTY
 (shocked)
 Do you know what you're doing?

 RIZZO
 What we're doing!

 She grabs Marty's arm and leads her toward the car,
 smiling brightly as she goes.

Hell's Chariot

Everyone loved this car, especially Dennis Stewart, who got to terrorize the town in it as Leo, leader of the Scorpions, and picked up Rizzo and Marty in this scene. Nicknamed "Hell's Chariot," this 1949 Mercury Series 9CM convertible had been built and customized by Eddie Paul. Just as Danny and Kenickie get their signature convertible, we wanted the Scorpions' leader to have a set of wheels that matched his snarling face. Black, with painted flames pouring from the headlights and wheel wells, Hell's Chariot also belched fire in every scene, a neat trick that made it the envy of every kid who dreamed of building a hot rod. A stunt version was used for the Thunder Road race, with signature serrated blades that stuck out from the hubcaps during the race (a reference to the blades on the chariot wheels in *Ben-Hur*). Hell's Chariot does some damage to Greased Lightnin', ripping a gash in its side and denting the back bumper, but Leo ultimately loses to the better driver, Danny. The boys bet "pink slips," or ownership papers, on the race. In the shooting script, after the race, Mrs. Murdock becomes the lucky owner of the losing car, Hell's Chariot. We ended up not shooting that moment, because we wanted to stick to Danny and Sandy's story.

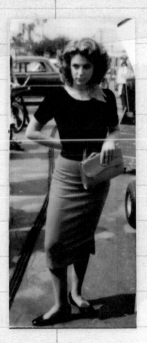

DINAH: That wardrobe was brilliant. My body was made for that decade, I've got to say. Albert [Wolsky] stitched me into those white little chinos at the carnival like he did with Olivia's black greaser pants.

RANDAL: Over the years, have you been recognized from *Grease*?

DINAH: People recognize my voice.

RANDAL: Didi said that too.

DINAH: I started teaching acting at a women's prison, and every time I start a new session, I bring in Didi's *Grease Scrapbook*. I say, "This is me. I was in this movie." I do it to intimidate them.

RANDAL: So they think that you know what you're talking about.

DINAH: It's like, "Okay. I'm the real deal, so sit down and learn."

The Dance Contest

The Script

The shooting script describes an extensive overview to the sequence but instead we wanted to quickly establish the scene and then focus on the main characters as they entered. Throughout shooting the sequence, the cast and crew members were constantly coming up with bits of business and dialogue to add—some of it made it into the shooting script and others appeared on the day during the takes.

 Doody and Frenchy didn't have lines when they entered the gym but Barry ad-libbed his comparison of Frenchy to "a beautiful blond pineapple." Michael Tucci, playing Sonny, came up with the idea of pouring a flask into the punch bowl in front of the teachers. When asked, "What are you doing?" he ad-libbed, "Washing my hands."

 Allan Carr was always thinking up new publicity stunts. He had flown in press from all over the country and wanted me to find a place to put them in the movie. They became the teachers hanging around the punch bowl near Sonny.

114 INT. GYM 114

The gym is a pandemonium of setting up. Patty and Eugene oversee an overworked group who are stuffing Kleenex into a giant chicken wire replica of the Rydell Ranger. A banner reading "Rydell High School Welcomes National Bandstand" is being raised by the students. Some students are primping in mirrors that line the inside of the gym. Teachers are subtly also primping. Other students enter and join the others. There are technicians setting up lights and television cameras. Chaperones are scattered around the periphery of the room, setting up refreshment tables, making sandwiches and setting up punch bowls. JOHNNY CASINO AND THE GAMBLERS are tuning up.

Through all this runs MR. RUDIE, the Stage Manager for the program. He is a bundle of nervous energy and he makes those around him twice as nervous as he is. Mr. Rudie stops at the bottom of the Ranger. Eugene is supervising a group of straight students as they stuff the Kleenex into the chicken wire. Patty is practicing a routine with some of her cheerleaders. Mr. Rudie stops at the bottom of the Ranger.

 MR. RUDIE
 What is this?

 EUGENE
 We're working up a routine to
 open the show.

 MR. RUDIE
 How amusing!

Mr. Rudie looks harried and moves off.

114A ANOTHER ANGLE 114A

Frenchy and Doody enter with Sonny. He has a hidden bottle in his pocket and no date. Throughout the sequence he will be on the make.

114B ANOTHER ANGLE 114B

Mrs. McGee's secretary Blanche reprimands a student for smoking. Meanwhile, Mr. Murdock spots Mr. Rudie and finds him interesting. The students do not smoke openly but try to camouflage it.

Nurse Wilkins enters in uniform and carries her old Red Cross Emergency Kit. Two students follow her with a coat.

 (CONTINUED)

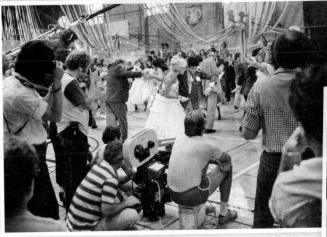

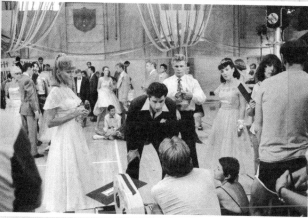

"GREASE" - Rev. 6/21/77

114B CONTINUED:

> ~~MR. RUDIE~~
> ~~And what do you think you're~~
> ~~doing?~~
>
> ~~NURSE WILKINS~~
> ~~I used to be a marathon dancer.~~
> ~~These things can get vicious.~~
> ~~Set it up over there, boys.~~

She exits.

115 OMITTED

116 DANNY AND SANDY

They enter looking excited.

> SANDY
> (overwhelmed)
> I can't believe it.

> DANNY
> Stick with me, kid. Nothing
> but the big time.

> SANDY
> But, Danny, I don't know these
> dances well enough.

> DANNY
> Sure you do.

> SANDY
> All I've had time to learn at
> Rydell are cheerleader routines.

> DANNY
> Sandy, you can do it.

> SANDY
> I'll make a fool of myself...
> on national T.V.!

> DANNY
> When you're with Danny Zuko,
> you're the best. That's all
> there is to it.

They continue into the throng as other students enter.

As Danny and Sandy enter, the shooting script shows him being a bit cocky. To keep him a little more relatable and speed up the pace, we cut some lines and gave him an "in with the cameraman." Meanwhile, we'd all come to know Susan Buckner's prissy Patty Simcox character well; we knew she would get angry when something goes wrong at "her" dance, so we worked in her horrified reaction when the giant Ranger float gets destroyed. When we rehearsed the scene where Cha Cha says, "I'm the best dancer at St. Bernadette's," casting director Joel Thurm came over to me and whispered, "With the worst reputation." I gave the line to Didi and Cha Cha shot daggers at her.

RANDAL: Olivia, I love the moment when you and John emerge from the crowd dancing. That's one of my favorite moments in the film. The way the music comes together and you and John enter—it was magic. What was going through your mind? Were you just thinking, "This is cool"?

OLIVIA: I think I was in character, so I was upset because he was dancing with the other girl!

RANDAL: That's very clear.

OLIVIA: Dancing wasn't my forte. I was probably just a little bit nervous.

RANDAL: You'd never know it.

OLIVIA: I wasn't really a dancer—but I started out with John Travolta and went to Gene Kelly in Xanadu.

RANDAL: Not bad!

The Scene

From "Hound Dog" to "Born to Hand Jive," the gymnasium of Huntington Park High School rocked and rolled. Shooting during brutally hot summer days, we wanted the dance contest to burst with energy. It would showcase the dance crazes of the 1950s, the patter of Edd Byrnes as host Vince Fontaine, and Sha Na Na as Johnny Casino and the Gamblers.

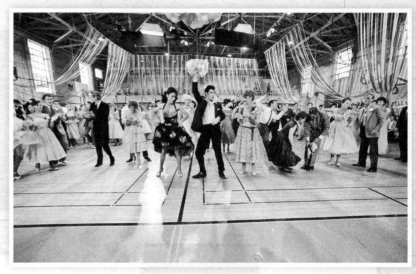

A parade of main characters enters, from Sonny nursing his booze and Leo sauntering in, his arms around Marty and Rizzo, to Doody admiring Frenchy's "beautiful blond pineapple" look. "He's the living end," croons Marty, introducing us to Vince Fontaine, whom the audience first heard on the radio over the animated title sequence. Edd had been one of the very first teen idols of the first TV generation, playing Kookie in *77 Sunset Strip* so he found the right comedic balance of sleaze and sex appeal in Vince. Danny and Sandy appear—she is hopeful and innocent in her pure white dress while Danny is cool in his tailored jacket that has more of a touch of seventies style. When Mr. Rudie introduces Johnny Casino and the Gamblers, the intensity of the dance kicks in as the camera swoops above the dancing crowd on a crane.

Dramatic action like the jealous rivalry between Kenickie and Leo punctuate the dance shots and help ratchet up the tension before the big car race later in the movie. Teachers get to have fun too, with Blanche dancing with Tom (again holding his own despite not having speaking lines), and Principal McGee and Coach Calhoun getting upstaged by Vince Fontaine's rhyming patter. Moments were designed for each character, like Patty's boisterous dance, Eugene's awkward acceptance of the cheers and jeers of his classmates, and the fight between Leo and Kenickie.

"GREASE" - Rev. 6/21/77 78. X

OMITTED 117

A RIZZO, MARTY AND LEO . 117A

They enter. Leo has his arms around them in a proprie-
tary fashion. The other boys look hostile as though
their women have deserted them.

Sonny approaches.

 SONNY
 Say, hey, Marty, you're looking
 good.

He puts his arms around her, but she deftly disengages
herself. Rizzo and Leo move away.

 SONNY
 (continuing)
 You're feeling good, too.

A weary technician pushes a full-length mirror across
the floor. As the mirror passes students, they take
out combs and make fleeting adjustments in the already
elaborate hair styles. Marty looks at herself and
goes through a few poutingly sexy expressions. Then
her eyes go wide in childlike amazement.

 MARTY
 Vince Fontaine!

VINCE FONTAINE is first SEEN in the mirror as it stops
in front of him. He is SEEN combing his hair from the
rear and the mirror brings his face INTO VIEW.

 SONNY
 I've seen better heads on a mug
 of beer.

 MARTY
 ~~Jealousy is a child's pastime.~~ *He's the living end!*
 ~~He's neato.~~

 SONNY
 If you like older guys.

Vince checks himself closely then glimpses Marty's
reflection in the b.g. His eyes light with interest;
he takes another look at himself, pastes on his Mr.
Nice Guy smile and starts toward her.

Production designer Phil Jefferies (*right*) created the look of the gymnasium, with streamers and floats, the bandstand, and the *National Bandstand* logo.

"GREASE"

117B ANGLE ON

Mr. Rudie approaches the mike.

> MR. RUDIE
> (nervously)
> We are going to be on the air
> in a very short time. Here
> are some warm-up numbers from
> Johnny Casino and the Gamblers.

He moves off the podium and down toward the Rydell Ranger.

> MR. RUDIE
> (continuing)
> Five minutes till air time.

> PATTY
> Can you make it ten?

> MR. RUDIE
> You're dealing with live T.V.,
> little lady.

> PATTY
> But our routine isn't ready yet.

> MR. RUDIE
> If it's not ready, it can't be
> shown.

> PATTY
> Stuff, girls, stuff.

She berates the girls like a top sergeant and they go doggedly back to work. Eugene among them. Patty ranks passersby and gives them handsful of Kleenex.

117C ANOTHER ANGLE

Near the end of the gym, a janitor stands beside a huge attic fan. He scratches his head while watching the girls stuff, then moves on.

117D DANNY AND SANDY

They sit in the bleachers with other couples.

> SANDY
> If I mess up, I'll just die.

During preproduction, I gave Phil Jefferies my rough sketch for the Rydell Ranger. I was amazed when I arrived on the set and saw it exactly reproduced ten feet tall.

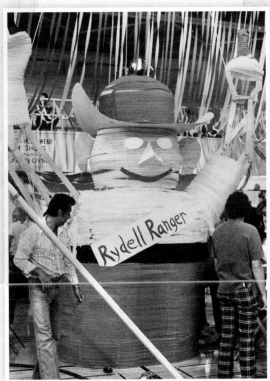

117C

11'D

One of my favorite moments is the way the dancing and music combine when Danny and Sandy emerge onto the dance floor in the contest. In the Broadway production, Sandy didn't even go to the prom and Danny danced with a wallflower-version of Cha Cha. In rehearsals, Pat Birch saw that Olivia "could put one foot in front of the other," as Olivia has joked.

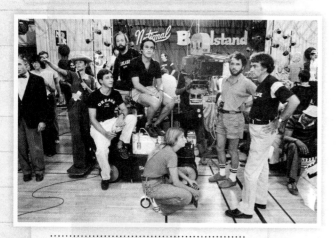

The film crew waits for a finishing touch from choreographer Pat Birch during the complex dance contest.

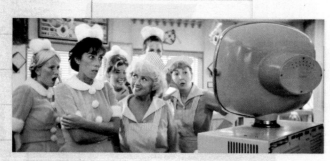

We used a vintage TV to show how America was watching in black-and-white. One of the people watching was John Travolta's sister Ellen, cheering Danny and Sandy on with other waitresses at the Frosty Palace.

117D CONTINUED: 117D

 DANNY
 (putting his arms
 around her)
 I'll never let anything bad happen
 to you. We're gonna win.

117E ANGLE ON PUTZIE AND JAN 117E

 as they dance. She turns him.

 PUTZIE
 You're leading.

 Jan grimaces in embarrassment.

 JAN
 I can't help it, I'm used to
 leading.

 CAMERA MOVES to Frenchy and Doody.

 FRENCHY
 Hey, Doody, can't you at least
 turn me around or something?

 DOODY
 Don't talk, I'm trying to count.

118 ANGLE ON DANNY AND SANDY DANNY SINGS " 118
 MAGIC
 as he teaches her to dance. CHANGES"

 SANDY
 I can't do this one. Let me
 try the next.

 Sandy leads Danny off the dance floor. MOVE with them
 to the entrance area where Kenickie and Cha Cha
 DiGregorio enter. Danny's eyes go wide in shock. It's
 evident he knows her.

 LEO AND RIZZO 118A

 Leo's eyes go wide as he steps toward them. He starts
 toward her but Rizzo grabs his arm.

 RIZZO
 Don't spill any blood, Leo. It
 makes the dance floor sticky.

 (CONTINUED)

GROUP WITH DANNY

142

"GREASE" - Rev. 6/21/77

118A CONTINUED:

Kenickie and Cha Cha cross to Danny and Sandy.

 KENICKIE
 Hi. I wantcha to meet Cha Cha
 DiGregorio.

Cha Cha elbows him out of the way.

 CHA CHA
 Hey, Zuke!

Sandy looks from Cha Cha to Danny with an idea forming.

 CHA CHA
 (continuing; to
 Sandy)
 They call me Cha Cha because I'm
 the best dancer at St. Bernadettes.

 SANDY
 (under her breath)
 With the worst reputation.

Cha Cha sways suggestively to the music and locks
Danny up and down. Danny and Sandy move away.

 SANDY
 (continuing)
 Do you know her?

 DANNY
 (shrugging it off)
 She used to be a friend of my
 cousin's.

Sandy looks unsatisfied. Danny looks at her in out-
raged innocence. Sandy looks at him sheepishly and
he puts his arm around her.

118B OMITTED
thru
119

119A VINCE FONTAINE AND MARTY

 VINCE
 (to Marty)
 I'm Vince Fontaine. Do your folks
 know that I come into your room
 every night over WAXX, that is!
 You know, I'm judging the dance
 contest.

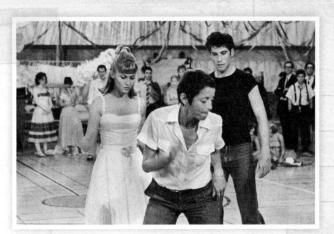

Choreographer Pat Birch demos dance
moves for Olivia and John

Sandy does a great job keeping up with Danny until a drunk Sonny sweeps her away and Cha Cha takes her place. Ever since Annette's characterization of the "best dancer at St. Bernadette's," many of the stage versions of *Grease* have included a sexy Cha Cha.

At the end of the contest, we had Cha Cha snatch the trophy out of Principal McGee's hands, and we kept the action going until everyone got into the shot for the finale. During rehearsals, Pat had seen Edd walking on his hands and doing handsprings, so she got him to do his gymnastics at the end of "Born to Hand Jive," when he flips into the shot and catches the microphone.

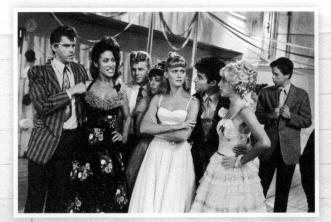

The Shot

Many people think that the dance contest is sped up because the dancers are moving so quickly. It wasn't. It was the spirit and energy of the actors and dancers.

"It was hot." That's usually what cast and crew say when interviewed about shooting the dance contest. It was the dead of summer and we spent a week at Huntington Park High School's gymnasium without air-conditioning, cranking the windows wide-open . . . until we couldn't stand the stench from the meat-packing plant next to the school and closed them again. As John has said, some days we spent more time sopping up sweat than dancing.

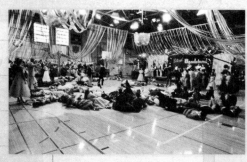

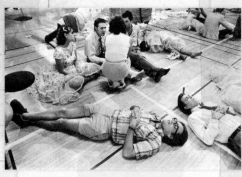

Five days of heat, unpleasant smells, and long hours left us so exhausted that we didn't mind taking naps on the hard gym floor.

"GREASE" - Rev. 6/21/77 82. X

119A CONTINUED: 119A

 MARTY
 I don't think I'm entered.

 VINCE
 A knockout like you? Things
 sure have changed since I went
 to school last... year, ha, ha!

Marty stares at him dumbly for a few seconds then
starts laughing.

119B ANGLE ON RUDIE 119B

He moves to the podium followed like a puppy dog by
Mrs. Murdock. He shouts up to Johnny Casino.

 MR. RUDIE
 Two minutes.

They begin to play "TEARS ON MY PILLOW."

 MRS. MURDOCK
 I've been admiring your functions.

 MR. RUDIE
 Madam, the chaperons are over
 there!

 MRS. MURDOCK
 Chaperones! I'm not one of them.
 Just think of me as one of the
 boys.

 MR. RUDIE
 Easily.

 MRS. MURDOCK
 I teach Automotive Repair.

 MR. RUDIE
 Charming. See if you can give
 the band a tune-up.

He exits.

The chaperones go about their duties. Sonny walks up
to the punch bowl just as the chaperone turns away.
He produces a bottle of Four Roses and spikes the
punch, then smiles innocently as she turns back.

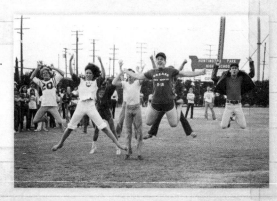

Periodically, Annette and the dancers fled outside for fresh air, where our set photographer David Friedman caught them jumping for joy.

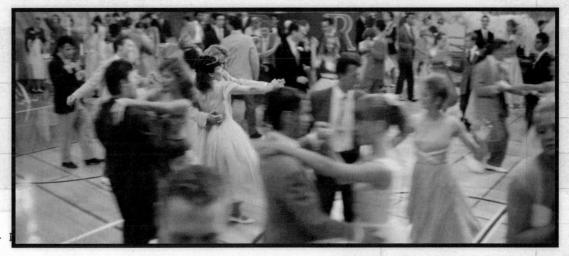

"GREASE" -

119C WIDE ANGLE

All the students and some teachers form a mammoth
stroll line. Non-dancers sit in the bleachers.

The students come down the stroll line. As the people
meet, there are bits of dialogue between them.

119D KENICKIE AND CHA CHA

She looks over her shoulder and winks at Danny.

 KENICKIE
 Hey, babe, remember who you're
 with.

 CHA CHA
 I've got lots of interests.

 KENICKIE
 Whatever you're interested in,
 I've got.

Another couple come down the line.

119E RIZZO AND LEO

 LEO
 Don't nobody move in on Cha Cha.

 RIZZO
 Nobody has to.

Kenickie looks up at them and Rizzo looks away. Leo
raises his arm toward Kenickie as if to get into a
fight.

 LEO
 (to Kenickie)
 We got a debt to square!

 KENICKIE
 Yeah. Charge it to the dust
 and let the rain settle it.

119F FRENCHY AND DOODY

 DOODY
 See. If you hadn't come back to
 school, you woulda missed this.

 (CONTINUED)

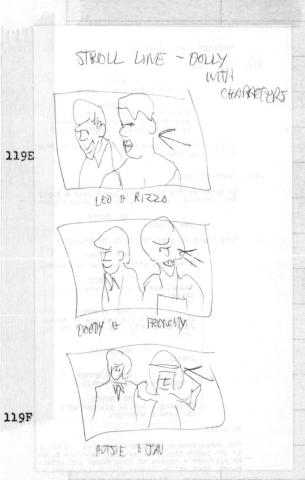

STROLL LINE - DOLLY
 WITH
 CHARACTERS

119E

LEO & RIZZO

DOODY & FRENCHY

119F

POTSIE & JAN

Another favorite shot was when we had the camera on a crane moving through the dancers as one conversation led to another. We used radio microphones on each of the actors. First Putzie says, "Doody, can't you let me lead for a change?" and then we dialed up Frenchy for her "Doody, can't you turn me around or something?" and then we ended up on Danny and Sandy. It was complicated to line up, but I think very effective.

The shot ends on one of the in-jokes when Danny sings along with "Magic Changes" and Sandy asks, "Did you ever think about taking up singing professionally?" The song had been John's solo when he was playing Doody in the stage production.

RANDAL: Dinah, do you remember when you put your hand on the camera lens?

DINAH: That was instinct.

RANDAL: That's one of the biggest laughs that we get.

DINAH: I have good instincts.

The original stage production of *Grease* had lots of sexual innuendo—one of the reasons it was such a hit with young audiences. For example, Vince Fontaine asks Marty by way of introducing himself, "Do your folks know I come into your room every night?" There were a lot of other things we threw in as well. When Marty is chatting with Vince and says her name is "Maraschino . . . like the cherry," she puts her hand on the lens of the camera.

CONTINUED: 119F

 FRENCHY
 Yeah. Dropping out was the
 lonesomist thing I ever did.

As the dancers reach the end of the stroll line, they rejoin it, though the antagonism is still evident from the looks they give each other.

DANNY AND SANDY 119G

 DANNY
 You've got it! You're doing it!
 SANDY
 Am I... I am.

She goes into a little dance and almost collides with the next couple, grimaces and makes a quick walk to the end of the line.

JAN AND PUTZIE 119H

 JAN
 Feet, don't fail me now.

Putzie smiles, dances around her and they do their own little improvisation to the end of the line.

Blanche has been swaying to the music at the sidelines. She is about to go into a little routine.

 PRINCIPAL McGEE
 Blanche, remember yourself!

 BLANCHE
 When I hear that music I just
 can't make my feet behave!

She breaks into the line and grabs the flabbergasted Tom Chisum and dances with him down the line, doing a shimmy as they reach the mid point.

Coach Calhoun grabs Principal McGee and starts toward the line.

 COACH CALHOUN
 Come on, Madge, let's show 'em
 how we used to do it at Teacher's
 State.

 (CONTINUED)

COACH CALHOUN & PRINCIPAL McGEE
DOLLY BACK THRU STROLL LINE

119H CONTINUED: 119H

> PRINCIPAL McGEE
> I've got a position to uphold.
>
> COACH CALHOUN
> You hold the position and I'll
> call the plays.

He swirls her into the line and they do a dance that
has little to do with the stroll. They look more like
Arthur and Kathryn Murray. Principal McGee gets into
the swing and dances with some abandon.

> PRINCIPAL McGEE
> Eat your heart out, Ann Miller.

Mrs. Murdock walks over to Mr. Rudie.

> MRS. MURDOCK
> Want to cut a rug?
>
> MR. RUDIE
> That would be preferable to
> dancing.

As Principal McGee finishes her dance the students
applaud. She tries not to look as pleased as she
is and holds up her hands for quiet.

> PRINCIPAL McGEE
> I think we all owe a big round
> of applause to Patty Simcox and
> her committee for the wonderful
> decorations.

The students cheer and jeer.

> PRINCIPAL McGEE
> (continuing)
> In a few minutes, the entire
> nation will be looking at Rydell
> High School -- God, help us --
> and I want you to be on your
> very best behavior.

Groans.

> PRINCIPAL McGEE
> (continuing)
> And now! Here he is! The peak
> of the week -- I can't believe
> I said that -- Mr. Vince Fontaine.

"Did you ever think
about taking up singing
professionally?"

Other racy moments

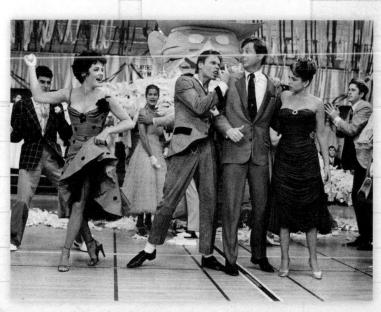

Like the dance moves that Pat choreographed
between Danny and Cha Cha, there are a few bits
throughout the movie that go right over kids' heads.
Many people have told me that years after they first
saw the movie, they saw it again and picked up on
the double entendres and racy moments.

The Cinematography

To move through Pat Birch's elaborate choreography during "Hand Jive" where Mr. Rudie walks through the dancers during the warm-up, Bill Butler came up with a combination of a wheelchair and a furniture dolly. Pat had worked out all the specific bits with the dancers, and Bill worked out the flow from one to the other.

Bill had experience shooting musical numbers for TV but this was his first big production musical, and even he wasn't immune to the pressures of getting the shots just right. He was impressed by the physical stamina of the dancers, but he didn't want them to have to do the numbers over and again whenever he needed to tweak any of the lights or cameras. So Bill and his gaffer, Colin Campbell, set up the lighting in the large gymnasium in such a way that we could shoot without making major changes. Each of the four corners of the room became a major light source, so that no matter in what direction we shot, one side could be the key light and the other side could be the backlight. We could shoot all day long without resetting the lights. This required a lot of preplanning, so he wanted to go to the location a couple of days before shooting was scheduled to take a look and plan everything out methodically. Unfortunately for him, someone at the school had decided to varnish the floors of the gymnasium and the floors didn't dry until the day before we were scheduled to use the space. Timing was tight, but to Bill and his crew's credit, everything was in place by the time the cast walked on the set.

Going handheld during the dance contest

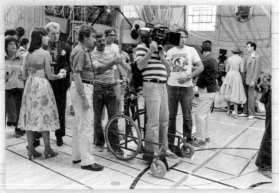

120 ANOTHER ANGLE 120

Vince Fontaine runs down the stroll line and is mobbed by the students who pick him up, carry him around on their shoulders and deliver him to the podium.

 VINCE
 (into mike)
 Hiya, kids, I'm glad to be here
 at Rydell High.

They all scream madly. Principal McGee takes the mike. Coach Calhoun is at her side.

 PRINCIPAL McGEE
 And now for the rules.

The students boo. Coach Calhoun looks at them sternly.

 COACH CALHOUN
 Rule one. All couples must be
 boy, girl.

121 PUTZIE 121

looks up at Eugene who continues to stuff.

 PUTZIE
 Too bad, Eugene.

 PRINCIPAL McGEE
 Rule two. Anyone using tasteless
 or vulgar movements will be
 disqualified.

Rizzo and several others go into several variations of the dirty boogie.

 RIZZO
 (to McGee)
 That lets us out!

 COACH CALHOUN
 Rule three. When you are tapped
 on the shoulder during the dance
 contest you must leave the floor
 immediately.

121A ANGLE ON MR. RUDIE 121A

He addresses Vince.

121A CONTINUED:

> MR. RUDIE
> (in a stage
> whisper)
> Twenty seconds.

Cameramen move into position and couples jump and
trip as camera cables are pulled past them.

122 ANGLE ON VINCE

He moves to the mike.

> VINCE
> Thank you fans and friends and
> odds and ends... and now for
> you gals and guys a few words
> to the wise... Jims and Sals
> are my best pals... and to look
> your best for the big contest
> ... just be yourselves and have
> a ball that's what it's about,
> after all... so forget about the
> camera and think about the beat;
> and we'll give the folks at home
> a real big treat... don't worry
> about where the camera is. Just
> keep on dancing, that's your
> biz. And if I tap your shoulder
> move to the side and let the
> others finish the ride.

> MR. RUDIE (O.S.)
> 10, 9, 8, 7, 6, 5, 4, 3, 2, 1
> on the air.

The National Bandstand THEME is HEARD as Vince smiles
into the camera.

> VINCE
> Hello and welcome to National
> Bandstand coming to you live
> from Rydell High school. This
> is the event you've all been
> waiting for... the National
> Danceoff. Away we go with
> Johnny Casino and the Gamblers!

There is a squeal from the crowd as Johnny Casino and
the Gamblers go into "HOUND DOG."

ELLEN TRAVOLTA CAMEO

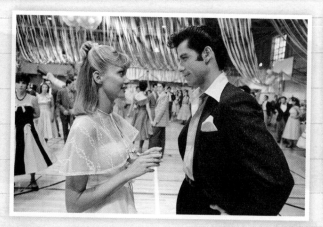

122A ANGLE ON CAMERA 122A

as it swings from Vince to the crowd.

122B ANGLE ON CROWD 122B

At the moment the cameras hit the dancers, they do all
the things they have been cautioned against. Look into
the camera, dance woodenly, and above all wave to the
folks in T.V. land.

123 INT. BEDROOM 123

Marty's MOTHER sits in bed in front of the T.V. set
as the CAMERA PANS over the crowd and picks out Marty
and Vince. Her husband snores beside her.

 MARTY'S MOTHER
 Fred, Fred, wake up. Marty's
 on coast to coast television.

She's so excited she gets on her knees and almost
presses her nose to the T.V. set.

124 EXT. STREET IN FRONT OF AN APPLIANCE STORE 124

There are about ten sets in the window of an appliance
store. People are lined up outside watching.

CAMERA PANS down the line of sets. People are nudging
each other and some are waving to the set.

125 INT. FROSTY PALACE 125

The Frosty Palace waitresses are clustered around a
set moving in time with the music.

126 INT. GYM 126

Mr. Rudie breaks up the kids who are waving to the
camera and pushes them back onto the dance floor.
They all begin dancing but are still aware of the
cameras around them.

126A ANGLE ON SONNY 126A

as he takes another drink from his hidden flask.

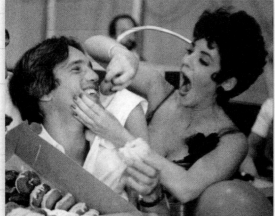

Fun on the set

126B ANGLE ON PODIUM 126B

As the song ends Vince approaches the microphone.

> VINCE
> And now the event you've all
> been waiting for, the National
> Danceoff! Some lucky guy and
> gal is going to go bopping home
> with some terrific prizes, but
> don't feel bad if I bump yuz out,
> 'cause it don't matter what ya
> do with those dancin' shoes.
> So okay, cats, throw your mittens
> around your kittens... and away
> we go with a little hand jive.

127 ANGLE ON GROUP 127

All the dancers begin dancing the hand jive as the
song "BORN TO HAND JIVE" begins.

128 ANGLE ON VINCE 128

as he moves to the crowd eliminating couples. Some
are reluctant to leave, but Mr. Rudie serves as a
bouncer shoving them along.

129 ANGLE ON JANITOR 129

He leans against the fan, accidentally turning it on.
The blast of air hits the Rydell Ranger and Kleenex
balls pellet the dancers.

130 ANOTHER ANGLE 130

The contest continues with more people being eliminated.
Among those remaining are Danny and Sandy, Jan and
Putzie, Kenickie and Cha Cha and Rizzo and Leo. As
they dance, Cha Cha and Leo try to sabotage not only
each other but the others as well. They camouflage
their moves but it looks like a small battle ground.
Jan and Putzie are eliminated. Putzie walks away
leaving Jan alone. Sandy finds it difficult to keep
up with the intricate steps and leads Danny off the
dance floor protesting. She apologizes and they both
watch the contest from the sidelines.

Sha Na Na

Performing as Johnny Casino and the Gamblers, Sha Na Na launched the dance contest sequence with a cover of Danny and the Juniors' "Rock 'n' Roll Is Here to Stay." Sha Na Na was the ideal band for the movie. Playing fifties rock and roll, they were a big hit at Woodstock, where they were the opening act for Jimi Hendrix. They went on to appear with the Grateful Dead, the Kinks, and John Lennon and had an international following. For our movie we outfitted them with flamboyant gold lamé outfits, leather jackets, and featured their pompadours and ducktail hairdos. In this sequence, they also perform two songs from the Broadway production, "Those Magic Changes" and "Born to Hand Jive," as well as covering Elvis's "Hound Dog" and "Blue Moon" and the Imperials' "Tears on My Pillow." I would have liked to play more of the movie on them, but there was too much story going on with all our characters.

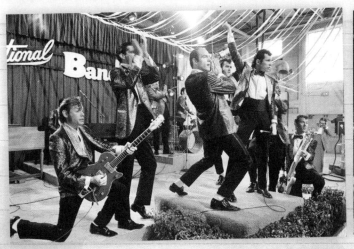

Set Visitors

There seemed to be a constant stream of visitors to the set, from Jane Fonda to Pat Birch's mentor, the amazing John Houseman, who had worked with Orson Welles. But my favorite visitor was Glynnis O'Connor, who had played opposite John in the TV movie *The Boy in the Plastic Bubble*, only one year earlier.

```
                "GREASE" - Rev. 6/21/77                         86D. X

    130A    ANGLE ON VINCE                                         130A

            as he heads for Marty who is behind one of the cameras.
            He begins putting the make on her then taps out Doody
            and Frenchy who are trying to get on camera.  He moves
            through the crowd to eliminate several other couples
            and then finally eliminates Rizzo and Leo.  They both
            give him the "finger" and head off the floor with Leo's
            arm around Rizzo.

    130B    ANGLE ON KENICKIE AND CHA CHA                          130B

            in the middle of their dancing Kenickie sees Rizzo and
            Leo heading off the floor.  He is distracted by this
            so much that Cha Cha bumps into him trying to dance.
            Kenickie storms off the dance floor leaving Cha Cha
            alone.  She looks around the side line and goes after
            Danny.  He objects and she forces him to come out and
            dance with her.  Danny looks at Sandy as though there
            is nothing he can do.

    130C    ANGLE ON VINCE                                         130C

            as he takes the mike and faces the camera,

                            VINCE
                    We've narrowed it down to the
                    final eight couples.  Not let's
                    all pick.  Number 1, number 2
                    and number 3.

            The group forms a semi-circle with the eight final
            couples dancing in the middle.  Some from the sidelines
            try to join in but Mr. Rudie keeps them in order.
            Among the finalists are Danny and Cha Cha and Patty
            Simcox and her date.  Sonny, who's now fairly drunk,
            runs onto the dance floor and pulls Patty's dress up
            over her head.  He then does a limbo and Rudie drags
            him off.

            Danny and Cha Cha continue dancing with two other
            couples.  The other couples drop out.

    130D    ANGLE ON SANDY                                         130D

            She watches.  Tom and a GIRL stand behind her.

                            GIRL
                    Look at them go.

                                                       (CONTINUED)
```

A Dropped Number: "It's Raining on Prom Night"

One of my favorite songs from the play that didn't make it to production was "It's Raining on Prom Night." I wanted to put this musical number after Sandy storms out of the dance because Danny dumped her to dance with Cha Cha. I had big plans for Olivia to sing this song while walking through the high school parking lot surrounded by rain machines. I wanted it to be a tribute to Gene Kelly in *Singin' in the Rain*. I thought it would be quite amusing to shoot Olivia, soaking wet, singing, "My hair is a mess, it's running all over my taffeta dress" and "Mascara flows right down my nose." But Allan Carr did not like the idea of his star looking disheveled, and nixed it. I wanted to have this cool song somewhere in the movie, so we placed it in the Frosty Palace scene when Danny tries to make up with Sandy at the jukebox.

130D CONTINUED: 130D

> TOM
> They ought to be able to --
> they went together for a whole
> summer.

Sandy turns in astonishment then turns back to watch
with tears in her eyes. As the dance ends, Cha Cha
grabs Danny's hand and holds both their hands aloft
as if they are the champs. Vince walks onto the floor
from one direction and Principal McGee comes in from
the other to congratulate the winners. They get caught
up in the dance and the kids clap them on. Vince flips
Principal McGee around while wild cheers come from the
group. The SONG ENDS.

> VINCE
> Here they are, ladies and gents.
> The new champs. Could I have
> your names, please?

> CHA CHA
> Cha Cha DiGregorio and Danny Zuko!

> VINCE
> Let's give 'em a hand! And now
> let's see our champs in a
> spotlight dance.

130E ANGLE ON DANNY AND CHA CHA

as a blue spotlight hits them and Johnny Casino and
the Gamblers begin playing "BLUE MOON."

In the b.g. a drunk Sonny lies on the cot being
ministered to by Nurse Wilkins.

130F THE SIDE OF THE GYM 130F

A door opens. Putzie peers out then beckons to a line
of boys. They head across the dance floor looking as
if they are up to something. Putzie and his pals care-
fully pull bags out of their pockets and put them over
their heads. Suddenly, Putzie and the other boys leap
onto the podium and rush in front of the camera.

130G INT. BEDROOM 130G

Marty's Mother sits smiling and nodding, and suddenly
she recoils in horror.

> MARTY'S MOTHER
> Fred, call the police!

130H INT. GYM 130H

The boys are bent over mooning the television cameras
with the blue spotlight giving them a true "Blue Moon."

153

Form R2-4 [logo]

COSTUME FOR _____ "Frenchy" _____

PLAYED BY _____ Didi Conn _____

PHONE NO. _____

CHANGE	SCENE NOS.	SET	DESCRIPTION
#1	116	int dance-off Gym	Dress: yellow organza ruffles over yellow taffeta slip. full ruffled skirt. double pink & lavender spaghetti straps. pink ribbon at waist
		gloves on · wristlet on	
		(R) wrist over glove.	
		above ruffle	
			Shoes: yellow open toe t-strap sandals - 2" heel
			Gloves: sheer white nylon w. wrist ruffle
			Wristlet: yellow velvet ribbon w. shaded pink silk rose buds

The Costumes

The fifties can be about rigid rules and conformity; this wasn't what Albert Wolsky envisioned for a stylized version of a high school dance. Within certain parameters—the actors needed to be able to move and do the choreography—Albert set to work on dresses that become bigger than life.

Sandy is prim and proper in a pastel chiffon dress, with a full skirt. She is glamorous yet innocent and you can tell Danny will do anything for her. Compared to Sandy, Rizzo is gleefully provocative in a red dress with large black polka dots glittering with sequins. (Allan Carr kept ordering, "More sequins! More sequins!") Marty, one of the most stylish characters in the movie, wows in an emerald-green dress that falls just below the knee—she almost looks like an adult, which attracts the eye of Vince Fontaine, who wears a flashy suit that fits both the role and Edd Byrnes perfectly. Albert said working with Eve Arden on her costumes was like working with an old-fashioned movie star—she was accustomed to wearing very stylish clothes, so Principal McGee became a very stylish principal.

Frenchy's bright colors and elaborate hairdo and ensemble were a lot of fun for Albert to create. It's not so unexpected to see Frenchy dressed so playfully, but Jan was a big surprise for the audience. She's blossomed from a sweatshirt-wearing slob into a girl wearing an attractive party dress and looking to have the time of her life.

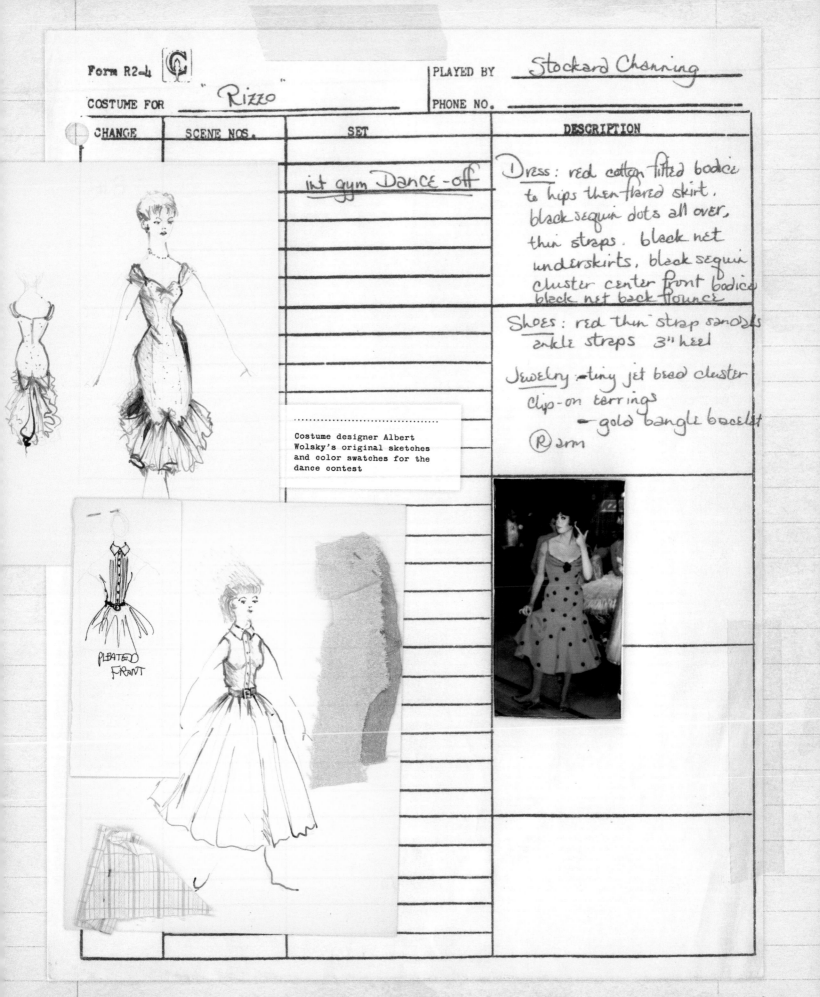

Form R2-4 Ⓒ

COSTUME FOR _____ "Rizzo" _____

PLAYED BY _____ Stockard Channing _____

PHONE NO. _____

CHANGE	SCENE NOS.	SET	DESCRIPTION
		int gym Dance-off	Ⓓ Dress: red cotton fitted bodice to hips then flared skirt, black sequin dots all over, thin straps. black net underskirts, black sequin cluster center front bodice black net back flounce
			Shoes: red thin strap sandals ankle straps 3" heel
			Jewelry: tiny jet bead cluster clip-on earrings — gold bangle bracelet Ⓡ arm

Costume designer Albert
Wolsky's original sketches
and color swatches for the
dance contest

PLEATED
FRONT

155

"Sandy"

The Scene

When I was a teen I used to go to the Main Line Drive-In in Devon, Pennsylvania. It was the hangout for all of us on weekends. Jim Jacobs had gone to drive-ins too in Chicago as a teen and suggested a bit of business based on this shared experience: sneaking buddies into the drive-in by hiding them in the trunk. The kids spill out of trunks and head off to the concessions stand or start making out—what most of us did instead of watching the movies.

Back then, girls and boys had different expectations about drive-ins. Sandy is anticipating "going steady" and getting a ring (even if it was made out of a spoon in shop class). Danny is hoping to get to second base, if not further.

The Broadway show dealt with serious issues like teen pregnancy; we kept Rizzo's pregnancy scare in the movie, with Marty innocently spilling the beans after Rizzo reveals that she's missed her period. Having Pat Birch by my side was such a blessing. I asked her to take her twenty dancers and choreograph them spreading the news. She had them jumping from car to car and whispering the bad news until it finally reaches Kenickie just as Rizzo walks up to him. The audience gets a glimpse of Kenickie's feelings for Rizzo, but she brushes him off with a snappy, "It's somebody else's mistake." The camera stays on Jeff and Stockard for their real moment.

133 EXT. STARLIGHT DRIVE-IN THEATRE - NIGHT 133

It's a triple bill. Cars are lined up to get inside.

CUT TO:

134 EXT. DRIVE-IN 134

Doody's car enters and parks near the rear of the drive-in. He opens the trunk and out climb Kenickie, Sonny and four other guys. It looks for a moment like a circus car where an impossible number of clowns get out of a small car.

 KENICKIE
 Let's find the chicks.

They start toward the concession stand.

CUT TO:

135 THE SCREEN 135

A western is on screen.

People are pouring out of cars and milling around, showing this is more of a social scene than an evening at the flicks.

CUT TO:

136 INT. DANNY'S CAR 136

Danny and Sandy pull in. He parks in the middle of a two-car spot, leans out his window and pulls in the speaker.

He hesitates, decides to ignore her mood and leans back, putting his foot on the dashboard and his arm around Sandy.

CUT TO:

137 MARTY'S STATION WAGON 137

Marty, Frenchy, Rizzo and three other girls pile out of a station wagon, light cigarettes and lean against the car.

(CONTINUED)

GUYS CLIMB OUT OF TRUNK

GIRLS OUT OF CAR

137 CONTINUED:

Rizzo surveys a row of packed cars and turns to the others.

 RIZZO
 I don't think anybody's here.

 CUT TO:

138 A CAR

A car pulls up and the couple never even bothers to get a speaker, they just begin to make out immediately.

 CUT TO:

139 INT. DANNY'S CAR

Danny and Sandy sit watching the movie. There is tension in the air. She has her arms folded in her lap.

 DANNY
 Okay. Okay. What is it?

Sandy slides away and looks at him, her back against the door.

Danny realizes she knows something and looks away.

 SANDY
 (accusing)
 You and Cha Cha went together.

 DANNY
 We didn't go together... we just
 went together.

 SANDY
 It's the same thing.

 DANNY
 It's not. Not like us... I
 mean it, Sandy. Come on.

Sandy regards him a moment longer, then sighs and leans back against the seat, but still not sitting much closer to him. Both of them affect great absorption in the movie.

Danny looks down at the homemade spoon ring on his finger.

The scene where Danny maneuvers to drop his arm around Sandy's shoulders and then tries to seduce her was used for the screen test between Olivia and John because their chemistry had to spark up the entire movie. Olivia loved having Sandy show a little backbone when she calls Danny's 1949 Dodge Wayfarer a "sin wagon." Sandy was a Goody Two-shoes but not a pushover.

This scene was wonderfully directed in the Broadway play by Tom Moore. I followed the beats that he laid out, including the comedic moment when Sandy slams the door on Danny's crotch, which always gets a big laugh.

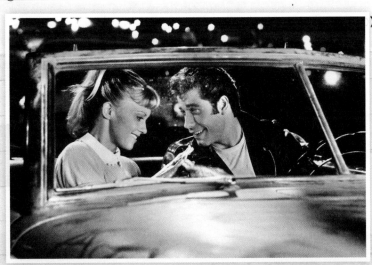

Shooting Sandy and Danny's date at the late, great Pickwick Drive-In

The Shot

We shot this sequence at the Pickwick Drive-In in Burbank (now a shopping mall, after the drive-in was torn down sometime after 1989). Pat and I discussed how to give this number some movement. It wouldn't work if Danny just sat in the car and sang. We needed a place for him to go—singers need an action to play and obstacles to overcome just as actors do in a dramatic scene.

I remembered my hometown's Main Line Drive-In, which had a swing set just below the screen where children could play while waiting for the sun to go down. This was the ideal place for Danny to end up. I wanted to have him stop in front of the projector so there would be a cool image as people honk their horns, and then end up walking over and sitting on the swing. Pat figured out a way to move him there, along the way turning back to sing in the direction of the departed Sandy.

I wanted something visual playing on the screen behind John, and I thought of the popcorn trailers I saw as a teen at the drive-in. Usually animated and often with a countdown to the start of the next feature, they encouraged people to visit the concession stand.

139 CONTINUED: 139

He reaches down to take it off, but it won't budge.
He struggles and turns it several ways, but to no
avail.

Sandy looks at him out of the corners of her eyes but
neither pretends to notice the other.

Danny looks out his window to see the couple in the
next car making out passionately. He struggles harder
with the ring. Suddenly, he gets an idea and rubs his
hand through his greasy hair and it comes off with
ease.

He gives a sigh of relief then turns to her.

 DANNY
 Sandy.

She looks up at him, her eyes glowing. He extends the
ring and her eyes go wide. Just as he is about to
hand it to her, he withdraws it, wipes it on his shirt
and hands it back.

 SANDY
 Oh, Danny.

 DANNY
 Wanta go steady?

He slips the ring on. It is much too big and almost
falls off. She gives him a peck on the cheek. He
smiles and gives a goofy sort of laugh.

 SANDY
 It's beautiful. Can I put
 some tape on it?

Danny is practically rubbing his hands together
waiting for some good loving, but Sandy slides back
next to the door, and holds the ring up to the light
so she can see it.

 SANDY
 (continuing)
 You see, when a girl holds her
 standards high, a boy respects
 her.

He looks at her dumbfounded. She smiles at him and
blows him a little kiss, then goes back to looking
at the ring.

158

140 INT. LADIES ROOM 140

The place is filled with smoke. In the b.g., girls
are lined up waiting for a booth. Rizzo, Marty and
another GIRL are in front of a mirror putting on
makeup. The Girl accidentally bumps Rizzo who elbows
the stunned Girl on the side of the bosom. The
Girl reacts in pain. Rizzo scouts at her and she
moves away massaging herself.

 MARTY
 What's with you tonight, Riz?

 RIZZO
 I feel like a defective
 typewriter.

 MARTY
 Huh?

 RIZZO
 I skipped a period.

 MARTY
 (all concern)
 Think you're P.G.?

 RIZZO
 I dunno... Big deal.

 MARTY
 Kenickie?

 RIZZO
 Nah. You don't know the guy.

 MARTY
 Ahh! They're all the same. I
 caught Vince Fontaine putting
 aspirin in my Coke at the
 dance.

 RIZZO
 Look, Marty, do me a favor.
 Don't say nothing. Okay?

 MARTY
 Sure, Riz. I'll take it to
 the grave.

They exit.

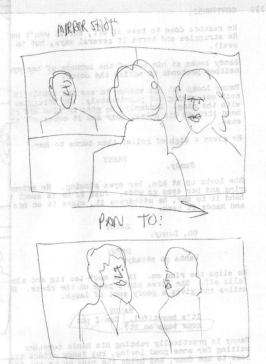

We sent away to Chicago for about twenty vintage popcorn trailers from the fifties. The problem was they didn't arrive until the night we were beginning to shoot the sequence. There I was, a first-time feature film director with 120 members of the crew waiting and I didn't know what I was going to shoot. So I did what I would never in my right mind do today: stopped production and asked Bill Hansard, the industry's top "process" projectionist, to run the trailers one by one for me on the drive-in screen. (I didn't know any better. It was like a "directing improv.")

We were nearly done screening them—I still wasn't sure what to put behind John—when my eye was caught by a quirky animation of a hot dog jumping into a bun. I asked Bill if he could sync that action up to the end of the song. He said he could, and the result looked as if it had been carefully planned. Thinking back, I guess I should have played more of the ending on Travolta, as it was his solo. But I was so excited by the luck in timing with the animated trailer that I was swept along and didn't shoot a close-up.

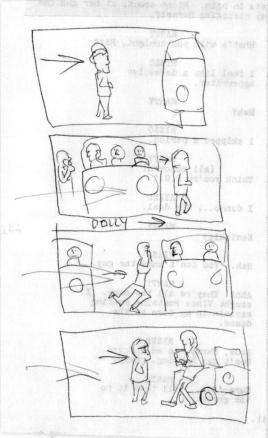

```
141         OMITTED                                        141
&                                                          &
142                                                        142

143         EXT. THE CONCESSION STAND                      143

            Rizzo and Marty join the throng.

                         MARTY
                  Coming through!  Coming
                  through!  Lady with a baby!

            She puts her hand to her mouth and looks at Rizzo.

                         MARTY
                        (continuing)
                  Sorry, Riz.

            As they make their way to the counter, Marty sees a
            girl.  Rizzo is several people removed.  Marty hesi-
            tates, then whispers in the girl's ear.  The girl's
            eyes go wide as she looks at Rizzo.  CAMERA DOLLIES
            with Rizzo and Marty as they walk back toward the
            car, sipping Cokes.  Marty looks AT THE SCREEN and
            Rizzo is lost in thought.

144         ANOTHER ANGLE

            In the b.g., Putzie and Jan are sitting in the outdoor
            seats which are filled.  The rumor starts at one end
            and is whispered to the other.  The last person who
            hears moves to a car where a couple is making out
            passionately.  There is a TAP at the window.  They
            stop, roll it down and a girl whispers to them.  The
            male smoocher rolls down his window and beckons to
            Kenickie who is walking by.  Kenickie cheerfully leans
            against the side of the car.  He suddenly reacts and
            turns in the direction of Rizzo and Marty.

            Kenickie comes up in back of them.  He tries to appear
            unconcerned.

                         KENICKIE
                  Hey, Rizzo, I hear you're
                  knocked up.

            Rizzo stops stone still.  She gives the embarrassed
            Marty a look of contempt.

                         RIZZO    (CONTINUED)
                  You do, huh?  Boy, good news
                  really travels fast.

            Kenickie looks at her earnestly.  They are trying to
            communicate, but they are blocked by their images.

                         KENICKIE
                  Hey, listen, why didn't you
                  tell me?

                         RIZZO
                  What's it to ya?

                         KENICKIE
                  Anything I can do?

                         RIZZO
                  You did enough.
```

 KENICKIE
 I don't run away from my mistakes.

 RIZZO
 Don't worry about it, Kenickie.
 It was somebody else's mistake.

 He is hurt and astounded. He is about to say something
 when he looks around to see the Pink Ladies and T-Birds
 standing nearby and eavesdropping. He reasserts his
 air of macho indifference.

 KENICKIE
 Huh? Thanks a lot, kid.

 RIZZO
 Any time.

 He walks away.

 Rizzo watches him and almost goes after him.

 MARTY
 It ain't so bad, Riz. You get
 to stay home from school.

 RIZZO
 Just leave me alone, willya?
 Just leave me alone.

 She storms away.

 CUT TO:

 145 OMITTED

DRIVE IN SONG

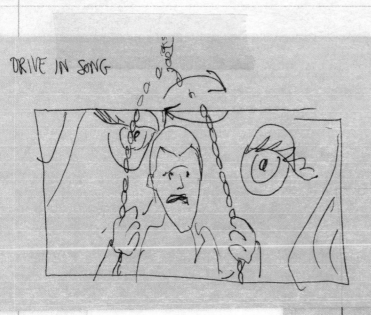

I Married a Monster from Outer Space
Space Children
Colossus of New York

War of the Worlds - destroying LA
Sampson & Delilah - temple destruction
10 commandments - sea open Fast Elvis number?
When Worlds Collide contrast to Ballad
Sailor Ruson
Funny Face

Danny and Sandy sit side-by-side looking at the movie.

Danny is trying to get closer to Sandy, but he tries
to make it look accidental by a series of seemingly
natural manuevers to which she remains oblivious.

He leans back, yawns, stretches out his arms, raises
his back and in one movement moves closer to her and
puts his arm on the seat behind her.

He effects a sneeze and drops his arm around her
shoulders.

 SANDY
 I hope you're not getting a
 cold.

 DANNY
 Oh, no. Noting like that.
 Nothing contagious. Just
 drive-in dust.

They sit for a moment with his arm around her. He
looks down at the steady rise and fall of her
breasts and bites his lower lip in anticipation.
His hand hovers in mid-air above her breast, but
his hand seems to have a life of its own and it's
shy.

Finally he takes a deep breath of resolve and solidly
clamps his hand over her breast.

Sandy's eyes practically bulge out of her head.

 SANDY
 (outraged)
 Danny!

 DANNY
 (passionately)
 Sandy!

She moves. He interprets this as a response, takes
her in his arms and in one clean swoop has her
lying down on the seat. He is on top of her. She
struggles. His eyes are half-closed in ecstacy.

 DANNY
 (continuing)
 Oh, baby, baby!

POPS UP: "NOBODY'S WATCHING"

 (CONTINUED)

 SANDY
 (struggling)
 What kind of a girl do you think
 I am?

 DANNY
 The best. The very best. I
 won't tell a soul. Nobody's
 watching.

She pulls past Danny, opening the door and pulling
herself out of the car.

She stands outside the car breathing hard in panic.

After a moment, Danny's face rises to the window.

```
                    DANNY
                 (continuing)
         Sandy, Sandy, come back.

                    SANDY
                  (angry)
         ... Are you kidding?  I'm not
         coming back into that, that...
         sin wagon.

   Danny blinks and looks at her in dusgust.

                    DANNY
         What are you getting so shook
         up about?  I thought I meant
         something to you.

   Sandy is so mad she can't say anything.  She just
   sputters.

   Sandy throws the ring at him and storms away.

                    DANNY
              (continuing; leaning
                out the window)
         But, Sandy, you can't just
         walk out of a drive-in.

   He tries to get out of the car, but he is wedged
   behind the wheel and his head hits against the HORN
   which sets off another spate of HORN BLOWING.

   He slumps down behind the wheel just as Kenickie walks
   by.
```

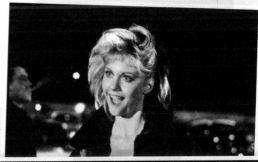

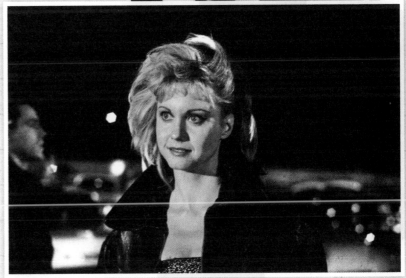

"Bad Sandy's Debut"

I was viewing the concession trailers on the big screen, trying to find the right one to play behind John during the number. Then, out of the corner of my eye, I saw a slinky blonde in a skintight leather outfit making her way through the crowd of extras, cast, and crew. They were similarly transfixed. Olivia had already been working with everyone for a couple of months but no one recognized her.

RANDAL: Olivia, you first came out in your "Bad Sandy"
 costume the night we shot the drive-in scene. The
 cast reacted to you so differently.

OLIVIA: Albert [Wolsky] wanted everyone to see the
 outfit. I could feel all their heads kind of turn as
 I went by . . .

RANDAL: I saw this vision coming toward me, backlit,
 with blond hair, and I said, "Who is that?"

OLIVIA: That's funny! That was a light bulb moment for
 me and for everyone else, I guess.

This was to become "Bad Sandy's"
iconic look, copied over and over
again in the coming years as Halloween
costumes and sing-along outfits. This
influence can be seen in other movies
such as *Spetters*, a 1980 film by Dutch
director Paul Verhoeven, in which Renée
Soutendijk has the "Bad Sandy" look.

The Song

Olivia was going to get a solo ballad, which eventually became "Hopelessly Devoted to You," and we wanted John to have a new ballad as well. "Alone at a Drive-in Movie" was a clever and funny song from the Broadway production. But for the movie, we wanted something that John could sing in a more romantic and less comedic way. Allan Carr told the music producer, Louis St. Louis, to "go back to the hotel and write it." There wasn't a lot of time, but from what Louis has said, inspiration struck after he crossed under the famous Paramount arch and was waiting for the light to turn onto Melrose Avenue.

He pulled out his cassette recorder and recorded: "Stranded at the drive-in, branded a fool, what will they say, Monday at school?" He called Screamin' Scott Simon of Sha Na Na and they quickly composed the rest of it. The next morning, he took it to Allan. It was approved on the spot. They then played it for Robert Stigwood, and he approved it on the spot. Later that afternoon, John loved what he heard and approved it—on the spot. By the end of the day, the song was slotted into the production schedule. It would be nice if things worked that way all the time.

```
146   CONTINUED: (2)

                         KENICKIE
            How's it going? .

                         DANNY
            It went.

                         KENICKIE
            Same here.

      Danny walks alone through the drive-in.

147   OMITTED
thru
149

150   EXT. PLAYGROUND                              150

      A children's playground is set up under the screen.

      Danny enters the deserted area, sits in a rickety
      swing and sings a love ballad (song).  " SANDY "

      (OPTIONAL:  The movie on the screen will show a counter-
      point to the song lyrics.)

                                              CUT TO:
```

DOLLY IN

SINGS: "SANDY"

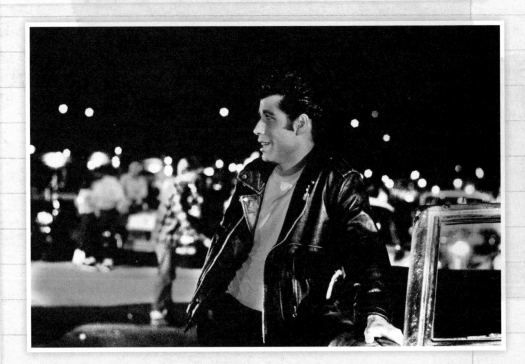

RANDAL: Was your high school experience anything like Rydell? Ever go to a drive-in?

JOHN: I only went to drive-ins in those days with my family. I didn't own a car till I was out of high school!

Danny sings "Sandy" in the projection beam of the drive-in movie.

STANDS IN PROJECTOR BEAM

The "jumping hot dog" that nearly upstaged John's solo

SHOW STARTS IN 5 MINUTES

SITS ON SWING

DELICIOUS HOT DOGS
VISIT OUR REFRESHMENT CENTER

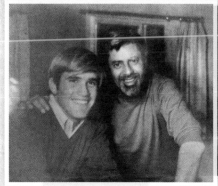

The Jerry Lewis Connection

When I studied film at the University of Southern California, one of my teachers was Jerry Lewis. My classmates thought the class would be a bunch of jokes, kind of like the Nutty Professor goes to college. We were surprised at how much we learned about all aspects of moviemaking from him. After college, I worked as a production assistant for him on his movie *Which Way to the Front?*

I wanted to pay tribute to him by having one of his movies on the drive-in screen. I chose *Hollywood or Bust*, a Paramount film starring Jerry and Dean Martin.

Years later, when I interviewed Jerry for the Directors Guild Visual History collection, I asked if he noticed the shot. "Of course I did," Jerry replied. "I ordered up a print to check on you. You did good, kid."

DEAN MARTIN AND JERRY LEWIS

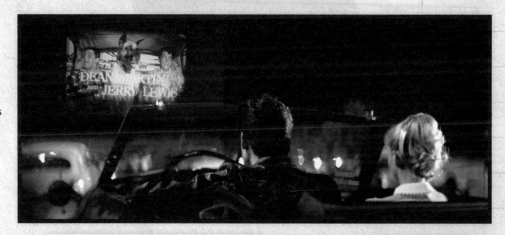

Jerry and me in his dressing room in 1970 when I worked as a production assistant on *Which Way to the Front?*

Forty-two years later, in 2012, at an event honoring him at the Academy of Motion Picture Arts and Sciences in Beverly Hills

150A EXT. STREET - DAY 150A

Putzie and Doody sneak up to a parked car and begin
removing the fenders. The OWNER, a large man, comes
out of a store and sees them. They run off with the
fender with the Owner trying to catch them.

151 EXT. AUTOMOTIVE REPAIR SHOP CLASS - DAY 151

Putzie, Doody, Sonny and several others wait impatient-
ly outside the double doors. They suddenly open and
Greased Lightning is driven out by Kenickie. Danny
rides beside him and Mrs. Murdock is in the back seat.
The car looks splendid. It has been painted a blind-
ing white with GREASED LIGHTNING written on the sides
in lightning bolts of yellow.

The boys applaud. Kenickie beams. Mrs. Murdock gets
out, looks at it critically, takes a rag out of her
back pocket, gives the car a wipe, crooks her thumbs
in her belt loops and saunters away.

 (CONTINUED)

NEW CAR

151 CONTINUED: 151

The guys crowd around the car congratulating Kenickie
and Danny.

 KENICKIE
 This oughta knock 'em outta
 the stands at Thunder Road.

 DOODY
 You could change your mind.

 KENICKIE
 (looking at his
 watch)
 In three hours the flag goes
 down and Greased Lightning strikes.

 PUTZIE
 Kenick, you've really done it
 this time.

 KENICKIE
 Gonna do it! Gonna do it!

The boys shrug and begin to exit. Danny takes
Kenickie's arm and pulls him to the side.

 DANNY
 Those guys at Thunder Road don't
 fool around.

 KENICKIE
 Where's your spirit of adventure?

 DANNY
 About two steps behind my spirit
 of survival.

 KENICKIE
 Look, Danny, we been buddies a
 long time. Right?

 DANNY
 Right.

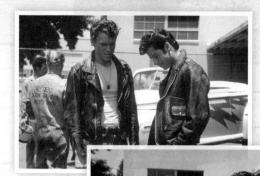

```
              KENICKIE
           (almost shy)
Well, what I want ya to do is
this.  It's kinda like an ancient
duel, ya know.  I mean, I don't
mind goin' out there alone or
nothin' like that, but if you
was to be my second...
```

 (CONTINUED)

151 CONTINUED: (2) 97.
 151

```
              DANNY
You mean ride with you?

              KENICKIE
The drivers drive alone.  But
I mean, you know, just...

Danny looks at Kenickie.  Neither of them are at ease
with the expression of their friendship.  Danny hits
Kenickie on the shoulder.  Kenickie hits Danny on the
arm.  Danny hits Kenickie on the side of the head.
Kenickie frogs Danny on the arm.  They stand rocking
back and forth like a couple of pugilists.

              KENICKIE
           (continuing)
Pick ya up at three.

              DANNY
See ya.

                                    CUT TO:
```

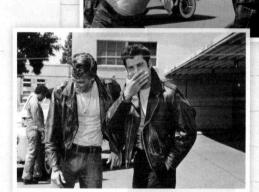

Jeff and John
working on the
T-Bird hug

Countdown to Thunder Road

While film veteran Alice Ghostley complained years later about working in the summer heat in the Los Angeles River culvert, her words as Mrs. Murdock as the boys prepared for the Thunder Road race rang true to her professionalism on the set: "I don't expect my boys to let me down, and I won't let them down." The shooting script's lines were originally focused on Kenickie and Danny but we felt it worked best coming from all the actors in the scene, so it's Mrs. Murdock who starts the countdown to Thunder Road with her "The flag goes down in three hours" comment, followed by Kenickie's "And Greased Lightnin' strikes!"

Jeff Conaway came up to me one day and said he had an idea for a scene. He'd worked out that when Kenickie asks Danny to be his second for the Thunder Road race, and Danny agrees, they'd hug. This was supposed to be the fifties and two guys hugging? Not going to happen. What was smart about their bit was what they did after the hug. When they see the T-Birds watching, they break apart, combing their hair in a "It's cool, it's cool" moment. The shooting script shows a more combative, macho response, but what these guys came up with was comedic. Jeff was very proud that this beat, his idea, was added to the scene.

Rizzo and Sandy have a similarly intimate scene—for a moment the audience sees a different side of tough Rizzo with her simple "Thanks," an acknowledgment of Sandy's kindness. When Sandy asks if Rizzo will go to Thunder Road, Rizzo's comment foreshadows Sandy's decision to break out of her Goody Two-shoes character: "Unless you've got wheels and a motor, he won't know you're alive."

In an earlier version of the script, Rizzo was the one to transform Sandy after Thunder Road into the sexy "bad girl" to "show her the ropes." In the final version of the screenplay, Frenchy does the honors. But this last scene between Rizzo and Sandy brings their relationship to a kind of resolution.

"There Are Worse Things I Could Do"

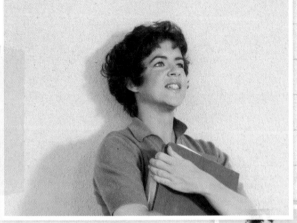

The Scene

Rizzo's song almost didn't make it into the movie—it's not even in the shooting script. The thought was that in an upbeat musical, adding another ballad might slow down the pace. But Stockard was Allan Carr's client and he wanted the song in—so we scheduled it into the production schedule. Once we filmed it, we knew it was a highlight of the movie.

Drawn to the song as soon as she heard it, Stockard played Rizzo as a tough girl with a hidden vulnerable side. She sang from the heart, adding dimension to the character of Rizzo.

The Shot

Stockard Channing acted the song beautifully, bringing out all the nuances of Rizzo's vulnerable bad girl. We filmed this number straight through in one dolly shot. I placed several guys playing catch in the background as a comment on the lyrics "There are worse things I could do, than to go with a boy or two." At the end of the song, she sings, "But I can feel and I can cry, a fact I'll bet you never knew. But to cry in front of you, that's the worst thing I could do." She is singing this to Kenickie, and he can be seen behind her driving off to the upcoming race.

At the twenty-year rerelease of the film we went back to the location of the original premiere, Grauman's Chinese Theatre. I was sitting across the aisle from Stockard and watched her reaction to seeing herself sing this song. At the end, she had tears in her eyes.

STOCKARD: If you remember, Randal, we shot the "There Are Worse Things I Could Do" number in like ten minutes. And people were coming back from lunch.

RANDAL: You were brilliant, hitting every moment and beat. Had you had broken it all down, line by line? Because it certainly felt like it.

STOCKARD: That I did. I really loved the song and I thought I did a good job of it. And you're right, every phrase is a thought. The song definitely was her little aria.

RANDAL: Absolutely.

STOCKARD: And it's where you see her being a little insecure—with a bravado to hide her insecurity.

RANDAL: It's one sequence in the movie when we really feel something for somebody—everything else is sort of jumping around and fun.

STOCKARD: Here's something you may not remember. Jeff Conaway insisted on being there, working on his car in the background.

RANDAL: That was a great idea.

STOCKARD: Sweetest thing ever.

152 OMITTED 152

153 EXT. THUNDER ROAD *LA RIVER?* 153

Thunder Road is (a high school football stadium), a cinder
track running around it. The Thunderbirds' Pink Ladies
and Mrs. Murdock are at the sidelines.

too expensive X

In the center of the field are floats and papier mache
replicas of gladiators and Roman statuary reminiscent
of the sets in "Ben-Hur." They have been used in a
high school parade and are stored.

Danny, Kenickie and Sonny stand beside Greased Lightning
looking at the crowd which is a beer-swilling, tough-
looking bunch.

The Scorpions are gathered around Hell's Chariot.

Danny, Kenickie and Sonny contemplate the enormity of
it and look around the rotting grandstand.

Leo and two others come swaggering over to look at
Greased Lightning in undisguised contempt.

 LEO
 So, you guys think you got
 a winner there.

 KENICKIE
 Think so.

 LEO
 Takes more 'n' a coat of paint
 to make it at Thunder Road.
 Sure you don't wanta change
 your mind?

 KENICKIE
 No way.

 LEO
 Okay, we're racing for pinks.

 DANNY
 Pinks?

 LEO
 Pinks, you punk! Pink slips!
 The ownership papers.

Danny gives a subdued, but slightly maniacle half-.
laugh which lulls Leo into thinking they are sharing
a laugh. Suddenly, Danny reaches out to slug Leo,
but is restrained by Kenickie and the T-Birds.
They take Danny to the side and Kenickie resumes
looking threateningly at Leo.

Cha Cha slinks out of the crowd and takes the pink
slips. She gives Danny a look of contempt.

 LEO
 (continuing)
 The rules are: there ain't
 no rules. It's three times
 around the track and whoever
 crosses first wins.

Thunder Road

The Scene

To the sound of revving engines,
the race between the T-Birds and
the Scorpions begins with the cars'
dramatic entrance through a dark
tunnel into a dry riverbed of the
Los Angeles River near downtown,
then as now a tough neighborhood.

My early sketches for this sequence
show the cars racing around the track
with giant "gladiator" floats, like those
used for the Rose Bowl, parked in the
center of the football field. The image
was to be a humorous homage to the
chariot race in *Ben-Hur*. I instructed the
prop department to watch *Ben-Hur* and
match the spiked wheels that were on
the chariots.

Lindsley Parsons Jr. was watching
the budget for the Paramount production
department and suggested a less
expensive way to do the scene: instead
of building the giant floats, why not
move the race to the Los Angeles River?
I was disappointed that my vision was
not going to happen, but we changed
the location. And when I saw the dailies
of the LA River on the big Panavision
screen I was thrilled. The decision really
opened up the movie, and the location
lent itself to the wide-screen format.

KENICKIE
I'm ridin' in the winner.

Leo makes a smacking sound.

LEO
We'll see about that.

He extends his grimy hand. Kenickie hesitates then shakes it. He turns to go back to the car.

The Thunderbirds are busily giving Greased Lightning a final check. The doors, hood and trunk are open.

(CONTINUED)

I did get to retain a remnant of my idea. The prop department had already built the knifelike hubcaps, so we used them to have bad guy Leo grind into Danny's 1948 Ford Deluxe convertible.

We tried to use the new location to its best advantage, with the embankment serving as a kind of bleachers for the kids to watch and the track turning into an obstacle course: starting from the Sixth Street Bridge, continuing under the Fourth Street Bridge, and with the midpoint a U-turn at the First Street Bridge, where they headed back to the starting line. As an amped-up version of "Greased Lightnin'" sets the tone, the two cars jockey for place, narrowly avoid a drainage outlet, speed over ramps, and skid through water, cheered on by their friends.

99.

153 CONTINUED: (2) 153

Kenickie holds his face-to-face with Leo, gives an ultra-macho shrug, pivots on his heel and takes a step toward the car just as Putzie -- who has been checking out the inside -- opens the door and hits Kenickie below the belt.

Kenickie's eyes go wide in pain and horror as he clutches himself and sinks bug-eyed to the ground.

The others surround him with Danny kneeling at his side.

DANNY
Kenick, Kenick, are you all right?

Kenickie makes animal sounds.

Danny looks up as the Scorpions push Hell's Chariot into position.

DANNY
(continuing; to
the others)
He'll never be able to drive. I'm taking over.

Kenickie makes more gasping sounds. Danny pats his shoulder, rises and turns toward the car.

DOODY
You could get yourself killed.

Danny rises, looks at Sandy who stands to the side-lines with Tom, then looks away.

DANNY
Life's not worth living unless you take a few chances.

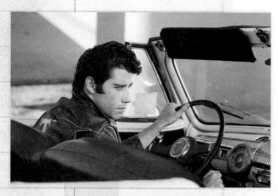

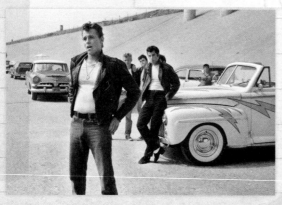

The Script

During rehearsals we'd worked out an interchange between the girls and guys to keep up the pace, with the Pink Ladies (minus Rizzo) watching Cha Cha giving Leo a locket for good luck. Jan asks, "What did she give him?" Frenchy insults Cha Cha with "A lock of hair from her chest!"

The shooting script had Kenickie get incapacitated by a car door to the groin. Instead, we worked out a bit where Jan finds a penny on the ground ("See a penny pick it up, all the day you'll have good luck!") and Marty takes the dirty penny at arm's length to Kenickie for a good-luck charm. She drops it, he gallantly offers to pick it up, and he gets hit in the head by Putzie opening the car door. This was a somewhat awkward way of giving the race to our star, John.

158 CONTINUED

158-A cont.

158-B (FAVOR DANNY) 158-C (DANNY)

-5-

① DANNY
Kenickie. Kenickie. Are you alright? Speak to me.
② "YOU PUTZ"

④ ZUKO
SONNY
He's out cold.

⑤ DOODY
What are we gonna do?

Kenickie groans and opens his eyes. He looks at Danny.

KENICKIE
You said you'd be my second. We can't let the gang down. This is something we worked for.

⑨ DANNY "YOU WANT ME TO TAKE OVER?"
Don't worry about a thing. You can depend on me.

⑩ "YEAH I GUESS SO."
He rises as Marty sits on the ground beside Kenickie.
⑪ "COME ON LET'S GET HIM UP."
Danny looks at the crowd as the others get him ready. sees Sandy standing on the edge of the crowd. They look at each other for a moment, then the others turn him toward the car. He appears to be looking for sandy who isn't there.
158-D , 158-E

Danny gets inside and looks over at Leo who leans out of his car.

MARTY
③ "Here put this under his head."

DANNY
④ Hey Buddy, you OK?

MURDOCK
⑦ You can't drive!

KENICKIE
⑧ Naw Hey I'm alright..it's just that I see two of you.

KENICKIE
If it wasn't for bad luck I wouldn't have any luck at all.

158F

LEO
The rules are--there ain't no rules. It's to the bridge and back and the first one who makes it here wins.
MURDOCK
(To DANNY) "HAUL ASS, KID."
You're looking at the winner.

LEO
You ain't gonna see me for dust, kid.

Sandy takes several steps toward Greased Lightning, but Frenchy takes her arm and motions for her to stand back.

159
CUT TO 2 CARS (8-9) 159.
159.
Cha Cha stands dramatically between the cars with her arms aloft.

Leo revs his engine and looks out diabolically. 159-B 159-A
 (8-9)
Mrs. Murdock walks up to Danny. LEO
"YOU AIN'T GONNA SEE ME FOR DUST, ZUKO.

MRS. MURDOCK
Haul ass, kid.

CHA CHA DROPS HER ARMS AND THE TWO CARS ROAR AWAY

161 ANOTHER ANGLE 161

Danny walks dramatically to Greased Lightning, opens the door, reaches to the seat, takes out a scarf which he puts around his neck.

(CONTINUED)

A page from script supervisor Joyce King's book with camera angles and on-set dialogue changes.

161 CONTINUED: 161

The wind hits it and sends it flying like a World
War II pilot. He gives Kenickie a salute, slams
the door and pulls the car toward the starting line.

 KENICKIE
 If it wasn't for bad luck, I
 wouldn't have any luck at all.

 CUT TO:

162 EXT. TRACK 162

Cha Cha stands in front of the cars with her arms
raised dramatically.

Leo revs his engine and looks out diabolically at
Danny.

Danny gulps but is determined not to show his un-
certainty.

Kenickie sits up and regards the hostile crowd of
Scorpions, as Putzie, Doody, Sonny and the others
come toward him.

Cha Cha drops her arms and the two cars roar away.

As the race begins a BEACH BOY-LIKE SONG is HEARD
on the highway (new song).

The SCREEN GOES TO 70MM SUPERSCAN and the SOUNDTRACK
is FILLED with the SOUND of CARS.

The cars start along the track.

(NOTE: The race is almost a satire on the "Ben-Hur"
chariot race -- the white car against the black and
all the dirty tricks.)

They are neck-and-neck. Suddenly the hubcaps on
Hell's Chariot appear to loosen and what appears in
their place are rotary blades that come with buzzsaw
precision toward Greased Lightning.

Danny looks out the window, sees what's happening
and tries to turn on the speed. There is no more!
The blades are perilously close to him and there is
no more room on the track. He comes close to a
crash but recovers.

Sandy, at the sidelines, bites her nails, and moves
away from Tom.

 101.

163 ANOTHER ANGLE 163

Greased Lightning and Hell's Chariot are neck-and-neck
once again.

164 INT. HELL'S CHARIOT 164

Leo pulls ahead of Danny, then reaches down and pulls
a lever.

Annette

Annette Cordana, who at the time
was using the stage name Annette
Charles, wanted very much to
do this tribute to Natalie Wood in
Rebel Without a Cause. But the day
this was scheduled to shoot, she
was in the hospital for tests. We
told her no problem—we wouldn't
need to use her in the shoot. But
she said, "No way." She left the
hospital, showed up on the set and
did the scene, and then returned to
the hospital. That's dedication.

BEN HUR sequence

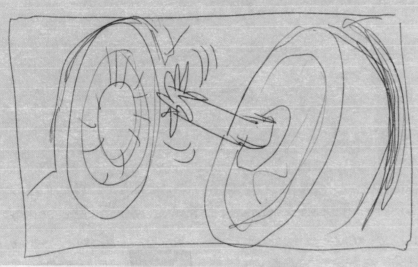

The Thunder Road sequence was inspired by the chariot
race in *Ben-Hur*. The giant "gladiator" floats on the
high school track didn't make it into the movie, but the
whirling hubcap knives did.

The Shot

Bill Butler had a chase car for
two cameras, small and built
low to the ground like a dune
buggy. This little car helped us get
footage on the steep slopes of the
embankments at high speeds.

Our stunt coordinator, Wally
Crowder, had some spectacular
crashes and jumps in mind, but we
wanted to scale it down and make
it about the two characters in the
story. Instead of having the cars
try to cross a bridge or end in a
crash, we had the cars jockeying
for space as they narrowly miss a
drainage outlet on the side of the
slope. Greased Lightin' jumps off
a ramp that's only about a foot
high (but it was tall enough for the
impact to flip open the trunk), and
Leo meets his "end" in a stream of
water with a satisfying slow-motion
splash. Like most cars from the
fifties whose undercarriage and
wiring were vulnerable to getting
wet, Hell's Chariot "died" simply
because it shorted out.

165 EXT. TRACK

Danny swerves in front of Hell's Chariot.

The front of Hell's Chariot is extended and bumps the
back of Greased Lightning causing Danny to lose
control.

The car limps to the sidelines.

Mrs. Murdock rushes toward it. She carries a toolbox.
She opens the hood as Danny opens the door and gets
out.

Mrs. Murdock works rapidly as Hell's Chariot roars
past.

In a moment, Mrs. Murdock slams the hood.

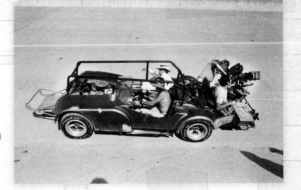

The chase car with cameras
catching the action on the
Los Angeles River

MRS. MURDOCK
Haul ass, kid.

Danny cranks up and lurches back onto the track.

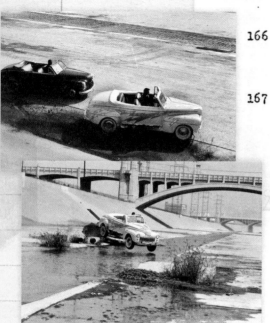

166 INT. HELL'S CHARIOT 166

Leo sees Danny gaining on him. He pushes a button.

167 EXT. TRACK 167

Oil spills out of Hell's Chariot and covers the track.

Danny sees the oil spill but cannot avoid it. Greased
Lightning hits the oil and spins like a top.

Danny fights for control of the car and regains it.

CUT TO: 102.

168 THE FINISH LINE 168

Cha Cha puts a nail-studded board about 100 yards
before the finish line.

CUT TO:

TOP: The cars jockeying
for position during the
race in the LA River

BOTTOM: Greased Lightnin'
jumping the ramp over the
drainage ditch with Hell's
Chariot close behind

169 BACK TO CARS 169

Greased Lightning pulls alongside Hell's Chariot. As
they come into the home stretch, they're neck-and-neck.

CUT TO:

170 ANOTHER ANGLE 170

Leo tries to pull in front of Danny. For Danny it's
either crash or slow down. Danny slows down. Leo
pulls in front of him... And right over the nails.
All four tires on Hell's Chariot blow out and the car
grinds to a halt as Danny pulls around him and drives
Greased Lightning to victory.

CUT TO:

CAR LEAPS OVER RIVER

171 THE THUNDERBIRDS AND PINK LADIES 171

rush toward Danny as he opens the door and almost falls
out.

Sonny, Doody and Putzie hold his arms aloft as the
others surround him. Sandy has approached, but hangs
back.

CUT TO:

SCORPION CAR IN RIVER

172 RIZZO AND KENICKIE 172

They are on their feet cheering. Kenickie suddenly
falls into Rizzo's arms. He looks up at her tenderly
and says:

KENICKIE
Hey, whatever happened between
us, I'm sorry.

RIZZO
Don't worry about it.

(CONTINUED)

They embrace. Kenickie hobbles over to join crowd at car.

173 ANOTHER ANGLE 173

As Danny is carried away, he turns and sees Sandy standing alone near the edge of the crowd. He looks as if he would like to go to her, but the others parade around the field with him heading toward where the defeated Scorpions stand, looking hostile.

Kenickie has been helped up by the others and goes with the parade.

Rizzo watches with Sandy.

Danny is carried up to the Scorpions.

 SONNY
 Okay, punks! Pinks.

One of the SCORPIONS yanks the pink slips away from Cha Cha and stands looking at the boys defiantly.

 SCORPION
 Come and get it!... If you think
 you're men enough.

For a moment it looks like there is going to be a rumble, then Leo comes out of the crowd and takes the pink slips from the Scorpion and walks toward Danny who has been set down by the others.

Leo and Danny are both grime-smeared and look at each other with an air of battle fatigue.

173 CONTINUED: 173

 LEO
 He's man enough.

He extends the pink slips to Danny who hesitates, gives Leo a nod that's a form of salute and takes them.

 RIZZO
 Well, they did it.

 SANDY
 Why is it the guys get the glory
 and the girls get the blues?

 RIZZO
 You're asking me? I thought you
 had all the answers.

 SANDY
 I thought I did. What am I
 doing wrong? I used to think
 it was Danny I couldn't figure
 out. Now it turns out to be me.

 RIZZO
 Come on, Gidget, and let Mama
 Rizzo give you some tips of the
 trade.

DO VISUALLY

X

Rizzo leads Sandy off. The crowd has picked up Danny in jubilation. He turns to see Sandy and Rizzo walking off. He looks forlorn.

"Sandra Dee Reprise"

After the race action we wanted a quiet moment where Sandy decides to change to get Danny. The original idea was that Rizzo would take Sandy aside and help her with a makeover. We decided to do this visually with a slow zoom as the lyrics of the song reveal Sandy's inner thoughts. She comes up with the idea herself and asks Frenchy to help. This sets the scene for the entrance of "Bad Sandy."

The Last Day of School: Leaving Rydell High

The Script

The day that the students and teachers were anticipating is finally here—but as in Blanche and Principal McGee's misty, nose-blowing moment ("Oh, Blanche, stop blubbering!"), it is a bittersweet day. The shooting script's concept was that the last day of school would be celebrated at "Wonder World Amusement Park." Sandy's transformation was to be set up with "Favorite Image Day," in which the characters would come as the person they most admired or the thing they'd like to be, a takeoff on a "where are they now" montage.

The shooting script had big plans for the celebration of the last day of school: the crowd would be full of students being Davy Crocketts, Marilyn Monroes, even Frankenstein's monsters and Draculas. Frenchy was going to show up in a dental hygienist smock. Putzie and Jan would have Mickey and Minnie Mouse masks. Marty would be wearing a WAC uniform and proclaim she was going to foreign countries with the USO "because the army needs men and so do I." Rizzo and Kenickie would appear as bride and groom, and even Patty Simcox would have found her soul mate, Tom Chisum, both in matching "business suits." We simplified.

EXT. SCHOOL – DAY 174

As Principal McGee SPEAKS, the school is SEEN for the last time.

> PRINCIPAL McGEE (V.O.)
> Now hear this! Tomorrow, being the last day of school, is hereby proclaimed Favorite Image Day which we are celebrating at Wonder World Amusement Park. Come as the person you most admire or the thing you'd like to be. And remember, students -- set your goals high.

OMITTED 175 105.
 thru 178
178 EXT. AMUSEMENT PARK – DAY 177

"WE GO TOGETHER" is PLAYED and SUNG on the SOUNDTRACK as the main characters APPEAR. The speeches are interspersed with the SONG and students are SEEN on different rides.

Students are dressed as different 50's images. Two girls are dressed as the Dancing Old Gold Cigarette Packs. There are Davy Crocketts, Marilyn Monroes, Marlon Brandos, Toni Twins, Frankensteins and Draculas galore, Elvis Presleys and one girl gotten up as a nun on roller skates. Marty is dressed as a WAC.

Frenchy appears in the spotless smock of a dental hygienist.

Putzie and Jan appear with giant blow-up masks of Mickey and Minnie Mouse on the heads.

> MARTY
> What are you two doing?
>
> JAN
> We're off to Hollywood.
>
> PUTZIE
> Yeah. Somebody's gotta take over on the Mickey Mouse Club.
>
> JAN
> (to Frenchy)
> What's with you?
>
> FRENCHY
> I'm gonna be a dental hygienist. The mouth's close enough to the hair so I won't feel like I'm in a foreign country.

MARTY
And speaking of foreign
countries, I'm going with
the USO. The Army needs men
and so do I.

Sonny and Doody walk up in Army uniforms.

SONNY
The Army builds men, too... I
hope. I hope.

(CONTINUED)

178 CONTINUED:

Tom and Patty walk past in business outfits seeming
to have discovered each other.

The others turn in surprise as Rizzo and Kenickie
appear dressed as a bride and groom.

FRENCHY
He's making an honest woman
of you.

RIZZO
Which one of you is gonna give
us a shower?

PUTZIE
I've been meaning to talk to
you about that, Riz.

Rizzo narrows her eyes in aggravation then looks up
in shock.

RIZZO
I've seen it all now.

She looks down and sees a pair of luminous white bucks.
Sonny reaches out and smears them with his foot.

A bottle of white shoe polish comes INTO THE FRAME
and a touch-up is done.

PULL BACK TO SEE that it is Danny dressed as Pat
Boone, perma-pressed slacks and all. He's had his
hair cut and is the epitome of the All-American boy.

The others look at him in disbelief.

KENICKIE
Zuko?

Danny gives them the beatific smile of a Christian
Athlete.

DANNY
Hi, kids.

PUTZIE
Kids?

DANNY
Kids.

PUTZIE
He is kidding.

(CONTINUED)

The Shot

You might not recognize the students bursting out of the school's doors on the last day of school. No one on set knew them until the day of the shoot.

It was another Allan Carr publicity stunt. He not only flew journalists in from different cities to play the teachers in the *National Bandstand* sequence, he also put on a nationwide contest for winning teens to be flown to Hollywood and have a role in the movie. He didn't mention this to me until the day before they were to arrive. He told me to find a place in the movie to fit the thirty contest winners with the stipulation that they could not be cut out of the movie. I asked, "How can we guarantee that?" He said, "You'll think of something." That night, while racking my brain in the shower, I came up with the solution. Principal McGee announces, "But always you will have the glorious memories of Rydell High. Rydell forever! Bon voyage." The next scene was going to be the carnival sequence. What better way to show that school was out for the summer than to film the contest winners blasting out of Rydell High.

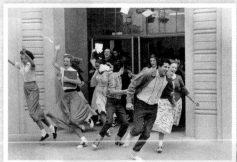

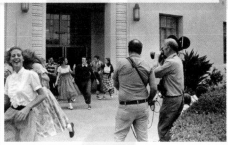

Nationwide contest winners make it big.

"You're The One That I Want"

Rehearsing Kenickie's "I'll make an honest woman of you" speech

The Scene

We kept Sandy's transformation but changed the planned entrance of a completely clean-cut Pat Boone version of Danny to show him only with a letter sweater, which he had legitimately earned running track. It fit our story better and tied up that loose end.

We also kept Principal McGee's admonition to "Set your goals high" and opted to use a shorter approach that would give each of the characters a little moment. In the film, Principal McGee says that within the ranks of the senior class was a future Eleanor Roosevelt (paired with a shot of Jan), a Rosemary Clooney (Rizzo), a Joe DiMaggio (Sonny), a President Eisenhower (Doody), or Vice President Nixon (cue Doody looking really inspired, a dig at "Tricky Dick" Nixon's reputation).

The original idea for the ending was to have school buses pulling up to an amusement park. Instead, we brought a carnival to Rydell's football field.

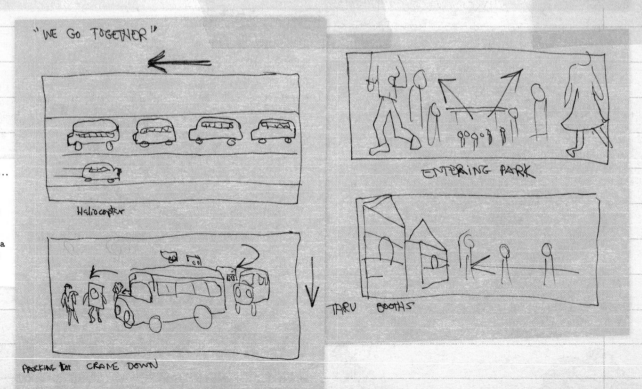

In the shooting script, the end scene location was written as a theme park. We decided to change it to a traveling carnival set up at the athletic field behind John Marshall High School.

When we showed up to shoot, we had rehearsed the finale, "We Go Together," written for the Broadway show, but John and Olivia's new duet by John Farrar had just been recorded and was being played for the first time. We needed to improvise the staging.

The script contained the idea that the T-Birds had flunked phys ed and would have to go to summer school to get their diplomas. This was because the original title for the sequel was *Grease 2: Summer School*. Combining the ideas in the shooting script with the possibilities of the carnival set, we captured the actors improvising, playing around, and otherwise having fun—just as kids would do at a real carnival. Most of this scene isn't in the shooting script, created as it was during the shoot, such as the "Cream the Teacher" sequence. There Eugene (who has been picked on almost the entire movie) finally gets his moment in the spotlight as his pie throw hits Coach in the face and wins him a spot on the next school year's baseball team. The T-Birds decided to give me a "pie in the puss" as well.

End of the shoot: the T-Birds' revenge on me

A happy ending

In another moment when we spontaneously used the carnival's attractions, we were able to resolve Rizzo and Kenickie's conflict with her shouting from the Ferris wheel that she's not pregnant. Didi said that was one of the only moments she saw the giddy kid in the character of Rizzo.

There is a quick pan to Danny in his letter sweater. He will do anything to get Sandy back, including becoming a jock, much to the shock of his friends.

In the shooting script, a "jazz-like staccato" heralds "a major entrance." It is Sandy, dressed as an "ultimate Thunderbird Dream-girl, a wild new hairstyle over one ear, motorcycle jacket, skintight pedal pushers, gold earrings, chewing gum and smoking a cigarette."

Danny's reaction, like audiences who see the movie, is basically "Wow!" He can't believe it. He is impressed. He is turned on. Olivia's line originally was, "How you hanging, stud?" She felt more comfortable with "Tell me about it, stud." And with that, the music and the choreography sweep the audience into another song.

> DANNY
> No, I'm not.
>
> KENICKIE
> But why...?
>
> DANNY
> I'm phasing into the world.

Rizzo rolls her eyes and looks O.S. as tough "West Side Story"-like FINGER SNAPPING is HEARD against a JAZZ-LIKE STACCATO heralding a major entrance. Heads turn as Sandy turns a corner and approaches them. She is the ultimate Thunderbird Dream-girl, a wild new hair style over one ear, motorcycle jacket, skintight pedal pushers, gold earrings, chewing gum and smoking a cigarette.

She looks different but actually more alive than she ever has.

Danny is slack-jawed in disbelief. She stands in front of him grinding her behind, then turns and blows smoke in his face, saving a bit of the smoke for a perfect French inhale.

The others gather in back of her murmuring excitedly.

> SANDY
> How you hanging, stud?
>
> DANNY
> Sandy?... What have you done to yourself?
>
> SANDY
> You noticed, huh?... Well, what's it to ya?

Tell me about it, stud!

The Song

John Farrar, one of Olivia's oldest friends, wrote a lot of her hits, like "Have You Ever Been Mellow." He had a tight deadline—the next day—to write a song that would showcase the "Bad Sandy" character and Olivia and John together. After an all-night session, he came to us with "You're the One That I Want." I liked the seventies take on a driving fifties Eddie Cochran–like rhythm. We got it recorded right away so Pat Birch could rehearse with it.

I recently asked John Farrar how he was able to write this hit song so quickly. "Maybe I got confidence from everyone liking 'Hopelessly Devoted to You,'" he joked, but then pointed to the meeting in which all of us had discussed the transition of the story during this moment; he had taken all those ideas and put them into melody and lyrics. Recording the song was another memorable experience for him. In the days before auto-tune, he said, the singers would do a few vocal tracks and then comp the best parts together. John Travolta's vocals in this song are in the higher range, so he was understandably a little nervous about singing it, and Olivia came to the recording session with him for moral support. John Farrar was thrilled with John's singing. "He definitely had a great feel for it, the way he did the chorus in particular. And he got like the little yodel thing that I wanted."

The day we filmed this number was the first time the song had ever been played. Olivia had said as soon as she heard the beginning of the demo, she knew it would be a hit. The cast and crew found the song "electrifying" and agreed.

Doody walks by and looks at Sandy in horror. She
flicks cigarette ashes at him and chases him away.

Danny looks at her with a new appreciation.

She looks him up and down.

 SANDY
 (continuing)
 What's with the square duds,
 dude?

 (CONTINUED)

RANDAL: Olivia, when we showed up to shoot
 "You're the One That I Want" that day,
 we really didn't know where we were going
 to do the scene. Were you nervous about
 improvising?

OLIVIA: Music is where I'm comfortable. I
 thought that it would all fall into place.
 Just being in that outfit with a different
 energy was exciting for me.

RANDAL: I wasn't there when you recorded the
 song "You're the One That I Want." Who was
 directing you?

OLIVIA: The songwriter, John Farrar. John
 Travolta had to sing really high, and John was
 encouraging him, because it was a difficult
 song to sing. We had a blast doing it.

The Shot

The duet between John and Olivia had not been rehearsed by Pat during preproduction, since the song had not been written. When we arrived at the set filled with the rented carnival machines, Pat and I looked around for a location. Among the attractions was the "Shake Shack," a kind-of cheesy funhouse. We walked into it, felt its floor shaking up and down and back and forth, and that inspiration was all Pat needed to incorporate those moves into the song. She worked out individual beats, like Sandy stamping out her cigarette and pushing Danny over with her foot to start the number right on the spot.

She also improvised the choreography of John and Olivia sashaying down the steps in time to the beat, with the other characters joining in at the chorus. In this number, as in the entire movie, there is a kind of looseness that comes from us not being hovered over by the studio. There wasn't a lot at stake—the movie was not expensive. We were just trying to do our best, and there was no one saying, "Oh, well, why are you doing it this way?" or, "Don't do that." It gave us a kind of freedom to try things out and see what happened.

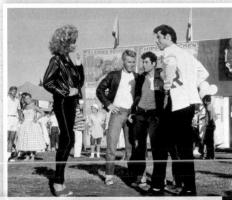

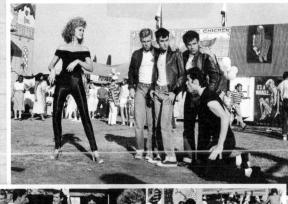

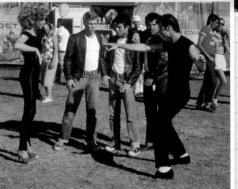

At the beginning of the song, after Sandy says, "Tell me about it, stud," she drops her cigarette on the ground, stamping it out. Pat really wanted that moment because she felt Sandy wasn't "tough" enough. We did take after take, but the cigarette kept bouncing off the mark where the camera was aimed. Finally, the prop man came over and just asked, "Why didn't you call me?" He inserted a bobby pin into the cigarette to weight it. We started the cameras and playback, and the cigarette dropped to the right spot.

Sunny Southern California sometimes made shooting difficult. Also during the shooting of this particular sequence, the sun was so bright that Olivia couldn't stop squinting; her eyes were watering and she just couldn't keep them open. Bill Butler put up a big silk to soften the light, but even that didn't help the problem.

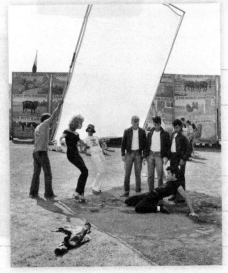
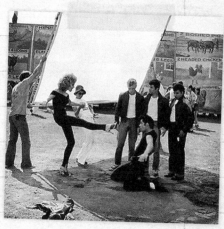

Then I remembered a lesson I learned at USC film school. I told Olivia to close her eyes and face the sun. This would make her irises contract so when she opened her eyes the sun wouldn't blind her. When I yelled, "Playback," and the music began, Olivia opened her eyes and was able to perform the song.

We shot the interior of the Shake Shack in one wide shot at the end of an afternoon—just a couple of hours, really—and didn't have time to shoot any close-ups. When we saw the footage the next day, we felt it would play better if we had had time to go closer to Danny and Sandy. We wanted to go back and shoot more, but the carnival had moved on. We played the shot for our production designer, Phil Jefferies, and he built a set on a soundstage that matched the background so we could add the close shots. As Sandy and Danny dance back and forth on the carnival set in the sequence, you'll see the later close-up shots as they whirl, edited into the sequence so you'd hardly know the difference.

| Form R2-4 Ⓖ | | | PLAYED BY _Olivia Newton-John_ |
| COSTUME FOR "Sandy" | | | PHONE NO. _____ |

CHANGE	SCENE NOS.	SET	DESCRIPTION
#12	178 -	Ext carnival — walks onto field w. jacket on unzipped, wrist zippers open,	**Top:** black cotton tube tops w. off the shoulder collar split front collar
			Trousers: stretch satin. capri length. black.
			Belt: black satin 3" w. gold hook fastening (attached to trousers)
			Shoes: red canvas uppers (her own) w. lt. wooden platform & high heels. backless
			Jacket: black imitation leather. collar. lapels sleeve zippers. flap pocket ⓛ side. zipper pocket ⓡ side. belt w. silver buckle. Epaulets w. silver stars
			Jewelry: lg. gold twisted loops earrings (personal Betsy Cox)

The Costumes

When I asked Albert Wolsky what he remembered about designing for "You're the One That I Want," he immediately said, "That was the number we pulled together, what, four days before shooting it?" All Albert really knew was that it would be outdoors with rides in an amusement park and involve dance. He had a very short time to pull it together.

After all the looseness of Olivia's big skirts and prim Peter Pan collars, her costume for this number had to be different, from head to toe. Hair, makeup, and clothes had to change completely. He thought "Frederick's of Hollywood" and gathered up some ideas to show Olivia. He remembers how eager she was to dress up in her black outfit: "She was dying. She couldn't wait. She was so tired of Miss Goody-Goody!" Albert confirmed that, yes, they did have to sew her into those pants. They were a stretchy spandex that were perfect for dancing in. Olivia limited her water intake so she wouldn't have to be ripped out of the pants to pee and then have to get sewn back into them. Her hairstyle was from the hairdresser on the set, playing around with a seventies take on a fifties style. Her red shoes were her own. It's sometimes a problem for the costume designer and prop people when actors bring their own pieces of costume—the actors could leave them at home or wear them out and get them scuffed up. If they are lost or damaged, there is no backup. But it worked for Olivia and the movie and added one more pop of seventies style.

Before this day, when Olivia was on set, the cast and crew were always respectful of her. But with her "Bad Sandy" makeup and hair and outfit, she was so sexy that the cast and crew all swarmed around her, chatting with her, bringing her coffee, and flirting.

The audiences who saw _Grease_ weren't the only ones knocked out by Olivia's transformation. One of the dancers, Sean Moran, said half the dancers fell to their knees in amazement when they saw her, and the other half wanted the outfit. Olivia's "new look" blew us all away. Later, Olivia commented, "If I knew I was going to get this reaction I would have been doing it much earlier."

"We Go Together"

The Scene

With a "a-wop-bop-a-loo-bop-a-wop-bam-boom!" the final number begins, marking the end of the school year. This scene is a good example of how Pat Birch's twenty dancers each instructed the extras around them in the choreography. Everyone in the background is fully engaged in energetic dancing. (You'd never know that we shot this during a record-breaking August heatwave.)

Adapting the choreography from the Broadway production to the large scale of the football field and hundreds of dancers among carnival rides was a challenge, but Pat was up to it. We built the beginning of the sequence up to get a last look at the characters: Danny and Sandy first, joined by Kenickie and Rizzo, then, as if popping up from under the camera, Jan and Putzie. From the sides enter Marty and Sonny, with Doody and Frenchy chiming in. When Pat's dancers zip in, dancing up a storm, it's like seeing the entire high school say goodbye on the last day of school.

There is something infectious about "We Go Together," and we came up with transitions to keep the energy of the song. From the dancers, we zip pan to rides moving in the same direction. Danny and Sandy jump into the frame and then exit to reveal Pat's dancers giving it their all in a shot that showcased their talent.

Then it is farewell, with Patty and Tom handing out yearbooks at the end of the long lines of dancers. Each person gets a final cameo moment, and the dancers reveal the fantasy version of Greased Lightnin', Danny behind the wheel and Sandy beside him, driving off into the skies.

178 CONTINUED: (3) 108.
 178

> DANNY
> I thought that you...
>
> SANDY
> Zuko, we got wavelength trouble.
> When I'm on yours, you ain't
> on mine.
>
> DANNY
> I changed for you and you changed
> for me. I'd say that was some
> kinda wavelength.

Marty cuts in. Mrs. Murdock pulls up in Hell's
Chariot.

> MARTY
> Mrs. Murdock brought the
> yearbooks.

Everyone crowds around the car to get their yearbooks.
Danny and Sandy are left alone. He reaches out for
her hand. A little shyness creeps out from behind
her facade. She smiles and takes his hand.

> SANDY
> Suppose we'll last?

He gives her a reassuring smile and puts his arm
around her.

> DANNY
> Time will tell.

He begins to sing "WE GO TOGETHER" (from the Broadway
show). As the song progresses, the words appear at
the bottom of the screen with an animated bouncing
ball.

> DANNY
> (continuing)
> We go together, like
> Rama, Lama, Lama, Ka-dinga Da
> Ding Dong
> Remembered forever as
> Shoo-bob sha wadda wadda
> Yippity boom-de-boom
> That's the way it should be
> (Whaa-oohh! Yeah!)

(CONTINUED)

SANDY
(singing)
We're one of a kind, like
Dip-a-dip-da-dip
Doo wop da dooby doo
Our names are signed
Boogedy, boogedy, boogedy, boogedy,
 shooby-doo-wop-she-bop
Chang changa chagitty chang shoo
 bop
We'll always be like one.
(Whaa-wha-wha-whaaaaaah)

The others come back INTO THE PICTURE as each
character does a bit and a walk-off as his finale
bow.

JAN AND SONNY
(singing)
When we go out at night
And the stars are shining bright.

FRENCHY AND DOODY
(singing)
Up in the skies above
Or at the high school dance.

MARTY AND PUTZIE
(singing)
Where you can find romance.
Maybe it might be love.

The entire cast comes in for the finale.

ALL
(singing)
We're for each other, like
A wop baba lu mop ahh wop bam
 boom!
Just like me brother, is
Sha na na na na na Yippity dip
 de doom
Chang chang-a changitty chang
 shoo bop
We'll always be together.

As the others sing and dance, Danny and Sandy
separate themselves from the others and walk toward
the rise of a hill. They look at each other, their
eyes brimming with love.

The Shot

Despite the exuberant dancing, at times the cast and crew were wilting in the triple-digit heat. One dancer even passed out as she jumped off the bleachers (only to wake up with her head in John Travolta's lap—she was okay). There was something about the song that kept everyone going.

We used a crane in the sequence, which allowed us to cover distance and pivot at a center point without a dolly track showing; as the dancers moved toward us as a group, we would back away smoothly on the crane. This gave us an incredible flexibility, and it worked without a hitch—almost. Bill Butler remembered when we were doing this and future movie director Andy Tennant decided to add an extra flip in the air during the shot, but we'd done only one in rehearsal, so we weren't prepared. As the camera crane was racing across the ground, Andy did that double flip right into one of the crane's arms and was dragged along. It was terrifying, but luckily he wasn't badly injured and even came back the next day to make that one flip we needed again.

Riding the whirligig with operator Jim Connell and cinematographer Bill Butler

The Choreography

"Nobody's going to like being one of three hundred people taught a step by some lady," is the reasoning Pat gave for assigning her dancers, "D1" through "D20," the task of teaching fifties dance steps to two hundred others. She knew that her dancers were a competitive bunch, so when she told them to break into girl-guy pairs, grab ten kids, and practice the steps, she was confident that they'd all try to "outdance" the others. By the day of the shoot, with the cameras trained on the dancers, they exploded with energy. The shot where Pat's "gang" is featured was during an instrumental section of the song, so the dancers got to show off their talent.

RANDAL: One crazy thing was doing the whole "We Go Together" sequence with no cameras in front of director George Cukor. Everyone jumping and dancing in the hot sun. But I was showing off to my idol. I was so excited to say, "Look what we've done!"

MICHAEL: "Excitement" is such a great word for it. We were all filled with excitement. Eve Arden, she just had a ball.

KELLY: My triumph was that—Randal, I don't know how you kept it in the film—I stuck my head between John and Olivia in "We Go Together" and split them apart, while we're walking at [singing] "We're one of a kind." I'm looking up at them like some kind of disembodied head on a swivel. I thought, "I'm going to get in trouble for this but I'm going to do it anyway."

RANDAL: It's good! It gave a feeling of camaraderie.

Set Visitors

Two of my favorite directors visited the set during this number, John Schlesinger, who made the Oscar-winning *Midnight Cowboy*, and George Cukor, the director of classic films including *My Fair Lady* and *A Star Is Born*. Pat and I offered to show Mr. Cukor the three-minute-long "We Go Together." We sat him in a director's chair at one end of the football field and started playback. Two hundred cast members and dancers at the other end worked their way down the field through the song until they landed at Cukor's feet, sweating and breathing heavily. Pat and I looked over at him expectantly. "Good stuff . . . very spirited," he quipped.

Looking back, I can't believe I didn't roll the cameras during this run-through. I was so excited to be showing this spectacular number to Cukor that it didn't occur to me.

Choreographer Pat Birch invited *Midnight Cowboy* director John Schlesinger to the set.

Popsicle break with *My Fair Lady* director George Cukor. Unreal!

RANDAL: Dinah, you were dancing
during the carnival at the
end but you've said you
can't dance. How did you
handle that?

DINAH: I could do all those
steps. My idea was, if I,
in this character, just move
my hips from side to side
and pout my lips, I'm going
to get away with whatever I
have to get away with.

Near the end of the shoot, the cast
begins their goodbyes.

The Song

While driving in my convertible back and forth to the set every
day, I listened to the music of the Broadway production on
cassette tape. During our preparation for the "We Go Together"
shoot, I heard the lines at the ending of the song—"We'll always
be together"—repeating over and over. As I drove, I began
singing some fifties riffs over it, like "Who put the bop in the
bob shoo bop shoo bop" and "Ooo eee ooo ah ah, ting tang,
walla walla bing bang" and various "ooo-ahhs." I took this idea
to our music team, who brought in singers and added those
riffs over the ending of the song.

I would listen to music
tracks to and from work.

The End

The ending with Danny and Sandy riding the fantasy Greased Lightnin' into the sky came from a desire to give the movie an over-the-top, surreal ending. Somewhere, someone started a rumor on the internet that the whole movie is a flashback appearing before Sandy's eyes before she drowned. This was triggered by the line in "Summer Nights" in which Danny sings, "She swam by me, she nearly drowned." What if she *had* drowned? Would that explain why they appear in the fantasy Greased Lightnin' car at the end and fly up into the sky? Did this whole story flash before her eyes before she drowned?

The answer is NO!

It just seemed like a fun way to end the movie.

178 CONTINUED: (5) 178

Just before they reach the crest of the hill a yearbook COMES SPIRALING OUT OF THE SCREEN and stills from scenes throughout the picture are SEEN in color, then FADE TO BLACK AND WHITE against the shiny yearbook pages, instant memories. Each major character is caught in a characteristic pose for which his teen years will always be remembered.

As the MONTAGE ENDS, we go BACK TO COLOR and Danny and Sandy complete their journey to the top of the hill and into a bright blue horizon that looks like something from a Peter Max drawing.

HOLD on Rydell High in gleaming color. CUT TO BLACK AND WHITE as Rydell High is SEEN pictured on the first page of the yearbook.

The TITLES at the end identify the characters glimpsed at moments throughout the movie while a medley of 50's SONGS PLAYS in the background.

FADE OUT.

THE END

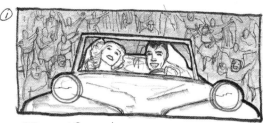

TO: ALLAN CARR, RANDALL KLEISER 1 of 4.
"GREASE"
TAG SEQUENCE

① Danny & Sandy in Fantasy Greased Lightning'
TAKE OFF
PLATE: SHOT MADE FROM CRANE @ CARNIVAL LOC.
NOTE: REAR PROJECTION PREFERRED BECAUSE OF HIGHLY REFLECTIVE HIGHLIGHTS OF CAR AND SANDY'S LOOSELY TEASED HAIR — BOTH PRESENT PROBLEMS IN BLUE SCREEN.

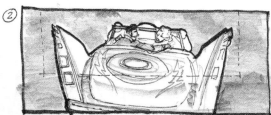

② REVERSE ANGLE (SKY PLATE - NOT SELECTED AS OF AUG. 29-77)
NOTE: MAXIMUM SHOT ILLUSTRATED — MORE OF CAR BELOW REAR BUMPER WILL REQUIRE BLUE FLOOR AS WELL AS BLUE SKY IF SHOT IS COVERED IN BLUE BKG AS WELL AS REAR PROJECTION
PULL BACK FROM TIGHTER SHOT POSSIBLE (IF SKY PLATE IS NON-DESCRIPT.) TO INDICATE CAR MOVING AWAY FROM US.

Other Endings

For the flyaway shot, we hired a helicopter to shoot the crowd below waving up at Danny and Sandy. We wanted it to pull back to see all of the city, but the crew and movie trucks were visible, so we couldn't use it. Today with digital technology, they could have been painted out.

The shot of Danny and Sandy in the car was using a Hollywood tradition, back projection. They sat in a car on a movable platform and the carnival crowd was projected on a movie screen behind them.

This was another moment on the movie when I truly felt like a Hollywood director. Our set visitor that day was the big boss, Charles Bluhdorn, president of Gulf and Western, who owned Paramount at the time.

I shot a take where Danny and Sandy kiss as they fly away. I don't know why it wasn't used at the time. When I went back to the archives to find it, there was only a black-and-white copy. This alternate ending can be seen in the added content of the 2018 Blu-ray.

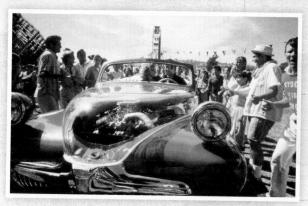

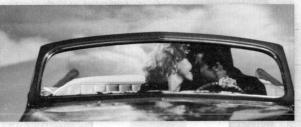

The missing kiss

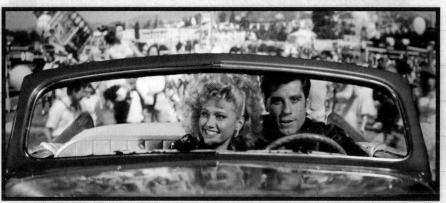

Why does this car fly?

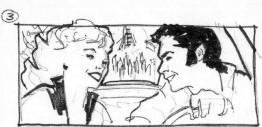

3. SANDY & DANNY — CLOSER SHOT &/or REPEAT SIZE OF #1 SET-UP.
PLATE: HELICOPTER SHOT

4. FINAL SHOT. CAR INTO SKY — DOES BARREL ROLL — OLIVIA'S VOICE HEARD OVER — "DA-NEEE!"

RANDALL — CONSIDER DISSOLVING INTO ANIMATION ON SHOT No. 3 AND CONTINUING WITH ANIMATION THRU No. 4 — THRU 'THE END' ———
NOTE: CAR SHOULD BE KEPT WITHIN FRAME — AS IF PANNING UP AS IT REDUCES TO A SPECK AND DISAPPEARS.

I had talked to production designer Phil Jefferies about the fantasy ending, and he drew these illustrations.

3 & 4

THIS THREE-QUARTER VIEW OF THE CAR WITH THE CAR ROLLING OVER ON THE SAME AXIS CAN BE DONE WITH ANIMATION — OR A REDUCED SCALE REPLICA OF THE CAR ON A WIRE. IT WILL NOT WORK BY OPTICALLY REDUCING AND ROLLING — EITHER OPTICALLY OR WITH 'ROUNDY-ROUNDY' — AS SUCH TECHNIQUE WOULD ROLL ONLY THE IMAGE SEEN AT LEFT ABOVE — CREATING AN ILLUSION OF AN AWKWARD WOBBLE.

NOTE: A STRAIGHT-ON VIEW AS SHOWN HERE CAN BE REDUCED OPTICALLY AND ROLLED ON A CENTER AXIS — BUT MUST BE SHOT — AS IS POSSIBLE ON THE MAGICAM STAGE WITH BLUE FLOOR WHICH ROLLS INTO BLUE VERTICAL BLUE BKG.

REVISED!AGAIN!

W.A. 1074

Series: _____

Producer: Stigwood / Carr

Director: Randal Kleiser

Title: "Grease"

CALL SHEET

Prod. No. 31108

Day: Wednesday, September 14, 1977
56th — Day out of 53 days
Call: 7:30AM
Shooting Call: 8:30AM
Location: Stage 16, n/LA River

SET # SET	SCENES	CAST	D/N	PAGES	LOCATION
Ext. Drive-In "Oh Sandy" COMPANY MOVES TO STAGE 12A	(Retake - C.U. Danny)	1	N		Stg. 16
Int. Frenchy's Bedroom - "Sandra Dee" (Retake) COMPANY MOVES TO LA RIVER	4,5,7,9		N		Stg. 12A
Ext. Thunder Road	(Retake - C.U. Leo) Stunt Action	22, A, B	D		LA River

	CAST & DAY PLAYERS	PART OF	MAKE-UP/LEAVE	SET CALL	REMARKS
1	John Travolta (New)	Danny	7:30A	8:30A	P.U. at home @ 7A
22	Dennis Stewart (New)	Leo	9A	9:30A	Report to Stg. 16
A	Hubie Kerns (New)	Stunt - Utility	—	9A	Stg. 16 (not to be photographed)
B	Larry Dunn (New)	Stunt - Utility	—	9A	Stg. 16 (not to be photographed)
4	Didi Conn (New)	Frenchy	7:30A	9:30A	Report to Stg. 10
5	Jamie Donnelly (New)	Jan	7:30A	9:30A	↓ ↓ ↓
7	Stockard Channing (New)	Rizzo	7:30A	9:30A	
9	Dinah Manoff (New)	Marty	7:30A	9:30A	

ATMOSPHERE AND STANDINS

2 Standins

SPECIAL INSTRUCTIONS

8A Report to Stg. 16

..........................
Movies are shot
out of order. Here
is our wrap party
call sheet, where
we announced the
first screening
of *Saturday Night
Fever* for our cast
and crew.

ADVANCE SHOOTING NOTES

SHOOTING DATE	SET NO.	SET NAME	LOCATION	SCENE NO.
		COMPLETION OF PRINCIPAL PHOTOGRAPHY		

Wrap Party - Wed., Sept. 14, 1977 - For Grease Cast + Crew
Before Party - at 6:30 PM in the studio theater - Screening of "Saturday Night Fever" for cast + crew
Stage 16 at 8PM Please Come!!

UNIT PROD. MGR. Neil Machlis — PHONE 2101 — ASST. DIR. Jerry Grandey — PHONE 2101
ART DIR. Phil Jeffries — PHONE 1876 — SET DEC. Jim Blikey — PHONE 1993
ISSUED BY OPERATIONS: DATE 9/13/77 TIME _____ APPROVED _____

190

"WE GO TOGETHER"

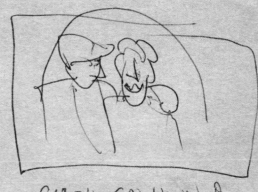

COACH CALHOUN &
PRINCIPAL MCGEE

The RELEASE

THE PREVIEW

WHEN WE FINISHED THE EDIT, it was time to check audience reaction. The studio executives weren't sure how the movie would play and decided to go way out of town to show it—all the way to Honolulu. The can containing the print had a fake title so no one would know what was being shown, but somehow a radio station got wind and leaked the info, so when we arrived at the theater, there was a line extending around the block.

The executives were seated throughout the theater to pick up on the reaction. The lights went down, and there was excited stirring in the crowd . . . and in my stomach. The audience was buzzing during the credits and the first scene. They seemed to be liking it. But then, when "Summer Nights" began and John started strutting down the bleachers, the audience broke into laughter. I felt another more intense jolt in my stomach. Were they laughing *with* the scene or *at* it? Was our movie a bomb? As the laughter and excitement grew, I realized, with relief, that they loved it.

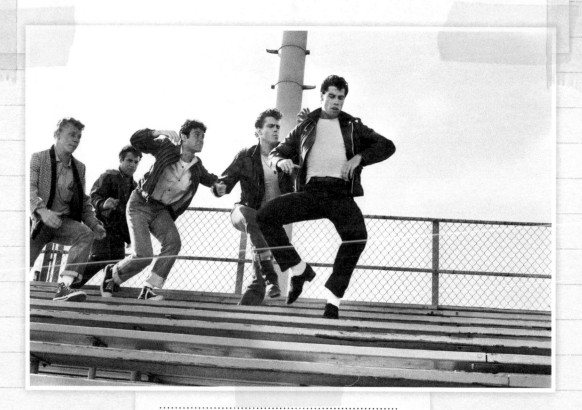

When the audience laughed at John's strutting in "Summer Nights," my heart sank.

193

THE PREMIERES

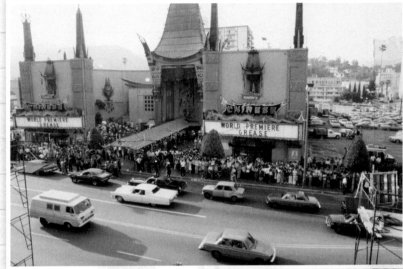

AT THE TIME of the movie's Hollywood premiere at Grauman's Chinese Theatre, *Saturday Night Fever* was a huge hit and John Travolta was one of the biggest stars in the world. On June 4, 1978, John and Olivia arrived together in a blue '57 Thunderbird convertible, with Olivia wearing a pink poufy prom dress, looking very "Good Sandy," and John in his T-Birds jacket. There was such crowd of thousands of cheering fans that security had to push a path through them for John and Olivia to even get to the theater.

This was my first premiere, and the chaos and screaming fans were thrilling. My parents, who had just arrived in Los Angeles from Philadelphia, my brother, and I rode in a limousine to the theater. A couple of the dancers had said they were going to moon me as I pulled up to the premiere, and I said, "No, you aren't." Sure enough they did, right in front of all the cameras. As our limo pulled up, these guys stuck their butts right in our window. It was hysterical.

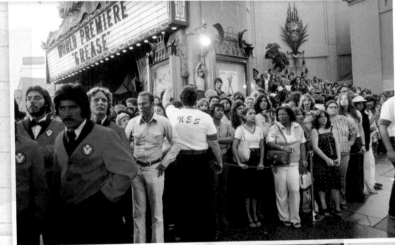

As soon as John appeared on the screen, the audience began whistling and cheering all over again, and that energy kept going all the way through the closing credits.

For the after-party at Paramount, which was themed like a prom in a specially constructed set of a gymnasium, Sandy changed into a pink jumpsuit, like a Pink Ladies version of "Bad Sandy." There was a marching band playing songs from the movie as we all danced the night away. I couldn't help laughing at the elaborate air-conditioned gym the studio had created just for our party—when we had sweated for days filming the dance contest on location.

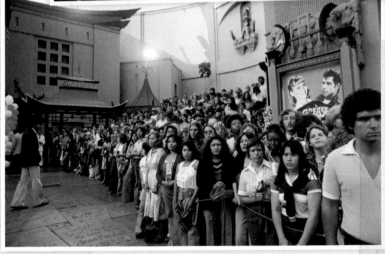

A dream come true: a premiere at Grauman's Chinese Theatre and lines around the block

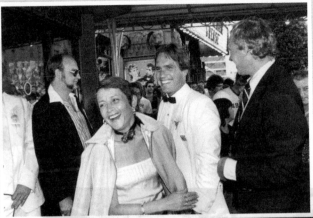

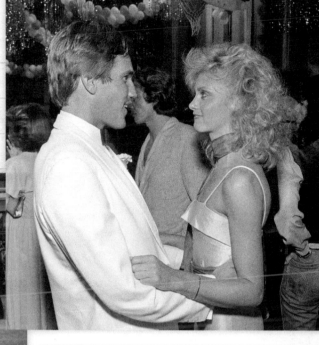

TOP, LEFT: Choreographer Pat Birch and I arrive at the premiere at Grauman's Chinese Theatre. • TOP, RIGHT: Celebrating with Olivia at the after-party at Paramount Studios • LEFT: My parents, Kelly and Jack Kleiser, at Grauman's Chinese Theatre for the twentieth-anniversary rerelease

LEFT: At the Deauville American Film Festival in France, French director Claude Lelouch (at center) hosted the *Grease* team for the first European showing. • BELOW: Press conference at the Deauville American Film Festival

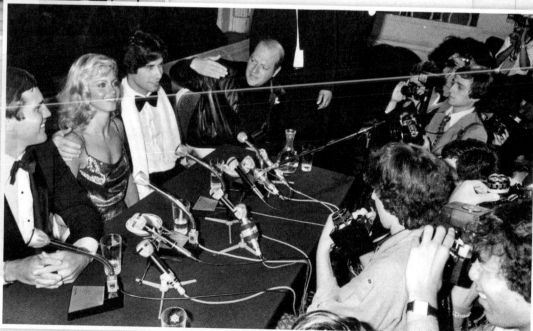

THE SUMMER OF '78

DURING THE SUMMER OF '78, as I drove through Los Angeles in my convertible, I heard every radio station playing songs from the movie. I would turn the dial and hear "You're the One That I Want," "Hopelessly Devoted to You," "Grease," and "Summer Nights" playing on all stations. Four of the songs were in Billboard's top 10 and the album sold thirteen million copies in that first year. The album became the soundtrack for a generation of high school students on the cusp of adulthood.

The studio called me when the movie opened. "The grosses for the weekend were $8.94 million," the caller said. "Oh," I replied. The person on the other end of the line seemed to expect me to say more. "Is that good?" I asked. As a first-time director—and with no social media available yet or even *Entertainment Tonight* to explain what grosses or per-screen averages were—I didn't know if that number meant good news or bad news. The studio seemed really excited, but I thought they were just being polite.

The "official" reviews were mixed. One reviewer thought *Grease* was merely "visual junk food"; another declared it "made by nitwits who haven't the slightest idea of what a camera is." It felt like a hit to us, and with lines snaking around the block at venues, it was beginning to look like one. I learned it topped the box office at $160 million for the year—a perfect storm of talent, vision, marketing, and luck.

Ever since I had seen the parting of the Red Sea in *The Ten Commandments*, starring Charlton Heston and Nina Foch, I had wanted to be a director. I had fulfilled my dream, practically on the site of where that dramatic scene was shot. (The tank is now used as a parking lot at Paramount Studios. The huge painted-sky backdrop still remains.) We had had fun making the movie but were now realizing it was an enormous hit. I think if we had tried to make a blockbuster musical, *Grease* wouldn't have turned out the way it did. Everything just clicked. I wasn't the only one surprised—we all were, and still are, after more than forty years.

THE BIG NEWS PAPER

DAILY **EXPRESS**

THE VOICE OF BRITAIN

No. 24,324　　Thursday September 14 1978　　*Sunny spells*　　TV Page 26　　8p　　★★★

GREASE FEVER!

TRAVOLTA AND OLIVIA MOBBED AS BEATLE STYLE CROWDS STORM PREMIERE

By David Wigg

LONDON has seen nothing like it since Beatlemania: the premiere of the John Travolta film "Grease" last night was a riot.

It was a case of Wednesday night fever—and it brought fear to the stars on parade.

First, disco-king Travolta's car was trapped by hundreds of fans bursting through ranks of 200 police in Leicester Square.

As a youth jumped on the car roof, the star with his girl friend Marilu Henner and co-star Olivia Newton-John had to be rushed into the Empire by bodyguards.

FEAR

' John, John, John," screamed crowds of girls.

Earlier this week, Travolta, talking about premieres, said : "It frightens me, the sheer physical force of it all — I am scared something will happen to me."

Last night in the Empire he sat down, pale and shaken, missing the film itself — and declared : "I will never go through this again. No one could imagine it would be like this. I was terrified."

In fact, he got off lightly compared with some.

Penny Needham, a publicity girl, had the front of her dress ripped down.

Actress Susan George was trapped in a car. "It was just terrifying," she said.

"They were pulling my hair and my arms. They did not mean to harm us—they were

Page 3, Column 4

First night frenzy... John Travolta and Olivia Newton-John run the gauntlet of fans at premiere. PICTURE : STEVE WOOD

At that September's premiere in London, a mob outside the Leicester Square theater attacked John and Olivia's limo, rocking it back and forth. Olivia said that the car's roof even started to cave in. An army of British bobbies came to their rescue.

The LEGACY

A COMMUNITY

*G*REASE STARTED AS A HIT SHOW at a converted trolley barn in
Chicago and became a hit movie. Since it first appeared on big screens across
the world in 1978, *Grease* has been rereleased on TV, DVD, and Blu-ray. It has
been an Emmy-winning live production broadcast as well as a sing-along happening, and
it seems as if every school has put on a production. Fans who watched the movie again
and again in 1978, singing along with the catchy lyrics, now watch it with their children
and even grandchildren. So many people know the songs and dialogue by heart and have
told me that when they are changing channels and come across it, they get hooked and
watch it again.

I am often asked to show my movies at film schools and have noticed a pattern in
the students. During the question-and-answer period after screenings, some students
come across as lofty critics, as if they know everything there is to know about film. I've
come to expect this uncensored criticism in students just starting out in their studies. But,
many years after the original release of *Grease* I was astounded by the students' response
to it at both the American Film Institute and the University of Southern California. The
students were watching it, wide-eyed and open-faced, like little kids. I couldn't figure it
out at first, then I realized: although they had seen it numerous times, it was always on
the small TV screen. I asked the group in the USC class how many had never seen it
before on a big theater screen. Four hundred hands went up. Then I asked if they noticed,
this time, all the raunchy references. Their response? A big cheer, applause, and laughter.

"Fun" is the word that comes up in cast interviews. And it *was* a lot of fun. The whole
experience of making *Grease* was like going through high school again—in a good way.
We learned a lot and had a great experience all around. That energy and joy comes out
whether someone's watching it on a big screen or streaming it onto a phone. The movie
is based in the Hollywood musical tradition, but it also arrived at the start of the music-
video age. Perhaps one of the things I love best about having been involved in *Grease* is
the fact that the community we created in the fictional halls of Rydell High has continued
to remain a tight circle of friends. For four decades we've reunited at premiere parties,
rerelease parties, sing-alongs, and anniversaries. It's true: "We go together."

THE SING-ALONGS

AROUND 1998 I saw that the New Beverly Cinema revival theater in West Hollywood was having a midnight screening of *Grease*. I called up Olivia and Didi and asked if they wanted to see how the movie held up with a midnight crowd. We waited until the movie was about to start and then sneaked into the back and sat in the last row. As we looked around, we noticed that most of the audience were dressed in fifties attire. The lights dimmed and then, when the first song began, the entire audience began enthusiastically singing along. We were even more amazed when they recited, word for word, the dialogue along with the movie. It felt like my college days, watching midnight screenings of *The Rocky Horror Picture Show*.

As the credits rolled, the audience cheered wildly. The lights came up, and Didi and Olivia pulled their hats lower to disguise themselves as the audience filed out. We thought no one had noticed them. But when we emerged, we saw the whole audience gathered under the marquee on the sidewalk. The crowd gave a big round of applause and began singing "We Go Together." Touched, Didi and Olivia brushed away tears welling in their eyes. This was the first time we realized how popular the movie still was.

Word got around that midnight showings and film festival screenings of *Grease* were attracting crowds. I asked interns in my office to create a PowerPoint file that could project the lyrics on the screen during these showings. We sent this—with some helpful tips to feature local talent—to the festivals. Festival organizers could then recruit a volunteer who knew the movie well and assign them to push the space bar at the right time to move to the next lyric. Low-tech but effective, and more and more festivals began holding these sing-alongs.

GREASE SINGALONG STAGING GUIDES

For gay themed events:
 A local drag queen is great for warming up the crowd. This gets the audience interactive with group responses, etc so that they will sing along and not be intimidated.

For gay and general:
 Dance and costume contests are great to get the crowd involved. Voting for the best.

DURING SCREENING

PowerPoint subtitles:
 A PowerPoint projector can place the subtitles for singing along below the picture. It is best to mask off the light from the screen except where the lyrics appear.
 The operator of the PowerPoint should practice with a video or DVD of the movie to get the timing right.

DANCERS:
 Local dancers who watch the film and work out routines for some of the numbers are effective, especially "Greased Lightning", "You're The One that I Want" and the end song; "We Go Together".

LEFT: These are tips I sent to organizers of the early sing-along screenings using PowerPoint projection of lyrics. • BELOW: The Hollywood Bowl was the site of the first "official" *Grease* sing-along, in 2010, but for years fans had already sung along to the lyrics during midnight screenings and festivals.

My college roommate, George Lucas, called the head of Paramount and recommended rereleasing our movie. He said every nine-year-old girl in the country was watching the video every day. Inspired by this recommendation and energized by the popularity of the screenings, Paramount executives hired a graphics facility to create an official sing-along print, with bouncing balls and cartoon images animating the lyrics. This version premiered at the Hollywood Bowl, where the crowd teemed with ponytailed, poodle-skirted women and leather-jacketed tough guys with pomaded hair. *Grease* goodie bags were handed out, which included bubble-gum cigarettes, glow sticks, and party poppers. Didi conducted a costume contest and introduced me and some of the other cast. The movie started and at Danny and Sandy's first kiss, a chorus of party poppers exploded. During "Beauty School Dropout" thousands of viewers blew bubbles that floated above the crowd, and every song was roared out by the many voices. The *Grease* sing-along was perhaps *the* celebration that has most matched the energetic innocent fun of the movie. Standing on the stage of the Hollywood Bowl in front of seventeen thousand cheering fans, all dressed in costumes from our movie, was an experience I'll never forget.

ABOVE: *Grease* sing-along at the Santa Monica Pier, 2006 • BELOW, LEFT AND RIGHT: The Hollywood Bowl, 2010

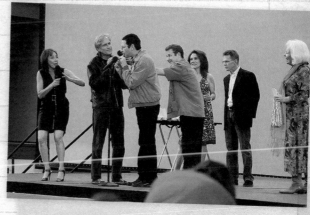

DIDI: People tell me, "You sound so familiar. Do I know you?" And usually the kid will tell the parent, "Oh, she's Frenchy from *Grease*." It's my voice that does it. And then everybody gets so happy. They just want to hug me. I think because Frenchy was such a good friend to Sandy. Honestly, it's very nice, Randal.

RANDAL: What was it like for you the first time you went on the Hollywood Bowl stage?

DIDI: Seventeen thousand people! I was nervous before I went on, but then I said, "A wop-bop-a-loo-bop," and they answered, "A-wop-bam-*boooom*." And I went, "Wow. Holy shit."

GREASE AS A SPRINGBOARD

MANY PEOPLE who were just starting out their movie careers worked in *Grease* as extras, dancers, and production assistants. In the basketball sequence, actor **Michael Biehn** is the one Danny Zuko punches in the stomach.

Michael went on to star in *The Terminator*, *The Abyss*, and *Aliens*. Years later, his five-year-old daughter wanted to watch him for the first time in *Grease*. He turned on the TV and left the room. When he returned, she was watching the screen with her fingers holding her eyes open. Michael asked what she was doing. She replied, "Daddy, you told me not to blink or I'd miss you."

One of the twenty dancers who appears throughout the film was **Andy Tennant**. His long career in film began in large part because Andy had gone to USC with Kelly Ward, who told him about the dance auditions for *Grease*. Although he was, as he calls himself, "more of an actor who can dance than a dancer who can act," Pat liked his ability to get into character—and being a gymnast also helped. To take part in the *Grease* rehearsals, he missed his graduation and his birthday celebrations, but he was hooked on the movie business from day one, even before Olivia sang "Happy Birthday" to him. Andy's backflips are seen throughout the movie, especially in "Greased Lightnin'" and "We Go Together," and his "knee slides" are featured in the dance contest. Andy went into directing, first TV and then features, including *Anna and the King*, *Sweet Home Alabama*, and *Hitch*.

Wendy Jo Sperber can be seen sitting behind Olivia and John at the dance contest. Her career took off acting in *Bosom Buddies*, *Back to the Future*, *Designing Women*, *Harry and the Hendersons*, *Married with Children*, *Will and Grace*, and *Home Improvement*.

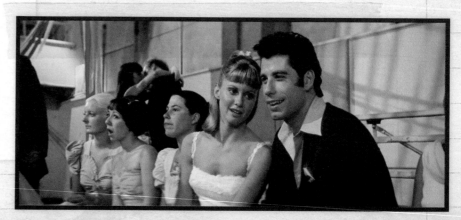

Peter Lyons Collister was a nineteen-year-old cinematography student at USC, and I hired him to be John Travolta's stand-in and a general production assistant. He had worked on a short I made about my grandfather, *Portrait of Grandpa Doc*, starring Melvin Douglas. One of his first tasks was to meet Olivia when she arrived in the States from Australia. Everyone was swamped preparing details for the production. So Peter took her on a tour of the entire Paramount lot, showing her where they were painting her dressing room and the sign on her dressing-room door. He then gave her a copy of the Broadway show's album and took her to lunch, quite nervous about hosting the star of the picture. Olivia was (and still is) so easy to get along with that they formed a close bond.

Peter's main interest was in cinematography, and he was getting USC school credit for interning with Bill Butler. He was thrilled when Bill invited him to operate the slate for B camera and become a "mascot" for the camera crew. He later worked in the camera department on my films *The Blue Lagoon* and *Summer Lovers*. He went on to become a director of photography on many feature films including *Poetic Justice*, *The Replacement Killers*, *The Beautician and the Beast*, *Deuce Bigalow: Male Gigolo*, *The Amityville Horror*, *Alvin and the Chipmunks*, *Hop*, and TV's *Arrested Development*.

JAMIE: After 9/11, I remember reading an article about how *Grease* was one of three movies that everybody was watching to soothe themselves after that crisis. It's so nice to be associated with something fun.

..

OLIVIA: I thought *Grease* was a sweet movie—and still do—but I had no idea what it would become. People ask, "Did you know it would be so big?" How could you know? It is like miraculous to have a movie that is still popular now.

..

BARRY: The question we always get asked is "Did you know?"

RANDAL: We didn't know how popular the movie would be.

BARRY: No, nobody ever knows. We know we were having fun, and maybe there was a shot at something. And, as I recall, we were not an artistic success.

KELLY: We were a commercial success.

MICHAEL: Well, we had the *New York Times*. Allan [Carr] said to me, "We've got the *New York Times*." That's all he needed. And the *L.A. Times*, which is great because then you know you have some class. And the London *Times*. The *Washington Post* gave it a good review.

BARRY: But I remember one critic saying they couldn't see our feet. I had no clue what that meant. Doesn't matter, because we just had a fortieth anniversary.

MICHAEL, BARRY, KELLY, AND RANDAL: The fortieth!

RANDAL: And to the fiftieth!

BARRY: Yeah, we're there, baby. And you'll definitely be there, Randal. You've got that picture in the attic.

THE FORTIETH ANNIVERSARY

THE FORTIETH ANNIVERSARY of the movie *Grease* was an opportunity to restore the film using twenty-first-century technology. In 2018, the Paramount archival team went back to the original sound mix of the 70mm version. Celluloid film has so much inherent information in it that can still be mined before it is lost as the film degrades over time. Using High Dynamic Range (HDR) technology, we were able to bring out greater contrast and richer gradations of colors that were preserved in the original negative.

Working with the Paramount team on the digital restoration in 2018

John, Olivia, Didi, Barry, and I attended a special screening of the movie at the Samuel Goldwyn Theater on August 15, 2018, hosted by the Academy of Motion Picture Arts and Sciences. Mario Lopez led us through some great memories in front of an audience excited to see the restored film on the big screen.

Everywhere I go in the world, I hear how much people love the movie, from kids to teenagers to grandparents. *Grease* had hit songs, cool dance moves, and great lines. But I think the connection people have with the movie is in large part due to the connection the actors all felt with one another.

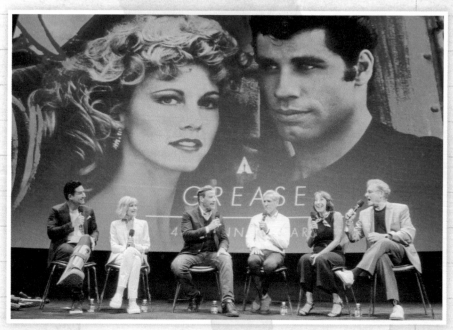

A reunion for the fortieth-anniversary screening of *Grease*, hosted by the Academy of Motion Picture Arts and Sciences, 2018

WE OWE IT ALL TO THEM

ALTHOUGH MY HIGH SCHOOL DAYS took place in the sixties, Radnor High was very much like the Rydell High of *Grease*. There were no shootings, no switchblades, no social media. The big decisions were who to take to the prom and how to skirt around the teachers' rules and have fun. People always ask why *Grease* has remained so popular through the years. I say it's because it captures the nostalgic feeling of a more innocent time, it had terrific music, and it had a one-of-a-kind cast. In the end, we owe it all to Jim Jacobs and Warren Casey, who originated the phenomenon of *Grease*.

ACKNOWLEDGMENTS

THIS BOOK WAS MADE POSSIBLE by the support of so many people. I thank my fellow Greasers who dug into forty-year-old memories to share their insights about the production: John Travolta and Olivia Newton-John; my partner and guide, choreographer Pat Birch; director of photography Bill Butler; the cowriter of the hit *Grease* musical Jim Jacobs; Pink Ladies Didi Conn, Jamie Donnelly, and Dinah Manoff; T-Birds Barry Pearl, Michael Tucci, and Kelly Ward; casting director Joel Thurm; dancer (now director) Andy Tennant; songwriter John Farrar; still photographer Dave Friedman; Travolta stand-in and future cinematographer Peter Lyons Collister; special photographer Jonathan Becker; and costume designer Albert Wolsky.

Grease was a community effort, from the entire cast, crew, and management to the many assistants and extras who populated the hallways of Paramount and Rydell High. I thank everyone who brought so much to the production of the movie *Grease*, especially those who have passed away but whose contributions live on. In addition to the people listed above, I especially thank Warren Casey and Ron Taft; actors Frankie Avalon, Joan Blondell, Susan Buckner, Edd Byrnes, Sid Caesar, Annette Cardona, Stockard Channing, Jeff Conaway, Eddie Deezen, Fannie Flagg, Alice Ghostley, Dody Goodman, Lorenzo Lamas, Dick Patterson, Sha Na Na, Dennis Stewart, and Ellen Travolta; the extras and dancers, especially Pat's "Dancers 1 through 20" (Barbi Alison, Helena Andreyko, Jennifer Buchanan, Carol Culver, Dennis Daniels, Cindy DeVore, Larry Dusich, Deborah Marie Fishman, Antonia Francheschi, John Robert Garret, Sandy Gray, Daniel Levans, Mimi Lieber, Sean Moran, Greg Rosatti, Andy Roth, Lou Spadaccini, Judy Susman, and Richard Weisman); musical director Louis St. Louis; producer Neil A. Machlis and Linda Zimmerman; assistant directors Jerry Grandey, Paula Marcus, and Lynn Morgan; script supervisor Joyce King; assistant choreographer Carol Culver and dance consultant Tommy Smith; camera crew Colin J. Campbell and George Hill; film editor John F. Burnett and Robert Pergament; the sound department's Jerry Jost, Sean Hanley, Charles E. Moran, and Bill Varney; Ron Hays for his electronic visual effects; property master Rich Valesko; the wardrobe and makeup department's Betsy Cox, Bruce Walkup, and Daniel C. Striepeke; stunt coordinator Wally Crowder; music editor June Edgerton and the music department's David J. Holman, Bill Oakes, Charles Fox, Cubby O'Brien, Bradford Craig, and Michael Gibson; animator for the main title John Wilson and end title designer Wayne Fitzgerald; location manager Alan B. Curtiss; and unit publicist Gary Kalkin.

At HarperCollins, I thank Marta Schooler, Elizabeth Smith, Lynne Yeamans, Raphael Geroni, and Dani Segelbaum.

This book would not be possible without the support of Paramount. I especially thank Bil Bertini, Risa Kessler, Sabi Lofgren, and Andrea Kalas, as well as the tireless efforts of Caitlin Denny, Becky Ruud, Dony West, Chuck Woodfill, Eric Hoff, and Jeffrey Osmer; Randall Thropp for discovering the costume-continuity book; and Jaci Rohr for her knowledge and hospitality.

I thank Anne Coco, Taylor Morales, and Rita Sotile at the Academy of Motion Picture Arts and Sciences' Margaret Herrick Library.

I thank my dear interns, who helped me blow the dust off my photo archives: Macarena Abad, Andrea Casamitjana Samper, Merisa Hakaj, and Ross Matlin.

And a special thanks to Mani Perezcarro, my jack-of-all-trades, who handled organization, tracked down rights, prepared graphics, restored pictures, supervised interns, and taught me things only millennials know.

HarperCollins books may be purchased for
educational, business, or sales promotional use.
For information please email the Special Markets
Department at SPsales@harpercollins.com.

First published in 2019 by
Harper Design
An Imprint of HarperCollins*Publishers*
195 Broadway
New York, NY 10007
Tel: (212) 207-7000
Fax: (855) 746-6023
harperdesign@harpercollins.com
www.hc.com

Distributed throughout the world by
HarperCollins*Publishers*
195 Broadway
New York, NY 10007

ISBN 978-0-06-285692-0

Library of Congress Cataloging-in-Publication Data
has been applied for.

Book design by Raphael Geroni

Printed in China

First Printing, 2019

CREDITS

All photographs © Paramount Pictures except the
following: Copyright © Matt Petit/Courtesy Academy
of Motion Picture Arts and Sciences: 165 (bottom
right), 204 (bottom left and right); © Jonathan
Becker/Courtesy Randal Kleiser: 186 (bottom left
and right); © Peter Collister/Courtesy Randal
Kleiser: 11; © *Daily Express*—Photo Steve Wood:
197; © Dirk De Brito/Courtesy Randal Kleiser: 4;
© and courtesy Jon Didier: 201 (top and middle right);
© Dan Douglas: 7 (top); © Donna Dunlap: 205 (left);
© Festival du Cinéma Américain de Deauville/
Courtesy Randal Kleiser: 195 (left, third from top,
and bottom); © Eddie Frank/Courtesy Barry Pearl: 15
(bottom left and right); © Nikki Jee/Courtesy Randal
Kleiser: 204 (top); © Philip Jefferies/Courtesy Margaret
Herrick Library, Academy of Motion Pictures Arts and
Sciences: 110 (top), 132 (top), 188 (bottom right),
189 (bottom left and right); © Jeff Kleiser/Courtesy
Randal Kleiser: 13, 24 (middle right), 106 (bottom),
119, 165 (bottom left), 187 (bottom), 196 (top and
bottom), 201 (bottom left and right), 208; © and
courtesy Randal Kleiser: 17, 195 (left, second from
top), 200; © Kenny Morse/Courtesy Barry Pearl:
5 (bottom left), 19 (bottom left), 178 (top), 186
(top right), 187 (top row); © Alan Pappé/Courtesy
Barry Pearl: 107; © Daren Scott: 205 (right); © Albert
Wolsky/Courtesy Margaret Herrick Library, Academy of
Motion Pictures Arts and Sciences: costume sketches
on 49, 83, 128, 135, 155.

Stock design elements © Shutterstock/Africa Studio;
© Shutterstock/amstockphoto; © Shutterstock/
Arttis; © Shutterstock/FabrikaSim; © Shutterstock/
Filipchuk Maksym; © Shutterstock/Fotokor77;
© Shutterstock/Happie Hippie Chick; © Shutterstock/
Katrien1; © Shutterstock/MichaelJayBerlin;
© Shutterstock/mexri; © Shutterstock/mtkang;
© Shutterstock/NatSarunyoo536; © Shutterstock/
Nils Z; © Shutterstock/Oksana Alekseeva;
© Shutterstock/pernsanitfoto; © Shutterstock/Schus;
© Shutterstock/sozon; © Shutterstock/Lukasz Szwaj.

ABOUT THE AUTHOR

RANDAL KLEISER's other credits include *The Boy in the Plastic Bubble*; *The Blue Lagoon*; *Summer Lovers*; *Flight of the Navigator*; *White Fang*; *Big Top Pee-wee*; *Honey, I Blew Up the Kid*; *North Shore*; and *It's My Party*. With George Lucas, he produced the educational course *The Nina Foch Course for Filmmakers and Actors*.

Always involved in cutting-edge technology, Kleiser worked in 70mm 3D for *Honey, I Shrunk the Audience* for the Disney Parks around the world. This led to the US government signing him to develop a virtual-reality simulator that trained American soldiers to deal with improvised explosive devices in the Middle East.

In 2019, he released the twelve-part virtual reality series *Defrost*, which debuted at Sundance Film Festival and was shown at Cannes. Experimenting with Paramount and Intel Studios, he reimagined the *Grease* song "You're the One That I Want" using volumetric capture technology.

Kleiser has served on the National Board of the Directors Guild of America and on the Sci-Tech Council of the Academy of Motion Picture Arts and Sciences.

WWW.RANDALKLEISER.COM • WWW.NINAFOCHPROJECT.COM